DRAW YOUR WEAPONS

DRAW YOUR WEAPONS
SARAH SENTILLES

 RANDOM HOUSE || NEW YORK

Published in the United States by Random House, an imprint and division of Penguin Random House LLC, New York.

RANDOM HOUSE and the HOUSE colophon are registered trademarks of Penguin Random House LLC.

LIBRARY OF CONGRESS CATALOGING-IN-PUBLICATION DATA
Names: Sentilles, Sarah, author.
Title: Draw your weapons / Sarah Sentilles.
Description: New York : Random House, [2017] |
Includes bibliographical references.
Identifiers: LCCN 2016039819 | ISBN 9780399590344 (acid-free paper) |
ISBN 9780399590351 (ebook)
Subjects: LCSH: Art and war. | Peace in art.
Classification: LCC N8260 .S47 2017 | DDC 701/.08—dc23
LC record available at lccn.loc.gov/2016039819

Printed in the United States of America on acid-free paper

randomhousebooks.com

123456789

FIRST EDITION

Book design by Simon M. Sullivan

In memory of Howard and Ruane Scott.
And for Miles.

In the dark times
Will there also be singing?
Yes, there will also be singing
About the dark times.

—BERTOLT BRECHT

PREFACE

I began writing these pages after seeing two photographs.

In one, an old man in a plaid shirt held a violin, his eyes shining; in the other, a prisoner stood on a box, a hood covering his face, wires attached to his body. I was a graduate student in divinity school at the time, preparing to be a priest, writing my dissertation about theological imagination, but those images made that life impossible. I left the church, wrote my dissertation about photography, and got a job teaching at an art school. The changes took years, more than a decade, which is also how long it took to write this book. The United States has been at war the whole time.

I live in a world where it is said, You are here and war is there. Us and them, friend and enemy, same and other, civilized and barbaric. But war is right here—the photograph on my screen of a girl splattered in blood at a checkpoint, the voices on the radio saying words like *charred* and *beheaded,* the body of a teenager left uncovered on the street of an American city, the drone factory an hour's drive from my house, the veteran in my classroom who fought so someone would pay for him to sit in my classroom. Here and there and here again.

How to live in the face of so much suffering? How to respond to violence that feels as if it can't be stopped? What difference can one person make in this beautiful, imperfect, and imperiled world?

To see a photograph of suffering is to become a citizen of photography, Ariella Azoulay argued; to be a viewer—*to see through the gaze of another*—is to become a plaintiff who must let the image speak. And though you may be the viewer today or the photographer tomorrow, soon will come a time when you are the one in front of the lens.

Bodies are bound by a shared precariousness. *Let's face it,* Judith Butler wrote. *We're undone by each other. And if we're not, we're missing something.*

A professor at the art school where I used to teach cut a head-sized hole into the wall of the gallery. The building where we'd taught for years would soon be leveled, replaced by condominiums. Inside the hole he'd made in the drywall, on the interior wood now visible, he taped an image: island, palm trees, sunset. Then he stood on a stool and put his face inside the hole and sang to the building for hours, for nearly an entire day.

Here: an opening for you to look through. Here: a song for the bodies coming down.

CONTENTS

PREFACE xi

1. THE PHOTOGRAPH IN THE NEWSPAPER 1

2. ANOTHER PHOTOGRAPH IN THE NEWSPAPER 11

3. DOORWAY TO THE DEEP 21

4. LOOKING AT THE SAME PICTURE 35

5. MANZANAR 53

6. *INTA* MEANS YOU 67

7. SOUVENIR 81

8. IN YOUR HEAD 99

9. WRITTEN IN THE STARS 115

10. CALL OF DUTY 135

11. SMALLEST POSSIBLE WEAPON 151

12. PAINT THE TARGET 169

13. WAR TOURISM 183

14. WATCHER OF HUMANITY 199

15. REENACTMENTS 219

16. LET THERE BE 239

17. DRAW YOUR WEAPONS 259

ACKNOWLEDGMENTS 277

NOTES 281

I.

THE PHOTOGRAPH IN
THE NEWSPAPER

The man in the photograph holds a violin, deep chestnut, almost red. He laughs, luminous, looks right at the camera, violin in one hand and bow in the other, a blue-and-gray plaid shirt, a gold wedding ring lit up by the flash. His hair, what's left of it, white.

It was Howard Scott's eighty-seventh birthday, the newspaper story said. His family threw a party at the assisted-care facility where he lived in Lacey, Washington. His children, grandchildren, and great-grandchildren came to celebrate. They sang. He blew out candles. Everyone ate cake.

We have a surprise for you, his grandson said, and handed him an instrument case. Inside was the violin. *Not just any violin, mind you,* I read in the paper, *but a violin 60 years in the making.*

. . .

To make a violin, you need horses. You need elephants, cattle, tortoises, snakes, abalone, whales. You need lambs fed on dry mountainous pasture. You need mastodons dug from arctic ice. You need trees felled in winter when their trunks are free of sap, trees grown on a forest's south side in stony soil with little water so they mature slowly, their trunks strong and branchless.

To make a violin, you need war. It is said Antonio Stradivari's most beautiful instruments were built of maple sent from Turkey to Italy, intended for oars that would row Italian warships. Because they were often at war with the Italians, the Turks sent wood with uneven grain, wood they knew would crack and split under the weight of water, but when Stradivari saw the curved wood, he knew he could make it sing.

. . .

People used to believe photographs captured something material from the person standing in front of the camera. They thought it worked like this: sunlight bounced off the body and onto the photographic plate, and when that light traveled from body to plate, it carried a physical element with it, a trace, however small.

Photographs were like icons, they thought, like the story about the woman so moved by the sight of Jesus falling under the weight of the cross he was carrying to Golgotha that she pushed through the crowd, past Roman soldiers, to reach him. With her veil, she wiped Jesus's face. Some call her Veronica, a name that comes from the Latin words *vera* (true) and *icon* (image), because in return for her tenderness, Jesus granted

her a portrait: on that cloth, in blood and sweat, she found an imprint of his face.

. . .

I called information and asked for the telephone number of a man named Howard Scott in Lacey, Washington. Hold please, the operator said, and then a recorded voice told me his number. I dialed. The phone rang. A man answered.

I read about you in the paper, I said.

Don't believe everything you read about me, he said.

I told him my name, explained why I was calling, asked if it might be okay for me to write about him.

Yes, he said. Are you one of my students?

No, I said.

I was also in Vietnam, he said.

Something wasn't quite right, but I couldn't put my finger on it.

I'll send you a letter, I said. I'll give you time to think about it.

I hung up the phone and wrote him a letter. I put it in the mail.

I waited for weeks, months. No response. I worried Howard had died. I called the number again. The phone rang and rang.

. . .

The artist Ann Hamilton held a canister containing a strip of film inside her mouth and used her lips as an aperture to create each exposure—a mouth-held pinhole camera. To take a photograph of another person, she stood facing her subject, less than a foot away, her mouth open, both people looking at each other, nothing between them, just Hamilton's open

mouth. She said she wanted the part of her body where all song exists to also become her eye.

. . .

I had nearly forgotten about the picture of Howard and the violin, about the letter I sent, about wanting to write about him, but then I heard a message on my phone from Kayleen Pritchard, Howard's daughter.

Kayleen told me she'd just found my letter on her father's desk, buried in a stack of papers. She called right away.

Months ago, she'd been going through boxes of her parents' files and letters. They'd saved everything. Ration stamps. Brochures. Newspaper articles. Letters to the editor. Her mother, Ruane, had died a few years back, and Kayleen wanted to put her parents' things in order, tell their story before it was too late, but she felt overwhelmed. I said to the universe, I need someone to help me, she told me. I need someone to write a book about this.

That was on May 25, Kayleen said on the phone. The same day you wrote your letter. Come see us.

. . .

It is a mistake to associate photography with darkness, Roland Barthes wrote. It should be named not camera obscura but camera lucida, camera of light.

. . .

When Kayleen called, I was living in Idaho with my husband, Eric, surviving on a dissertation fellowship and student loans.

Through the window above my desk I could see the Boulder Mountains and hillsides covered in sage. For one week in late winter, an elk slept on the front porch of our house, curled up like a cat.

I flew to Seattle, took a taxi to the ferry landing, boarded a ferry to Bainbridge Island.

I walked down the dock and Kayleen and I recognized each other from the descriptions we'd given over the phone. We hugged and laughed and loaded my suitcase into the trunk of her car. We drove to Indianola, where Kayleen lives with her husband, Paul.

They'd recently moved into a small house a block from the water. Their old house had felt too big, and they'd wanted to downsize—right-size, she called it. After the realtor showed her the house, she walked along the beach and collected sea glass. She found eight pieces of agate and counted it a good omen.

Kayleen turned the car into the driveway and parked. Their house looked so familiar I felt I'd seen it before, which was impossible, because I'd never been to Indianola in my life. But then I remembered a meditation a friend of mine had led me through years earlier. In the meditation, my thirty-something self met my old-woman self inside a cabin in the woods, its walls lined with books, a long desk in the middle of the room. Follow the writing, my old-woman self said when I asked her what I needed to know. Her writing cabin in the meditation looked exactly like Kayleen and Paul's house.

Kayleen led me inside. The front door opened into a room with built-in benches and soft cushions, a kitchen with a stovetop and oven and counter and sink, a woodstove, a table for four, a reading chair, a ladder to the loft where Kayleen and Paul sleep. This is it, she said. Home. Now let me show you the studio.

Trees with trunks wrapped in white lights lined the path between the house and the studio. On the right side of the garage, a door, and inside, stairs. At the top of the stairs, a side table covered with family photographs, arranged like an altar, electric tea lights in front of the pictures so they glowed.

Make yourself at home, Kayleen said. Dinner's at six, but come to the house whenever you're ready. She walked down the stairs. I heard the door open and close, and then I was alone in Indianola, staying in the home of the daughter of a man whose photograph I saw in the newspaper, a stranger who didn't feel like a stranger at all.

. . .

Faces in photographs endure, and they instruct, Alex Danchev wrote. They tell us about themselves, and they tell us about ourselves—*who we are, and who we may become; what we are, and what we are capable of.*

. . .

Just talking with him, you might not know there's anything wrong, Kayleen said as we drove to see Howard the next morning. Red-tailed hawks floated over the tall trees lining the highway. If there had been no clouds, we would have been able to see Mount Rainier.

He's delightful, lucid, entertaining, she said. He tells wonderful stories. About Ruane. About their decision to get married. About getting his doctorate in education. About teaching at the university. About protesting war. But if you stay with him long enough, he'll tell you the same stories again, as if it's the first time he's told them.

He wants to know when he repeats himself, Kayleen said. The nurses don't tell him, and it scares him to think people would believe his mind is so far gone he wouldn't want to know, scares him to think you'd listen and pretend his words are new.

After her mother died, Kayleen drove the ninety miles between her home and Howard's three times a week to be with her dad. Sometimes a barred owl crossed the highway in front of her car, its wings wide. She watched the changes in Mount Rainier—light, clouds, snow—and felt the mountain guide her. It's where their ashes will go, she told me. They wanted to be together.

Kayleen didn't like the place where Howard was living. Too institutional. Concrete-block walls. Long hallways. They moved the dining room from the first floor to the basement and then blamed Howard for not being able to find his way to dinner. Howard didn't feel comfortable there. He worried people were taking his things. Kayleen didn't know if he was right to be worried or if he was paranoid.

When I told him you were coming, he was excited, she said. He feels like what he did made no difference, like he's been forgotten.

· · ·

The word *lost* comes from the Old Norse word *los*, meaning *the disbanding of an army*, Rebecca Solnit wrote. One thinks of *soldiers falling out of formation to go home, a truce with the wide world.*

· · ·

Some claimed an image of the musical bow, the violin's earliest ancestor, was painted on a cave wall before 15,000 B.C.E.

Others believed the original plucked note was sounded when someone accidentally struck the drying sinews stretched across a tortoise shell. Still others said the first music made with a string was the ping of a hunter's bow, the sound so disturbing to the quiet he was trying to keep while tracking his prey, and so surprisingly sweet, that the hunter put down the bow, unable to use it to kill another living thing.

. . .

Kayleen and I walked down the hallway of identical doors and knocked on the one with a sign next to it that read, DR. HOWARD SCOTT. Howard opened the door. He was wearing gray pants, a light blue short-sleeved shirt, and a brown golf cap.

It's you, he said.

2.

ANOTHER PHOTOGRAPH IN THE NEWSPAPER

Two years before I saw the photograph of Howard, I saw a different photograph on the front page of *The New York Times*. In the divinity school's library, at a coffee shop, inside a blue box on the street—I don't remember where I first saw the photograph, but I do remember what I saw: A man standing on a box wearing nothing but a blanket. A bag over his head. Arms stretched out from his sides. Wires attached to his body.

. . .

To look at a photograph of someone after that person has died is to take into your arms *what is dead, what is going to die,* Roland Barthes wrote. The person is still alive in the photograph, yet dead in the world, and you, the viewer, the person looking

at *a living image of a dead thing,* must ask yourself, *Why is it that I am alive here and now?*

<p style="text-align:center">. . .</p>

Let's start with a photograph, Virginia Woolf proposed in *Three Guineas*. This photograph. A photograph of a body. A body so mutilated, she couldn't tell if it was a human being or a pig. *But certainly those are dead children, and that is undoubtedly the section of a house.*

Woolf was responding to a lawyer who had asked how, in her opinion, they were to prevent war. To answer, she pointed to the photograph. She was sure she and the lawyer would have the same response to it—*horror and disgust*—a response that would allow them to bridge the difference between them that resulted from the fact that she was a woman and he was a man. (Men make war and men like war and women do not, Woolf argued. *The vast majority of birds and beasts have been killed by you, not by us.*) Looking at the photograph, she knew they would agree that war is an abomination, that it must be stopped. *For now at last we are looking at the same picture; we are seeing with you the same dead bodies, the same ruined houses.*

<p style="text-align:center">. . .</p>

There are pictures of prisoners strapped to metal bed frames. Men covered in excrement. Men on their knees. Bodies packed in ice. Naked men against walls. A man on the end of a leash. In some images, American soldiers wear blue latex gloves. Smile. Laugh. Thumbs up. Arms crossed. Cigarettes dangling out of the sides of their mouths.

There are pictures of female prisoners, too, their shirts

lifted, breasts visible, but they didn't show those, not on television or in the newspaper.

Newspapers curated online slide shows that started with a warning: *Images contain explicit sexual content. Viewer discretion advised.* Parts of bodies in the images that followed had been pixelated, blurred, blacked out, as if the only thing troubling about the photographs was the nakedness.

. . .

People in photographs watch you, silently address you, Eduardo Galeano wrote. *My world is your world too, they say; my time is also your time.*

. . .

The first person to use the word *photography*, in 1833, was Hercules Florence, a French artist living in Campinas (now part of São Paulo, Brazil), a district of slave-maintained coffee plantations. The first image Florence made was of the jailhouse he could see from his front porch, a jailhouse that housed runaways and disobedient slaves.

Photography rendered slavery visible, Nicholas Mirzoeff wrote.

. . .

Sabrina Harman—the woman in the Abu Ghraib photographs crouched behind the pyramid of naked bodies, the woman giving the thumbs-up and smiling next to a dead body packed in ice—is the daughter of a homicide detective.

Harman, one of the soldiers prosecuted in the Abu Ghraib scandal, was charged, in part, with taking photographs. Of that

pyramid. Of that dead body. It was Harman who attached wires to the man on the box, who told him if he fell off, he would be electrocuted. She was sentenced to six months in prison.

Harman's father often brought home pictures of crime scenes for his family to examine, her mother told *The Washington Post*. Harman had been looking at autopsies and crime-scene photographs since she was a kid. Her mother insisted Sabrina took the photographs—and collected photographs of torture taken by others—so she'd have evidence of the mistreatment of prisoners, proof.

When her mother had first learned Sabrina was taking photographs at the prison, she'd told Sabrina to bring the pictures home. Hide them and stay out of it, she'd said.

. . .

In 1850, the biologist Louis Agassiz hired J. T. Zealy, a daguerreotypist, to take pictures of enslaved Africans living on plantations in South Carolina. Agassiz wanted the daguerreotypes to prove the races were so physically different that there must have been two separate moments of creation, two origins, one for Whites and one for Blacks, which would, in his mind, justify enslaving one group for the benefit of the other.

The abolitionist Frederick Douglass called Agassiz's theory of polygenesis *scientific moonshine*.

. . .

At Abu Ghraib, Sabrina Harman stopped other soldiers from stepping on insects. *Sabrina literally would not hurt a fly,* her team leader Sergeant Hydrue Joyner said. *If there's a fly on the floor and you go to step on it, she will stop you.*

We'd try to kill a cricket, because it kept us up all night in the tent, Specialist Jeremy Sivits said. Harman would rescue the cricket, carry it outside the tent, and let it go.

She wouldn't step on an ant, Sergeant Javal Davis said. *But if it die[d] she'd want to know how it died.*

<div align="right">. . .</div>

More than one hundred years after they were taken, fifteen of Zealy's daguerreotypes were found in the attic of the Peabody Museum of Archaeology and Ethnology in Cambridge, Massachusetts. The images show five Black men of African birth and two African American women, daughters of two of the men. The people in the photographs stand alone, facing the camera, with their backs to the camera, or in profile. In most of the images, their clothing has been removed. Labels on the photographs record the subjects' names, the African tribe with which they were affiliated, and the name of their owner. In one photograph taken in 1850, titled *Delia, Country-Born of African Parents, Daughter of Renty, Congo, Plantation of B. F. Taylor, Esq.,* a woman stands in a patterned dress that has been forced down to expose her breasts.

Despite the photographer's intentions, what you see in the photographs is *the refusal of the enslaved to perform as racialized human property.*

<div align="right">. . .</div>

Sabrina Harman had a pet in Iraq, a kitten. It was killed by a dog. The kitten's body had no visible injuries, so she performed an autopsy and found internal organ damage. One of her friends mummified its head, gave it pebbles for eyes. Harman

photographed it in different places—*on a bus seat with sunglasses, smoking a cigarette, wearing a tiny camouflage boonie hat, floating on a little pillow in the wading pool, with flowers behind its ears.*

She also took pictures of mummified human bodies in a morgue in Al Hillah, close-ups of faces and hands, torn flesh and bones, a severed foot, a punctured chest. In one, Harman leans over a blackened corpse, smiles, gives the thumbs-up. *Whenever I get into a photo,* she said, *I never know what to do with my hands.*

. . .

At the root of all art is *the practice of embalming the dead,* André Bazin wrote. *A mummy complex.* Art is the creation of an image that will live on after death. *Preservation of life by a representation of life.* The photograph is a death mask, he wrote: *the taking of an impression by the manipulation of light.*

. . .

If you look up Agassiz in the *Encyclopedia Britannica,* you won't find any mention of racism or the daguerreotypes. The entry on Agassiz tells his story this way: born in Switzerland, the son of a Protestant pastor, Agassiz studied extinct fish and the movements of glaciers. In 1847, he moved to the United States to be a professor of zoology at Harvard. After his first wife's death, he married Elizabeth Cabot Cary of Boston, a writer and a promoter of women's education. He studied Lake Superior. He studied turtles. When Darwin's *On the Origin of Species* was published, in 1859, Agassiz rejected the idea of a common origin because he believed every species represented a differ-

ent moment of creation—each plant, each animal, he wrote, is a *thought of God*.

. . .

The very first daguerreotype is said to show a section of a wall and bench (or window ledge) cluttered with plaster casts of cupids with small wings. But when you look at the image, Ariella Azoulay wrote, this description is revealed to be a fabrication. The daguerreotype has become *a plane of silvery ash*. There is a gap between what was once visible and what can now be seen.

For Barthes, photographs attest to what *was there*—but Azoulay turned this idea on its head. Photographs, she argued, show *that what "was there" wasn't there necessarily in that way*.

. . .

The artist Carrie Mae Weems, in a series called *From Here I Saw What Happened and I Cried*, altered photographs taken in the nineteenth century, including the daguerreotypes of the enslaved commissioned by Agassiz. Weems photographed and enlarged each image. She used a red filter when reprinting them. She placed each print in a circular mat and framed it under glass she'd sandblasted with text. Over an image of Delia, the woman whose dress was forced down to expose her breasts, Weems wrote these words: *You became a scientific profile*.

. . .

Susan Sontag began *Regarding the Pain of Others* by writing about the same photograph Virginia Woolf asked the lawyer

to look at with her, the photograph of the body so mangled it's not clear whether it's a human or a pig, but, unlike Woolf, Sontag didn't think photographs of war-caused violence necessarily turn people against war.

War tears, rends, Sontag wrote. *War rips open, eviscerates. War scorches. War dismembers. War ruins.* And photographs show this violence. Photographs say, Look: this is what a bullet does, a tank, a grenade, a rocket, a missile, a drone, a bayonet. But Sontag knew there was no guarantee about the kind of response a photograph of atrocity would give rise to. *A call for peace. A cry for revenge. Or simply the bemused awareness, continually restocked by photographic information, that terrible things happen.*

Yes, war is an abomination, yes, it must be stopped—Sontag agreed with Woolf's conclusions. But who today believes war can be abolished?

No one, she wrote. *Not even pacifists.*

3.

DOORWAY TO THE DEEP

Howard stood inside the doorway that opened to his home: white concrete walls, couch, rocking chair, bookshelf, dining table and chairs, a picture of the planets titled *Portraits of Our Celestial Family* taped to the wall. A countertop divided the living room from the kitchen. Through a sliding glass door next to the couch was a deck.

We sat in the living room. I put my digital recorder on the coffee table between us and turned it on.

. . .

Would you rather have a painting of Shakespeare or a photograph of him? Susan Sontag asked. Most people would choose

the photograph, she wrote, because having a photograph of Shakespeare would be like having a nail from the True Cross.

. . .

Howard told me his story started here: 1924, the first of September, his family at the beach, on the shore of the Sacramento River. His father and aunt were swimming in the river. His father was a good swimmer, a swimming instructor, but a strong undercurrent pulled him down. He struggled. He waved his arms, shouted for help. And everyone—Howard's aunt in the water, his mother and siblings and Howard on the shore—thought his father was clowning, because he was playful, a trickster. They didn't help him. They watched, laughing, as he drowned.

Howard's aunt went deaf after that. For the rest of her life, she could not hear.

. . .

In the water there is a doorway to the deep forty feet below the surface. The human body, compressed by the ambient pressure, by all that weight, becomes denser than water, and instead of bearing you up to the surface, the water pulls you down.

. . .

In divinity school, I rented a studio space in a community art center. I was an encaustic painter—created work with warmed beeswax and resin on wood—and I'd been commissioned by the university to paint the Stations of the Cross for the divinity school's chapel—Jesus condemned to death, Jesus carrying the

cross, Jesus falling, Jesus falling again, Jesus stripped, Jesus whipped, Jesus nailed to the cross. When I first saw the Abu Ghraib photographs, they looked familiar.

. . .

When Howard was ten, a preacher came to the house, day after day, to persuade his mother to have him baptized. His father was dead, and the preacher, imagining himself a kind of surrogate, wanted to save Howard.

The preacher sat in the living room, talking about salvation, about banishment and the gnashing of teeth, but his words didn't scare Howard's mother. She told the preacher that Howard's baptism was not her choice to make; the decision was his alone.

Howard knew he could go through the motions, get baptized to placate the preacher, but at age ten he was already driven by a sense of integrity. He was also driven by stubbornness. It's still an ongoing struggle, he told me, to distinguish between the two.

He couldn't believe in a God who would cast him out because this man in his living room hadn't immersed him in water. If his salvation could be guaranteed by a single act, an act that did not, as far as he could tell, do any good for any other human on this earth, then he wanted no part of it.

. . .

Waterboarding began as a form of forced baptism during the Spanish Inquisition and in the persecution of Anabaptists during the Protestant Reformation. Waterboarding-as-baptism was presented as a way to save heretics and deliver the accused

from their sins. Torture by near drowning was punishment for sins, and punishment was an act of salvation.

. . .

Swimming a witch: in the sixteenth, seventeenth, and eighteenth centuries, a woman suspected of being a witch would be tied, right thumb to left big toe and left thumb to right big toe, and lowered into water by ropes. It was believed that water—an agent of baptism—would reject servants of the devil. Floating proved guilt, and sinking, innocence.

. . .

The memo Assistant Attorney General Jay S. Bybee wrote on August 1, 2002, to John Rizzo, acting general counsel of the CIA, explained how to waterboard: *In this procedure, the individual is bound securely to an inclined bench, which is approximately four feet by seven feet. The individual's feet are generally elevated. A cloth is placed over the forehead and eyes. Water is then applied to the cloth in a controlled manner. As this is done, the cloth is lowered until it covers both the nose and mouth. Once the cloth is saturated and completely covers the mouth and nose, air flow is slightly restricted for 20 to 40 seconds due to the presence of the cloth. This causes an increase in carbon dioxide level in the individual's blood. This increase in the carbon dioxide level stimulates increased effort to breathe. This effort plus the cloth produces the perception of "suffocation and incipient panic," i.e., the perception of drowning. The individual does not breathe any water into his lungs. During those 20 to 40 seconds, water is continuously applied from a height of twelve to twenty-four inches. After this period, the cloth is lifted, and the individual is allowed to breathe unimpeded for three or four full breaths.*

The sensation of drowning is immediately relieved by the removal of the cloth. The procedure may then be repeated.

. . .

When God saw the wickedness of humans, that every thought of their hearts was evil, God was sorry to have made them. I will blot out what I have created, God thought. I will blot out everything on the earth—people and animals and creeping things and birds in the air.

Only Noah found favor in God's sight, so God confided in him. The earth is filled with violence because of humans, God told Noah. I am going to destroy them. Make yourself an ark of cypress wood. Make doors and decks and roof. I will bring a flood, and everything will die, except for you and your family and two of each kind of animal, which you will bring with you onto the ark.

And Noah built the ark, and the waters came, and the ark rose above them, and every other living thing drowned.

. . .

Weapon or tool? The difference depends on the surface on which they're used and on the intention of the person using them, Elaine Scarry argued in *The Body in Pain*. In the hands of a surgeon, a knife is a tool; in the hands of a thief, a knife is a weapon.

. . .

In 1937, Howard enrolled as a student at the University of Washington in Seattle and signed up for ROTC. He needed money to help pay for school. It's what people did, he said.

He found himself lined up, gun raised at his shoulder, eyes on the target, which showed the silhouette of a body. His superiors gave the order to shoot, but he couldn't do it.

What's the problem, Scottie? they asked.

I can't kill, he said, and he never picked up a gun again.

. . .

Torture unmakes the world by transforming the tools of ordinary life—doors, bed frames, buckets, music, gloves, leashes, ice, water—into weapons, Scarry wrote. Think of Germany in the 1940s: *"ovens," "showers," "lampshades," and "soap."*

. . .

In his sworn statement about his experience at Abu Ghraib, Ameen Sa'eed Al-Sheikh described what the guards did to him: beat his broken leg, threatened to rape him and his wife, threatened to kill him, put a gun to his head, deprived him of blankets and clothing, made him stand naked and hold his buttocks, urinated on him, hung him from the cell door, took photographs of him, forced him to eat pork and drink liquor.

In the middle of his deposition, Al-Sheikh said, *Someone else asked me, "Do you believe in anything?" I said to him, "I believe in Allah." So he said, "But I believe in torture and I will torture you."*

. . .

Room, door, camera, blanket, clothing, food, voice, body, God—torture turns everything against you.

. . .

At the National Rifle Association's annual convention in 2014, former governor and vice presidential candidate Sarah Palin said, *Well, if I were in charge, they would know that waterboarding is how we baptize terrorists,* and the Internet lit up with people insisting that Palin wasn't Christian, that she'd gotten Christianity all wrong.

. . .

This crusade, this war on terrorism is going to take a while, George W. Bush said on September 16, 2001, a Sunday.

The White House later apologized for his remark.

. . .

In 2005, the company Trijicon was awarded a $600 million, multiyear contract to provide eight hundred thousand advanced combat optical gunsights to the U.S. Marine Corps. On their high-powered rifle sights—good for no light and low light and bright light conditions, good for seeing multiple moving targets—Trijicon inscribed numbers and letters referring to Bible verses, chiefly from the New Testament. At the end of one scope's model number, you can read JN8:12, which refers to the Gospel of John, chapter 8, verse 12: *I am the light of the world. Whoever follows me will never walk in darkness, but will have the light of life.*

. . .

In a letter she sent home from Abu Ghraib, Sabrina Harman wrote this: *I cant [sic] get it out of my head. I walk down the stairs after blowing the whistle and beating on the cells with an asp [baton]*

to find "The taxicab driver" handcuffed backwards to his window naked with his underwear over his head and face. He looked like Jesus Christ.

. . .

After forty days, Noah sent a raven from the ark. Then he sent a dove, but the dove found nowhere to land. After seven more days, he sent the dove again, and when it returned, it carried in its beak an olive branch, so Noah knew the waters were subsiding. He waited another week, then once more released the dove, and the dove did not return, so Noah knew he could leave the ark.

On dry land, he built an altar. He chose the good animals from among the ones he'd saved on the boat, and he burned them.

. . .

Without ROTC, Howard didn't have enough money to live in the dorms, so he moved into the Y. His roommate was also a college student, a man named Gordon Hirabayashi. Across the street from the Y was the dormitory for women.

That's where Ruane lived.

Ruane and Howard were friends first, and though each longed for something more, neither spoke of it, not during long afternoon walks or evening paddles on Green Lake with the sun going down and turning the world pink, then purple, then midnight blue. It wasn't that they were afraid to confess their feelings to each other. They knew they would spend the rest of their lives together, knew it more than they knew any-

thing else, so there was no reason to speak it. Is there a need to say the world is round?

. . .

Seventy percent of the earth is covered by water—our bodies made of nearly the same percentage. *Every living cell is essentially just a tiny bag of water,* the scientist Hope Jahren wrote. *Viewed from this perspective, life (the verb) is little more than the construction and reconstruction of trillions of bags of water.*

. . .

Howard spent one summer after college in New York City, away from Ruane, helping Jewish refugees settle in their new country. It was 1940, and they were fleeing Hitler.

Taking a break after moving another family into an apartment, Howard sat on the stoop of a building in the heat. He had his harmonica with him; he carried it everywhere. He'd noticed that many of the songs the refugees liked were in A minor, so he began to play a song he knew in that key called "The Peddler." As soon as he got a bar or two into it, three men ran out of the building, and one of the men, a Russian, said: "'The Korobushka'! 'The Korobushka'! You're playing 'The Korobushka'!" He started dancing, and the other two joined him, arms around each other, knees bent and extended and bent again. Then a group of men carrying instruments joined them—violins, guitars, tambourines, drums—and they played together, dancing in a circle until dark, until the moon rose and lit up the sidewalk like a stage.

After he told me this story, Howard stood and took his har-

monica out of the front pocket of his blue shirt and played "The Korobushka" for me, his hands cupped around the instrument, foot tapping.

That's a thing a man will never forget, Howard said. To me it was just "The Peddler," but to them it was home.

. . .

When Jesus stood in the river Jordan after being baptized in its waters, the sky opened, and the spirit of God descended on him like a dove. You are my beloved, the voice said. With you, I am well pleased.

God then sent Jesus to the wilderness to be tempted by the devil.

. . .

During the summer Howard spent in New York City, Senator Edward Burke and Representative James Wadsworth sponsored the Burke-Wadsworth Bill, calling for mandatory conscription, which required American men to register for the draft. In September, Congress passed the bill as the Selective Training and Service Act of 1940—the first peacetime draft in U.S. history.

Howard was drafted in August 1941, before the United States entered the war, but he knew himself well enough by then to refuse to fight, and with the help of the Quakers, he registered as a conscientious objector, one of more than seventy-two thousand men who applied for conscientious objector status during World War II.

Conscientious objectors were assigned what was called work of national importance—tasks involving soil conservation, forestry, social services, mental health. Churches that

supported conscientious objectors paid the cost of running the work camps, of feeding and housing the COs who labored in them. Howard was sent to a Civilian Public Service camp in San Dimas, California. He fought forest fires instead of fighting men. He looked after the trees.

I imagine Howard in the fire watchtower on December 7, 1941, searching for smoke rising from the forest, too far away to see the fires consuming Pearl Harbor. That day, 2,403 people were killed. So little left to salvage.

. . .

When torturers use domestic objects as torture devices, they erase the victim's world, Scarry argued. With the *conversion of a refrigerator into a bludgeon, the refrigerator disappears,* she wrote, and *its disappearance objectifies the disappearance of the world.*

Can the victim's world be brought back?

If the tools of daily life can become weapons, can they be turned back into tools? Swords into plowshares? Shower back into shower? Door into door? Water into water?

. . .

The American lawyer Susan Burke traveled to Istanbul in 2006 to take depositions from Iraqis who had been detained and tortured in Abu Ghraib. She brought three artists with her: a writer, a playwright, and a painter.

The painter made watercolor portraits of the former detainees while they talked. Sometimes, in the silence between when the lawyer asked a question and when the question was answered, the only sound in the room was the *clink clink clink* of the artist cleaning his brush in a glass of water.

There were rumors that Japanese Americans had helped plan the attack on Pearl Harbor, stories about spies and espionage, about arrows cut into crop fields to show the pilots where to go, none of it true.

Pearl Harbor fueled existing racism. The California Alien Land Laws of 1913 and 1920 already prohibited immigrants from Japan, China, India, and Korea from owning land. In 1916, a Washington senator founded an anti-Japanese league in Seattle because of his fear that Japanese immigrants were taking jobs away from White Americans. White farmers who wanted to eliminate their Japanese American competition, politicians using racism to gain standing, and a scared American public pressured President Franklin D. Roosevelt to remove all Japanese Americans from the West Coast.

On February 19, 1942, Roosevelt signed Executive Order 9066, granting the military the right to declare any place a military area and forcibly remove people should it be deemed necessary for the defense of the United States. The internment of American citizens began.

On weekend leaves from the CPS camp, Howard visited towns from which Japanese Americans were being removed. He helped them pack and store their belongings, prepare their houses, find people to take their pets. A strange time to be an American—welcoming refugees on one side of the country, creating them on the other.

Soon Howard received a telegram: his college roommate Gordon Hirabayashi and his family had been ordered to internment camps.

4.

LOOKING AT THE
SAME PICTURE

Eric and I moved from Idaho to Southern California so he could take a tenure-track job at a university. I taught part-time while I finished my dissertation. The university used to be a state mental hospital, and the joke on campus was that it still was: they just tell the patients they're professors. There were stories that parts of *One Flew over the Cuckoo's Nest* were filmed there, that the hospital was the hotel in "Hotel California"—the place where *you can check out anytime you like, but you can never leave.*

It was beautiful. Bougainvillea, pepper trees, cactus gardens, birds-of-paradise. Mission-style architecture: white walls, courtyards, bell towers, quadrangles, big green lawns, terracotta rooftops, each tile curved because they were made by women who would shape the wet clay around their thighs,

leaving the form of the tilemakers' bodies all over the buildings.

The ocean was five minutes away by car. I could smell salt water, seaweed, fish. I could also smell lemon, eucalyptus, and strawberries. Strawberry fields lined the entrance road to campus, and every so often when I drove by, people in white hazmat suits, their bodies covered, faces covered, rode tractor-like vehicles trailed by clouds of pesticide.

Though many of the buildings on campus had been renovated and retrofitted, turned into classrooms, faculty offices, computer labs, student lounges, and dining halls, they retained their institutional feel. Long, sloping uncarpeted hallways went on forever, and students would ride their skateboards up and down the narrow passages until someone came out of an office to tell them to stop. Every hallway looked the same, and I would get turned around easily. I had trouble finding the room with the copy machine I was allowed to use and ended up using the machine in the math department. Some of the stairways climbed the outsides of the buildings, and swallows built their nests in the light fixtures, leaving bird shit everywhere.

I could still see evidence of the mental hospital the place used to be. At the edge of campus, a raised walkway connecting the second floor of one building to the second floor of another was caged all the way around. There were interior courtyards you needed keys to exit.

I peeked through barred windows to see inside some of the buildings that hadn't yet been remodeled. Trash littered the floors. Paper. Broken glass. Drawings on the walls. I looked into one building over and over again. Animal fur caught on the window's broken glass; coyotes, cats, raccoons, and skunks had made homes there. Inside, I could see a room, and inside

that room, a second room, with a door that opened halfway so you could leave the bottom closed. It must have been where patients lined up to receive their medication. I imagined nurses with trays of pills and small paper cups.

. . .

Three thousand conscientious objectors in World War II worked at state mental hospitals. With so many men and medical professionals away at war, the wards were understaffed and overcrowded, and the treatment of some patients was brutal. At Philadelphia State Hospital, also known as Byberry, a few COs developed a plan for making public what they'd witnessed: attendants hitting patients with sawed-off broom handles, rubber hoses filled with buckshot, rows of men shackled to bed frames, an unfurnished room called the incontinent ward housing naked men. Charlie Lord, a Quaker, snuck in a small camera. He shot pictures in secret without looking through the viewfinder. Three rolls of film, thirty-six images each. Some of his photographs were published in *Life* magazine—thin naked men huddled against a wall.

. . .

All photographs, Ulrich Baer wrote, especially photographs of violence, *signal that we have arrived after the picture has been taken, and thus too late.*

. . .

Eric and I bought a townhouse on campus, through a program subsidized by the university so professors could afford to live in

Southern California. I looked at old maps of the state hospital and learned our home was located on the former site of the children's ward.

Two blocks from our house was the university library, brand-new and modern, glass and cement. Our neighbor's husband had friends on the construction crew, and she told me the library had been built on top of the mental hospital's morgue. It's haunted, she said, as we watched her kids ride their bikes in the alleyway between our houses. These are big guys, burly guys, and they got so scared they wouldn't finish the job, she said. They poured cement into the basement rooms without clearing everything out. They left bodies in that morgue.

. . .

Who can forget the three color pictures by Tyler Hicks that The New York Times *ran across the upper half of the first page of its daily section devoted to America's new war, "A Nation Challenged," on November 13, 2001?* Susan Sontag asked in *Regarding the Pain of Others.*

I can forget those pictures.

I have forgotten them more than once.

Sontag described the photographs. In the first, a wounded Taliban soldier found in a ditch by Northern Alliance soldiers advancing toward Kabul is being dragged on his back by two of his captors. One holds an arm and the other holds a leg, and they pull him across a rocky road.

In the second, the wounded soldier is being hauled to his feet.

In the third, the moment just before death. The man lies on

his back in the middle of a dusty road, knees bent, arms outstretched, naked from the waist down, bloodied clothing of some kind around his feet—pants? underwear?—as if there was no time to pull them all the way off, as if it was not worth the effort for his captors to remove his clothing completely. His face is turned away. A semicircle of men surround him, most of them with guns aimed at this man on the ground, in the dust, whom they are about to kill.

One of the people in the circle is Tyler Hicks, the photographer. Instead of a gun, he points a camera.

. . .

This is what happens when you see a violent photograph, John Berger observed: First, shock. The other's suffering engulfs you. Then, either despair or indignation. If despair, you take on some of the other's suffering to no purpose; if indignation, you decide to act.

To be able to act, you must emerge from the moment of the photograph and reenter your own life. But as you leave the world of the photograph and return to your life, the contrast between the two—the photograph's world and your world— is so vast you know whatever you might be able to do, whatever action you might be able to take, will be a hopelessly inadequate response to what you have just seen.

The object of your shock has shifted. No longer is it the violence in the image that shocks you. It is your sense of inadequacy. You are too small. Violence is too big. You have failed before you have even begun.

. . .

When I wasn't teaching, I worked on my dissertation. I researched and wrote and stared at the Abu Ghraib pictures that filled the screen of my computer—the dead body packed in ice, the pyramid of naked hooded men, the man covered in excrement—and then I looked out my office window and saw hillsides covered in prickly pear cactus, their fruit red as rubies in the sunlight. In the morning I heard songbirds, the thrum of hummingbirds' wings, the descending call of canyon wrens. In the afternoon I heard kids coming home from school. At night I heard coyotes. For weeks, Eric and I had trouble sleeping because an owl sat on top of our roof all night, asking, Who? Who? Who?

. . .

Lucretius, an ancient Greek philosopher, thought *all bodies were continually throwing off certain images like themselves.* Every object shed a film from its surface, like skin shed by snakes or bark shed by trees, and when you looked at other people, it was those shed films your eyes saw. The films were fleeting and disappeared as soon as the object or person or animal was out of sight.

It was this belief that made the first cameras so miraculous: photographs captured those vanishing films, made people immortal, because when you died, if you'd had your photograph taken, part of you was left behind. In 1859, Oliver Wendell Holmes, a physician and Harvard Medical School professor, called this new invention *the mirror with a memory.*

. . .

But the camera is not a mirror with a memory, and it never was—or if it was, or if it is, it is a fun-house mirror, because

from the beginning, it has been used to trick people. People have taken this thing defined by the fact that it cannot be faked—and they've faked it. With this machine that promises to tell the truth, they've lied.

. . .

To make the case for the start of another war in Iraq, Colin Powell addressed the United Nations Security Council on February 5, 2003. During the speech, he presented satellite photographs to prove Iraq had weapons of mass destruction. *The photos that I am about to show you are sometimes hard for the average person to interpret, hard for me,* he said before he displayed them. *The painstaking work of photo analysis takes experts with years and years of experience, poring for hours and hours over light tables.*

He put an image on the screen and said it showed a weapons facility that housed chemical munitions. One of sixty-five such facilities in Iraq. *How do I know that?* Powell asked. He showed close-ups of the same image. Yellow arrows superimposed on each image labeled the buildings and vehicles. *The two arrows indicate the presence of sure signs that the bunkers are storing chemical munitions,* he explained. *The truck you also see is a signature item. It's a decontamination vehicle in case something goes wrong.*

Inspectors who'd previously visited the site had found no evidence of weapons of mass destruction, but all this proved, Powell argued, was that *Iraq had been tipped off to the forthcoming inspections.*

. . .

After the invasion, when U.N. inspectors again visited the site in Powell's satellite image, they located the vehicle he'd pointed

to and discovered it was not what he'd said it was. It was a fire truck.

. . .

A digital image can easily contain much more information than anybody would ever want, Lev Manovich wrote. *More information than can be seen with the human eye.*

. . .

General Richard Myers and United States senator James Inhofe insisted the photographs from Abu Ghraib, if seen around the world, would put U.S. troops at risk. Myers asked CBS to delay the broadcast, concerned the lives of the coalition soldiers and hostages in Iraq would be further endangered. Americans will die, people said, because of these photos. During a hearing on the Abu Ghraib prison scandal, Inhofe said, *I'm probably not the only one up at this table that is more outraged by the outrage than we are by the treatment.* He continued: *I am also outraged that we have so many humanitarian do-gooders right now crawling all over these prisons looking for human rights violations while our troops, our heroes, are fighting and dying.*

. . .

In the fifteenth century, people would look at life-sized paintings of Jesus on the cross and kiss his wounds. Their kisses did nothing for Jesus, who was already dead, already risen, but it was believed viewers' kisses earned them seven years of remission from purgatorial punishment and protection from sudden death.

In Rory Kennedy's film *Ghosts of Abu Ghraib,* a former prisoner held a photograph that showed another prisoner in white underwear, a black hood over his head, leaning against a tiled wall. The man in the film looked at the picture for a long time. *This is my brother,* he said, and lifted the photograph to his lips and kissed it.

. . .

Here it is, Kayleen said the first time I visited Howard. She put the box in my lap, and out of it I lifted the violin. I'd seen it in a photograph. Now I held it in my hands.

. . .

When Roland Barthes looked at a picture of someone, he felt connected by what he called an *umbilical cord* that linked the body in the photograph to his gaze. Light is a *carnal medium,* he wrote, a skin he shared with anyone who'd been photographed. In *Camera Lucida,* he looked through photographs, searching for an image that captured his mother, who had died. He was Thomas reaching out for Jesus, putting his hands in the wounds. Barthes called photographs the *return of the dead,* and he wanted the return to be literal.

. . .

One day in 1861, when William Mumler was developing a self-portrait he'd taken, the ghostly figure of a young girl appeared behind him in the image. At first, Mumler assumed it was the

afterimage of a subject he'd photographed earlier. In those days, photographic plates were often reused, and if the plate was not cleaned properly, an imprint of the previous image might remain. But when he looked more carefully at the girl, he recognized her as a cousin of his who had died some years ago.

Mumler showed the image to a friend, and his friend showed it to another friend, and soon everyone wanted Mumler to take their picture, so he quit the jewelry business to concentrate on photography. The going rate for a photograph at that time was twenty-five cents apiece. Mumler charged ten dollars a sitting.

The Civil War had begun, and there were so many dead.

Spiritualists pointed to Mumler's photographs as proof of their claims that they could communicate with the dead. See, they said. Your beloved is right there.

Mumler's wife, Hannah, was known in Spiritualist circles as a healer and a clairvoyant. Sometimes she'd stand next to William's camera and touch it, as if imparting magic. When she entered the studio, people reported hearing raps across the floor, a sign that spirits were present. She saw spirits before the photographs were taken, and she'd describe what she saw; then, when the images were developed, exactly what she'd described would appear. An apparition with folded hands standing behind you, to the left. A woman touching your shoulder. Someone cradling your head.

Arms crossed, hands in their laps, head slightly turned, dresses and suits elegant and dark—Mumler's subjects hold themselves motionless, their faces utterly still. And the dead ones come.

. . .

No matter how careful the photographer, the camera lens doesn't discriminate, Christopher Pinney wrote. While the painter's brush is a *filter capable of exclusion,* keeping out of the canvas what the painter wants out, *the lens of the camera can never be closed because something extraneous will always enter it.* Substrate, Pinney called it. *Margin of excess. Subversive code. Ineradicable surfeit.*

Photographs are unstable. Volatile. Meaning leaks out of them. They are textured. Fertile. Multilayered. Open and available to uses the photographer may not have ever intended. They can be recoded.

. . .

During graduate school, I was awarded a fellowship from the Episcopal Church Foundation, and they asked for a picture of me for their publicity materials. I sent a photograph my mother had taken at my aunt's wedding, and when I received the newsletter announcing the fellowship recipients, I noticed my picture had been altered. The dress I'd worn to the wedding had thin black straps, but they'd added a shawl, wrapping my shoulders, covering my skin.

. . .

French colonists arrived in Algeria accompanied by photographers, who planned to photograph harems to create images of the women they wanted to colonize. But instead of harems, the photographers encountered veiled women, their bodies hidden from the cameras. Unable to photograph what they'd imagined, the photographers grew frustrated and hired models to take the veiled women's place.

The photographers set up backdrops, transformed their studios into harems and bedrooms and prisons and living rooms, and though their images were staged, though the models were paid to pose, were dressed and undressed and dressed again, the pictures were presented as if they captured the real thing. Women lounging on carpets. Women standing, naked, behind bars. Women veiled, revealing only their eyes and breasts.

The photographs were turned into postcards, sold to tourists, soldiers, and colonists, pseudoknowledge of the colony that could be mailed home. The postcard produces *stereotypes in the manner of the great seabirds producing guano,* Malek Alloula wrote. *It is the fertilizer of the colonial vision.*

. . .

Luc Tuymans's *Our New Quarters* is a painting of a place that was meant to deceive. It is based on a Nazi-era postcard of Theresienstadt, which Tuymans saw in a reproduction of the sketchbook belonging to Alfred Kantor, a concentration camp survivor. Four black horizontal lines run across the plane of the painting; there are three rows of dark cavelike openings in the shape of tombstones, a vertical line that could be a tree with bare branches, the title in yellow paint.

Theresienstadt was a collection center for deportations, housing people between camps. Prisoners were given postcards to send into the world, false images designed to create false ideas about what the Nazis were doing.

When reports about the death camps emerged, at the end of 1943, the Nazis presented Theresienstadt to the International Red Cross. Before the Red Cross committee arrived, the

Nazis painted buildings and renovated barracks, opened fake stores and a coffeehouse, a bank and a school. They planted flowers. When the Red Cross left, the deportations resumed. More than 140,000 Jews passed through Theresienstadt; more than 30,000 people died there; more than 90,000 were deported to be murdered.

Gaskamer (Gas Chamber) is the first Tuymans painting I ever saw. Painted from a watercolor Tuymans made while visiting the site of the Dachau concentration camp, it shows an enclosure that looks, at first, like any other room, with its corner door, with its dark spots on the ceiling that could be recessed lights. Until you read the title. Until you see the drain. *The room remains incredible to the end. Its purpose deception,* Tuymans said in an interview. *The room deceives, the objects deceive.*

. . .

There were those who thought Mumler was a trickster, a fraud, a fake. They recognized the so-called ghosts in his spirit photographs, they said; they'd seen them on the streets of Boston, knew they were alive.

At that time, you could create spirit photographs in two ways: double printing and double exposure. In double printing, you printed the scene and the subject from one negative and the spirit from another. In double exposure, you photographed the subject and the person posing as the spirit at the same time. When you had positioned the pair as you wanted them arranged, you took off the lens cap and photographed them together. Then you capped the lens, and the person performing as the spirit left the room; you then again removed the lens cap, so that when the photograph was printed, the subject

who'd stayed for the whole exposure appeared sharp, in focus, while the spirit who'd left halfway through looked ghostly, transparent.

The photographer William Guam went to Mumler's studio to determine which method Mumler was using to trick people, and Mumler allowed Guam to investigate every aspect of his operation. In later reports, Guam insisted he never took his eyes off Mumler, never let Mumler touch the glass, but then, to Guam's astonishment, when he looked at the portrait Mumler took, there were two people behind him: his wife and his father, who were dead. Even though he'd gone to the studio to prove Mumler was a fraud, Guam later admitted that as he'd sat for the photograph, he'd been longing for his wife and his father to appear.

. . .

The founders of Spiritualism—Maggie and Kate Fox, sisters—were playing a joke on their mother. They wanted to spook her. They tied strings to apples and dragged them down the stairs to mimic footsteps. They cracked the knuckles of their toes. They knocked on floorboards. Hearing these sounds, their mother thought the farmhouse was haunted. She asked questions she thought only the spirit would know the answer to, and the girls, hidden from view, rapped the correct answers on the floor. *How many children have I had?* Seven raps. *How many are still living?* Six raps. And then their mother went to get the neighbor, and the joke had gone on so long, and their mother was so convinced, that the girls, afraid of getting into trouble, kept up the charade.

. . .

When Colin Powell gave his speech and pointed to aerial photographs at the U.N. to make the case for war against Iraq, he sat in front of a blue curtain. Behind the blue curtain was a tapestry reproduction of Picasso's *Guernica*.

. . .

On April 26, 1937, the town of Guernica, a Basque village in northern Spain, was bombed for three hours by German and Italian forces. It was Monday, a market day, when church bells sounded the alarm. Bombs, explosives, shrapnel, all aimed at civilians—women and children and the elderly, because most of the town's men were away at war. Planes flew low and strafed anyone trying to escape. Guernica burned for three days. Sixteen hundred dead and wounded.

News of the attack reached Paris on May 1, and a million protesters filled the streets. Picasso learned about the slaughter in the newspaper, saw black-and-white photographs of the destruction, and the color palette of his painting echoes that black and white and gray. Small vertical lines on the body of the horse in the center of the painting look like newsprint.

Cries of children cries of women cries of birds cries of flowers cries of wood and of stones cries of bricks cries of furniture of beds of chairs of curtains of casseroles of cats and paper, Picasso wrote in a poem about the attack.

At the top of the canvas is a light bulb whose light looks like the sun or like flames. In Spanish, the word for light bulb is *bombilla*, which, when spoken, sounds like the diminutive for bomb: *bombia. Bomba-bombia,* art historian Tomas Llorens said, is a poetic metaphor for *the terrifying power of technology to destroy us.*

. . .

The writer Mark Danner called the flash of digital cameras at Abu Ghraib a shame multiplier that let the prisoner know the humiliation wouldn't stop when the torture stopped; it would continue every time someone looked at the photographs.

But the soldiers sometimes lit up the prisoners without a flash. They broke fluorescent tubes and rubbed the liquid found inside the light bulbs on the prisoners' bodies until they glowed.

. . .

People disagreed about why U.N. officials covered *Guernica* on the day of Powell's speech. Some said the choice was aesthetic, pragmatic—a solid blue background would be better for the TV cameras. Others said it would have looked bad for Powell to make a case for going to war in front of a painting about the devastating effects of war.

5.
MANZANAR

If Eric hadn't told me where to look, I would have driven right by Manzanar the first time we visited. To take a break from teaching and dissertation writing, we'd drive north on Highway 395 and escape into the foothills of the Sierra Nevada.

Right there, Eric said, pointing out the window, but there was nothing to mark the site of the former internment camp, just a pile of rocks that could have been the remains of a fence post or a guard tower.

It's possible to stand on land where great violence has been done and not know it.

. . .

For three thousand years, the Owens Valley Paiutes lived on the land that later became Manzanar. They created complex irrigation systems, hunted, gathered piñon nuts, made baskets and pottery, traded. In the 1860s, prospectors arrived looking for gold and silver. Ranchers and farmers followed soon after and used the Paiutes' irrigation system to grow their food. Not understanding the Paiutes' careful use of the valley, the White arrivals considered the land wasted. They grazed cattle, depleting the native plants whose seeds and roots the Paiutes depended on. The winter was harsh and food scarce. To survive, the Paiutes hunted, occasionally killing one of the ranchers' cows or oxen to eat, and in retaliation, the White settlers killed Paiutes, destroyed their homes and food stores. Some of the Paiutes fought back, each side trying to wipe the other out. The U.S. Cavalry was sent to protect the settlers and the land and water they had taken.

The Paiutes wanted the killing to stop, so in 1863 they initiated peace with the U.S. Cavalry, whose leaders then invited the Paiutes to Fort Independence for a barbecue to signal the start of a new relationship. At the barbecue, the Paiutes were taken hostage and forced to march in the July heat to Fort Tejon, in the mountains of Bakersfield, California, two hundred miles away. Some of them died.

Many Paiutes soon returned to the Owens Valley and lived in camps near farms, working on ranches growing apples, peaches, potatoes, and alfalfa. By 1866, they were indispensable to the agricultural economy.

In 1910, the town of Manzanar was developed as an agricultural settlement and named after the Spanish word for *apple orchard*.

. . .

Manzanar was officially called a war relocation center, but some people called it a Jap camp. President Roosevelt called it a concentration camp, and others referred to it as a *solution for the Japanese problem,* echoing the language of the Nazis. *If making one million innocent Japanese uncomfortable would prevent one scheming Japanese from costing the life of one American boy,* wrote syndicated columnist Henry McLemore, *then let the million innocents suffer.*

Internees began to arrive in March 1942, when the camp was still under construction, one thousand people a day, though their barracks still had no roofs, though they could lie down on their straw mattresses and see stars.

Some of the people building Manzanar were Paiutes.

There were two schools at Manzanar. A White woman volunteered to be a teacher there. She had very few supplies. She used butcher paper for a blackboard. Pretend this is a Bunsen burner, she told her students, holding nothing. They didn't have an American flag, so every morning in her classroom students saluted an empty corner.

One of Manzanar's six hundred structures included what was called the children's village, the only orphanage in any of the ten internment camps the United States built between March and October 1942. One hundred children lived there. They had been removed from orphanages and foster homes on the West Coast.

By September 1942, Manzanar held ten thousand people. It was the largest city between Los Angeles and Reno.

. . .

I went to Manzanar again a few years after my first visit, and there was more to see than a pile of rocks. The national his-

toric site now has buildings, parking lots, exhibits, films, signs, a driving tour, maps. Inside the rebuilt gymnasium is a scale model of what the camp used to look like. Former internees at Manzanar—the graduating high school classes of 1943, 1944, and 1945—spent thousands of hours rebuilding their prison. You can stand above the model and look down at the tiny buildings. Rows and rows of barracks, trees, mountains.

In the exhibit hall, there are wall-sized black-and-white photographs. Photographs of signs hung across streets, taped to store windows, stapled on telephone poles, hung from front porches: WE DON'T WANT ANY JAPS BACK HERE EVER; JAPS KEEP MOVING; THIS IS A WHITE MAN'S NEIGHBORHOOD. Photographs of evacuation orders: INSTRUCTIONS TO ALL PERSONS OF JAPANESE ANCESTRY. Photographs of signs announcing EVACUATION SALES, families selling everything they own, everything they cannot fit into the two bags allowed per person.

Once the evacuation order was posted, people had only a few days to prepare. Whatever could not be sold would be given away. What could not be given away would be burned.

Refrigerators sold for five dollars.

People buried heirlooms and photographs.

One woman stood on the street in front of her house, cradling a stack of delicate plates. She threw each plate to the ground one at a time, until the stack was gone.

People gave away their pets, because they weren't allowed to bring them.

They turned in their radios and flashlights and guns.

Cameras were not permitted.

In the photographs of crowds waiting to board buses headed for the camps, guards point guns at the long lines of people, not away from them, so right away everyone knew the

story they'd been told—that they were being moved to the camps for their own protection—was a lie.

The guards handed out rectangular tags, the kind you might tie to a gift or a suitcase, and ordered people to tag themselves. Everyone followed the instructions, wrote names, looped white strings through buttonholes, tied knots, and in the photographs the day seems so quiet I imagine the only noise you could hear was the rustling of those tags in the wind.

There was a spirit of *shikata ga nai,* the exhibit explains: *It cannot be helped.*

The government called them *dislocated people,* called them the *unwounded casualties of war.*

. . .

Across the valley from Manzanar are bristlecone pines, the oldest living things on earth. Eric and I drove an hour up White Mountain Road to Schulman Grove to see them.

I expected them to be tall, wide, bigger than redwoods, with trunks so large people could cut archways into them for cars to drive through, but bristlecone pines are not tall and they are not wide. They are multitrunked, gnarled, their bark worn smooth from centuries of ice and snow and wind-whipped sand.

Though they are the oldest living things on the planet, much of each tree is dead wood. A survival strategy. After fire or drought or storm damages a tree, the bark and the tissue that conducts water die back, reducing the quantity of nutrients it has to supply to itself. The parts of the tree that remain alive, though, are healthy, the bark red-brown, grooved, thick. *A ten-inch strip of bark,* I read, *can sustain a large crown.* Bristlecone pines put more energy into surviving than into growing tall.

. . .

In the film I watched in the auditorium at Manzanar, a man said, *Because I looked like the enemy, I was treated like the enemy.*

. . .

When internees arrived, they were searched by armed guards. Given typhoid shots. Handed bags and told to stuff them with straw for their beds.

Each barrack had four apartment units. Each apartment unit had eight cots, a light bulb hanging on a wire from the ceiling, and an oil-burning stove. Eight people were assigned to each apartment, regardless of family size.

Besides the cots, there was no furniture. Some internees were old. They needed places to sit. People used wood from fruit and packing crates to build chairs and tables and dressers.

One man, Hikoji Takeuchi, got permission to take lumber from a scrap pile to build furniture for his sister and his mother. As he was gathering wood from that pile, he was shot by a military police officer, who thought he was stealing. The guard later said he shouted at Takeuchi and Takeuchi ran, but Takeuchi said he never heard the guard. While he recovered in the hospital, his friends and family finished the table and chairs he'd started.

Though internees sewed dishcloths and canvas bags into curtains, nothing stopped the dust that blew through knot-holes in the walls.

There was always wind.

There were common latrines. There were no stalls. Internees created their own stalls with cardboard boxes and put bags over their heads to simulate a sense of privacy.

Though bathing was important to Japanese Americans,

there were no bathtubs. They bathed in the laundry room in the tubs meant for dirty clothes.

Kuichiro Nishi, a nursery owner and garden designer, cultivated wild roses at Manzanar, budding more than fifteen thousand shoots.

Ryozo Kado, a stonemason who'd constructed shrines and grottoes for the Roman Catholic Archdiocese of Los Angeles before he was sent to Manzanar, created the camp's most enduring structures: sentry posts, the hospital garden, and a cemetery monument. Each family living in Manzanar contributed fifteen cents to buy cement for a monument to honor the dead. Kado worked on the monument in the dark while his son held a lamp, and when people in the camp saw his light, they thought it was a ghost. Written in Japanese on the white stone obelisk: SOUL-CONSOLING TOWER.

The internees supported the war effort. They worked in a camouflage-netting factory and provided thousands of nets per month for the U.S. Army. They extracted rubber from the desert shrub guayule to help alleviate the rubber shortage. They planted victory gardens. Purchased war bonds. Recycled metal. Collected glycerin from laundry drains to use in munitions manufacturing.

On August 15, 1942, Ruby Watanabe, who'd arrived at Manzanar from Los Angeles pregnant, delivered twin girls, Diane and Sachiko.

Over the years, 143 internees died at Manzanar, including Watanabe and both her daughters.

. . .

Eric and I walked along a path through the bristlecone pines. Sagebrush and light-colored rock and sky. Quiet. The oldest

known tree in the grove has been named Methuselah, after Noah's grandfather, who the Bible says died just before the flood and was the oldest human on the planet. Methuselah the tree is much older than its human namesake—4,789 years old, which means it has been living on the planet since around 2773 B.C.E.

Methuselah is not labeled and could have been any of the trees we passed. To label the tree, to place a sign near it that says, THIS IS METHUSELAH, THE OLDEST KNOWN LIVING BEING, would expose it to harm, the brochure I took from the visitor's center explained. It would tempt people to cut Methuselah down. Carve their initials in its trunk. Cut off a branch and take it home. Set it on fire.

. . .

The brochure told the story of a geologist studying ice age glaciology who brought a team to examine the bristlecone pines. He wanted to know exactly how old they were so he could develop a glacial time line. He had a coring tool, a borer. He drilled inside several of the trees, removing a small cylinder, counting the rings, but then something went wrong. His tool got stuck in one of the bristlecones.

He and his team decided the best thing to do would be to cut the tree down to retrieve the tool. They needed that tool, they reasoned, and they had no other way to get another one, all alone in the wilderness.

There are so many other trees out here, the man thought. What are the chances that this one tree, with my tool inside it, is the oldest?

He gave the order to cut it down.

It was more than five thousand years old. Already five hun-

dred years old when the pyramids were being built in Egypt. Three thousand years old when Jesus walked the earth. The oldest bristlecone pine. The oldest living thing.

And this scientist killed it.

. . .

Plants that spread beyond the area in which they have been cultivated, into an area where they have not been planted by humans and do not occur naturally, are called *escapes*.

. . .

Methuselarity refers to the idea that it's possible to develop rejuvenation technologies to keep human beings alive forever. I imagine plants and animals not wanting us to succeed. I imagine the whole planet rooting against us.

. . .

The War Relocation Authority hired the photographer Dorothea Lange—famous for her photographs of migrant farmworkers and sharecroppers during the Depression—to document the internment of Japanese Americans. She photographed roundups and forced removals and assembly centers all over California. Then she took pictures of Manzanar. There were rules, types of pictures she was forbidden to take. She couldn't photograph the barbed wire or the watchtowers or the armed guards. She couldn't document any resistance. They wanted her to create a record that would prove there had been no mistreatment.

The government impounded her photographs.

Toyo Miyatake, a well-known photographer in Los Angeles before the war, was interned at Manzanar from 1942 to 1945. Though internees were not allowed to have cameras, the camp director gave him special permission to take photographs. To comply with War Relocation Authority rules, Miyatake was allowed to set up the shot, but only a White person could take the picture.

The restriction was eventually lifted, and Miyatake was designated the official camp photographer. He collaborated with Ansel Adams, a friend of the camp director's.

Miyatake's son Archie was sixteen when he was sent to Manzanar with his father. Archie and his friends would sneak past the guard towers to fish for rainbow trout in the river, using poles made of willow branches with paper clips for hooks. Toyo built a camera disguised as a lunch box for Archie so he could take his own photographs.

. . .

A good photograph, Ansel Adams said, *is knowing where to stand.*

. . .

The United States spent $4 million to build Manzanar—$80 million on all ten camps—but when the war was over and the internees were released, the government sold most of the lumber as scrap. Owens Valley Paiutes and Shoshones and former Manzanar internees helped tear the structures down. Two hundred buildings were saved and moved elsewhere—to become homes, churches, motels, meeting halls. Driving down

Highway 395 today, you can spot them if you know what you're looking for.

Manzanar's hospital equipment was transferred to Northern Inyo Hospital in nearby Bishop, California. The morgue was sold to the Arizona State Hospital. Barracks were offered to returning soldiers for $333.13 apiece to use as raw materials: seasoned pine, redwood, wallboard, windows, doors, wiring, outlets. The Owens Valley Unified School District bought housing units for teachers. The Los Angeles Department of Water and Power acquired several structures, including eight dormitories. A building from Manzanar now houses the tribal office of the Lone Pine Paiute-Shoshone Reservation.

. . .

On the self-guided tour through Manzanar, Eric drove and I took photographs of the sites where things used to be: rose gardens, Japanese gardens, mess hall, baseball field, cemetery. If you were to look at my pictures, all you'd see would be numbered markers and blue sky and desert, an expanse of sage, blooming wildflowers, the Sierras reaching north and south. I stood near the site where the newspaper office used to be to stretch my legs before the drive home, and I wondered, if we couldn't treat one another well here, under the wingbeats of red-tailed hawks and kestrels, under the shadow of Mount Whitney, can we do it anywhere?

6.

INTA MEANS YOU

Two students were in the classroom when I arrived early to rearrange the chairs, from rows to a semicircle, so we could have a discussion.

One elbowed the other. Tell her, she said.

Miles shook his head.

Tell her.

He shook his head again.

If you don't tell her, I will, she said.

Fine, he said. Tell her.

Miles was a soldier in Iraq, she said. He was stationed at Abu Ghraib.

. . .

It felt like a movie, people said, watching the planes hit the towers, watching the towers fall.

. . .

Miles replaced the soldiers who replaced the soldiers in the photographs.

Both students were art majors taking my critical theory course, and the woman told me what Miles was painting: images of the children who were kept as prisoners in Abu Ghraib.

There were children? I asked.

Miles used his nephew as a model, dressed him up in one of the yellow jumpsuits he brought home from Iraq. He photographed his nephew wearing the jumpsuit, then painted from the photographs.

I didn't know what to say. For years I'd been researching Abu Ghraib, writing about those photographs.

Students were filling the room. Class would start in three minutes.

If you ever want to talk about what you experienced there, I said to Miles, I'd be happy to listen.

. . .

Artists set up listening stations in the days after September 11 on the streets of New York City, on subway platforms, in train stations. Would you like me to listen to you? they asked people walking by, and people stopped to talk. Reflective listening, simply repeating what someone says to you, is supposed to be healing.

Ever since that day I feel alone.

You feel alone. Tell me about your loneliness.

I feel alone when I'm with people, even my own family.

You feel alone even when you're with people, even your own family.

Yes. I am afraid.

You are afraid.

. . .

When class ended and I was gathering my things, Miles walked up to me. Can we talk now? I remember him asking.

. . .

They call the secret prisons outside the United States *black sites*. They call the detainees whose names they don't record *ghosts*. They call torture techniques that leave no physical marks *clean*.

In *Torture and Democracy*, Darius Rejali explained how governments that torture have to develop clean techniques to evade detection by the groups monitoring them—the Red Cross, the United Nations, Amnesty International, the ACLU. Interrogation teams are trained in methods that leave no marks. Stealth torture. *Allegations of torture are simply less credible when there is nothing to show for it.*

Stealth torturers use what's easy to find—sheets, gas masks, police batons, light bulbs, buckets, cardboard boxes, water, ice, blankets, hoses—because if anyone were to come looking for torture devices, they wouldn't see any. You can hide a blanket and a cardboard box in plain sight. You can let ice melt.

Stealth torture is not new. American slavers created ways to

torture the enslaved that would leave no mark because they knew any future buyer would think that bodies with scars must be trouble—and would not purchase them.

. . .

The Scourged Back is a photograph of an enslaved man named Gordon, his back scarred by a severe beating, the lashes from the whip visible in raised lines. In 1863, Gordon escaped slavery, fleeing toward the Mississippi River with onions in his pockets, which he rubbed on his skin to avoid detection from the bloodhounds his owner sent after him. It was during the Civil War, and when Gordon reached Union soldiers in Baton Rouge, he declared he wanted to join the Union army. Doctors examined him and discovered his scarred back. They asked the camp photographers to take Gordon's picture. The portrait of Gordon—shirtless, his head turned to the side, the scars so raised they catch the light—was mass-produced and circulated around the country. A writer for the New York *Independent* wrote, *This card-photograph should be multiplied by the hundred thousand, and scattered over the States. It tells the story . . . to the eye.*

. . .

Miles and I sat together in my office, which was not really my office. I shared it with several other part-time adjunct professors. The desk coated with dust, the keyboard filled with it, nothing on the walls.

He started to talk.

. . .

Miles lived in a cell in a bombed-out prison; all the soldiers did. A hole blown through the wall allowed the wind to come through.

They'd been helicoptered into the prison complex and could bring stuff for only two to three days because they had to keep the weight down for the flight. One soldier didn't follow directions, and her bag was too heavy for her to carry. Miles had to decide what would be safer: for him to carry her bag or for the woman to carry it and slow everyone down because they couldn't run around her, because the slowest person always set the pace, and if they were moving slowly, people could shoot at them, because the walls around the complex were so low you could see right over them, and on the other side of the wall was one of the most dangerous roads in Iraq, and people shelled the prison from that road all the time. They had to move quickly.

Miles traded bags with her.

It was freezing in the prison that first night, and Miles had no blankets. In his cell there was no bed frame, no mattress. He found a mattress in another part of the prison. He put it on the floor of his cell and covered himself with magazines and his duffel bag to try to keep warm.

. . .

An eighteen-year ban on publishing photographs of flag-draped coffins of U.S. soldiers was lifted by Barack Obama in 2009. In *Soul Repair*, Rita Nakashima Brock and Gabriella Lettini argued the media blackout hid the costs and consequences of war from public consciousness. We choose collective amnesia about war and its aftermath, they wrote. Veterans return to a nation *unwilling or unable to accept responsibility for sending them to war.*

. . .

What surprised Miles most about war was the intimacy. He hadn't known how much touch there would be, how much physical contact. His first job at the prison was to supervise scanning the eyes and fingerprints of new arrivals. Soldiers stood next to detainees, side by side, shoulders touching. They'd position palms on scanners, press fingers on the glass. It was like they were holding hands.

. . .

Pierre Bourdieu wrote that feelings like friendship, love, and sympathy can be transferred between bodies, from one person to another. Bodies acquire the same dispositions when they are located in the same place in the social structure. Bourdieu called this *synchronized morphology*.

. . .

I heard a story on the radio about a scientist who programmed a computer to repeat back whatever a person typed into it. The hope was to create a cheaper, more accessible form of therapy, the illusion of being listened to. But one of the people who worked with the scientist started coming to the office before anyone else was there, and when the others would arrive, they'd find her talking to it, typing in the story of her life, waiting for the computer to answer her. She told the computer everything.

I miss my father, she typed.

You miss your father.

I love you.

I love you.
No one knows me like you do.
No one knows you like I do.
No one else listens to me.
I'm the only one who listens.

. . .

Miles was supposed to be a cook—that was what they'd trained him to do, prepare food, assemble meals for soldiers to eat—but that work was outsourced to private corporations, so they made him a guard at the prison instead.

He drank his coffee in the medical tent every morning in Iraq and watched the detainees get shots—vaccines for tetanus, measles, mumps, rubella. Most of the prisoners were scared, they didn't understand what the shots were for, and sometimes Miles smiled at them to try to make them feel comfortable, and sometimes they smiled back, and sometimes he teased them, told them the shots were poison, put his hands around his throat like he was choking, like he couldn't breathe. Some of the prisoners were so afraid of the needles that they'd pass out, and everyone in the medical tent, including the other prisoners standing in line, would laugh.

. . .

Some governments build elaborate torture chambers. The *House of Fun* was designed by a British firm that advertised the setup as *prisoner disorientation equipment*. Installed in Dubai Special Branch Headquarters, it was outfitted with strobe lights and white-noise machines and took on the appearance of a disco, but the sound that could be generated inside that

space was so loud it was capable of reducing the victim to sub-
mission within half an hour.

. . .

Miles told me he didn't decide to go to war because he sup-
ported the war. He didn't think there were weapons of mass
destruction. He went to war because he wanted to go to col-
lege, and joining the military seemed like the best way to pay
for it. And that was true for most of the soldiers he knew. Their
reasons were pragmatic, and once they found themselves in-
theater, they did their jobs and they did them well, because if
they didn't, they'd die or their friends would die or the people
next to them would die, and the war became about protecting
each other, about being willing to die for one another. When
you're there, he said, all you want to do is protect your bud-
dies.

. . .

Miles told me I was the first person who'd asked about his ex-
perience in Iraq. He'd been back for more than two years.

. . .

Flying home after visiting my parents, I heard the captain an-
nounce there was a soldier on board. Then I watched everyone
who passed the soldier on the way to or from the restrooms at
the back of the plane touch his shoulder or call him son or
thank him for his service. One passenger, an older man,
stopped at his row and hit the button above the soldier's seat so
it lit up. A drink, he said. Anything you want. And the flight

attendant arrived and offered the soldier a tray of tiny bottles to sift through, the sound of the glass like marbles. The man stood in the aisle next to him, talking while the soldier drank his bourbon and Coke, telling his stories about war, about Korea.

When the plane hit the runway, the captain spoke again, directed the passengers to stay seated when we reached the gate, to stay seated even when the seatbelt light turned off, to let the soldier off first. The least we can do, he said. Show a little appreciation for our men and women in uniform.

Applause followed the soldier down the aisle.

. . .

Most civilian actions toward veterans shield us from accepting our own complicity in war, Brock and Lettini wrote.

. . .

The barred walls of every soldier's cell were covered with plywood to make them more private, Miles told me, though the plywood didn't reach the ceiling, so you could see the light in the cells next to yours and you could hear one another. All the windows were blacked out with paint. Otherwise snipers would be able to see right into the prison and kill you.

Miles was friends with the guy in charge of supplies, so he was able to get Sharpies, even a good set of thicker felt markers. He drew images all over the plywood walls of his room—Spider-Man, Batman, characters from *The Simpsons*, his friends, other soldiers. On the door to his cell he drew his own name, made it beautiful.

When his tour was over, people told him to take the walls

with him, that he'd want his drawings when he got home, but he couldn't imagine ever wanting any of it.

He wants it now.

. . .

Fayum portraits—images created thousands of years ago in beeswax and pigment on wood or linen in a town called Fayum, south of Cairo—were painted while the subject was alive, but when he or she died, the image was attached to the mummy and buried. The images ensured safe passage through the underworld. They worked like passport photos, identifying the person's body on his or her journey.

Fayum portraits were images destined to disappear. What does it mean to create a painting the artist knows will exist only with the dead, in the dark?

I've always been taught the job of the artist is to look, but in *The Shape of a Pocket,* John Berger insisted the Fayum artist had a different job—not to look but to be *looked at.* The artist paints being looked at, he wrote. This is the contract between artist and subject, and it is an intimate one. *The two of them, living at that moment, collaborated in a preparation for death.* The subject addresses the artist, speaks to her in the second person singular—*you*—and the artist's reply, which is the painting itself, uses the same intimate voice: You, the one who is here. You, who will very soon, too soon, not be here.

. . .

Miles's assignment was changed from fingerprinting new detainees to guarding prisoners in the yard outside the building. They were kept in cages, larger versions of what you might

find at a kennel for dogs. The prisoners prayed five times a day on mats they were given, their voices beautiful. They knelt on the ground in rows, and the guards would be quiet while they prayed, and the prisoners returned the favor by being silent on Christmas. It was a sign of respect, Miles told me.

In some of the cages were children, in others old men. Many spoke English and Miles became friendly with them, joked with them to pass the time.

. . .

Inta, the Arabic word for *you*. That's what the soldiers called every prisoner, Miles said.

The soldiers who worked the yard kept their cigarette butts in a jar. Hey, *inta*, one of the soldiers said to a prisoner one afternoon. Guess how many cigarette butts are in the jar.

If he didn't get it right, he'd have to spend two hours in the cage reserved for prisoners who were in trouble.

A few soldiers brought the jar to that prisoner and made him write down his guess, made him dump out all the butts, made him line them up in neat rows in the dirt, made him count each one.

So many things were funny there that aren't funny here, Miles said.

. . .

Consider this sentence, James Elkins suggested: *The observer looks at the object*. It seems simple, even obvious, a given, but the sentence comes apart right away, because it's built on the mistaken idea that the observer and the object are two different things. The beholder looks at the object, but the object

changes the beholder, and therefore the beholder does not look at the object.

Or consider this sentence: The soldier kills the enemy. It sounds like a one-way gesture, but it's not, because the act of killing doesn't only change the person who is killed. *The act of killing changes the killer,* Elkins wrote.

In *The Body in Pain,* Elaine Scarry put it differently. *Every weapon,* she wrote, *has two ends.*

. . .

Calling other human beings *inta,* calling other human beings *you* instead of addressing them by name, dehumanizes, creates distance between guards and detainees, but what if it had been Berger's *you,* the Fayum *you,* a way of saying to the people they were charged with watching, to the people who were watching them: *Both of us are destined for the dark.*

7.

SOUVENIR

I went to visit Howard's daughter Kayleen in Indianola again, and after dinner the night I arrived, we sat at the long table in the studio, boxes of documents between us. We wore gloves to protect the fragile paper and read letters from Howard and Ruane's friends and relatives, letters from his college roommate Gordon Hirabayashi, pamphlets about ending the war and resisting conscription, letters to the editor Ruane wrote and sent to the local papers, weekly newsletters from the Quakers, from the American Friends Service Committee. We found war ration booklets with tickets still tucked inside. We put the hundreds of letters Howard and Ruane wrote to each other in chronological order, slipped them into plastic sleeves.

Kayleen went to bed, and I stayed up late, reading. I marked

with Post-it notes what I would photocopy the next morning. I put a Post-it on the outside of a slim binder containing what Kayleen called the violin letters so I could copy them all.

. . .

Miles showed me things he brought home from Iraq. Coins and paper money. A yellow prison jumpsuit. A vinyl poster listing prison rules and regulations, the dos and don'ts acted out by a cartoon version of a man with a mustache who looked like Saddam Hussein. A drawing of the man running away: *Don't try to escape*. A drawing of the man throwing grenades: *Don't bomb anything*. A drawing of the man holding his index finger to his mouth: *Don't make any loud noises*.

. . .

The word *souvenir* comes from the Latin word *subvenire*, meaning *to come into mind*. *Souvenir* can refer to what you do to preserve something in your mind, or it can refer to the thing that triggers the memory. It is the object you use or the action you take to bring the sensation of the other into yourself, to remember.

. . .

In one of the violin letters Ruane sent to Howard I read this: *The book says about the back, belly, and side of the violin that it is most important to have the wood cut properly and apportioned. If too thin—weak and feeble tone; too thick—sluggish and dull tone.*

. . .

One afternoon Miles brought in some red-and-green bracelets made out of string. They looked like friendship bracelets, the kind I braided at summer camp. Detainees had made them by knotting together threads from the fraying towels they were issued. They fashioned clasps out of the pits of dates. Prisoners gave bracelets to each other, wore bracelets going up their arms, a kind of popularity contest, who had the most, and it didn't count if you made them for yourself. A few prisoners made bracelets for Miles.

After the bracelets, Miles brought in a prayer rug. Each prisoner was given a Koran and a prayer rug when they arrived, he explained, and when the detainees were released, they were given another Koran and twenty-five American dollars.

We used to give them white tunics to wear when they left, he said.

But dressed in those tunics, they were easily identifiable as men who had just been in an American prison, marked as men detained by the Americans.

The soldiers kept finding the released men outside the prison, dead.

People would kill them for the twenty-five dollars.

. . .

I read this in *Harper's*: There is a black site at Guantánamo nicknamed *Camp No* because *anyone who asked if it existed would be told, 'No, it doesn't.'* Camp No is a hidden room on an island of hidden rooms. It is not visible from the main road. Access to the road that leads to it is blocked.

Three men—Salah Ahmed Al-Salami, from Yemen, thirty-seven; Mani Shaman Al-Utaybi, from Saudi Arabia, thirty; and

Yasser Talal Al-Zahrani, also from Saudi Arabia, twenty-two—died in Camp No on June 9, 2006. None of the men had been charged with a crime. They'd been participating in hunger strikes to protest their imprisonment for years without charge, without trial.

According to the government and to the military, all three men committed suicide, at the same time, in the same way: by swallowing rags and hanging themselves. Somehow each prisoner made his own noose, tied it to the top of his cell's eight-foot-high steel-mesh wall, bound his own hands and his own feet, and stuffed rags down his own throat. Scott Horton wrote, *We are then asked to believe that each prisoner, even as he was choking on those rags, climbed up on his washbasin, slipped his head through the noose, tightened it, and leapt from the washbasin to hang until he asphyxiated.*

When the men's bodies arrived home to their families, their throats had been cut out. A particular region of each man's neck including the larynx, hyoid bone, and thyroid cartilage—the very structures that would have been essential to determining whether they'd died by hanging or choking or being strangled—was gone.

Though the families asked for them, the missing parts have not been returned.

. . .

On the 750th anniversary of his death, the body of Saint Anthony was unburied. Inside the tomb, in addition to Anthony's remains, the researchers found a large pinewood box wrapped in four linen sheets, and inside the large box was a second smaller box, also made of pine, and inside that box were three

bundles wrapped in red silk, and inside the bundles were a tunic, a plaque, ten white rings and fifty black rings from a necklace or rosary.

Anthony's skeleton had no left forearm, tongue, or jaw, which was not a surprise because it wasn't the first time Anthony had been dug up. In 1263, when the basilica in Padua where his bones are kept was under construction, church officials moved his coffin to another church to keep it safe. They opened the coffin when they relocated it and discovered that Saint Anthony's tongue—a fragile part of the body, a part of the body that should have disintegrated soon after death—was still intact. A miracle. They decided to keep the saint's tongue, jaw, and left forearm separate from his body. You can visit these relics today. You can see his tongue and forearm and jaw in their gilded displays, and if you look closely, you can see the cartilage of his larynx.

. . .

Believers venerate parts of the body belonging to saints. Shards of bone. Vials of blood. Fingertips and hands and forearms. Tongues and larynxes and jaws. In the Catholic Church, there are three classes of relics: a first-class relic is a body part from the saint—skull, thumb, lock of hair, skin; a second-class relic is a personal item that belonged to the saint—clothing, a letter, a piece of furniture; a third-class relic is an object that has touched a first-class relic. To obtain third-class relics, small holes are drilled into the saints' tombs so objects can be lowered on strings through the holes to touch the saint's body.

. . .

When White Americans lynched Black Americans, the crowd would descend on the body and carry away pieces of the person—ears and nose and fingers, liver and stomach and heart, genitals and teeth and hair—to keep as souvenirs. Schools would open late so children could attend weekday lynchings. If they took place on Sundays, White pastors would delay church, encouraging their congregations to attend.

In "The Black Body as Souvenir in American Lynching," Harvey Young quoted the *Springfield Republican,* a Massachusetts newspaper that recounted the scene of the lynching of Sam Hose, who was burned alive in Newnan, Georgia, on April 2, 1899: *Before the body was cool, it was cut to pieces, the bones were crushed to small bits, and even the tree upon which the wretch met his fate was torn up and disposed of as "souvenirs."* Those who could not get remains themselves bought them from friends.

The word *remains* is a noun and a verb, Young wrote. As a noun, it means *that which is left.* As a verb, it means *to continue to exist.* The dismembered finger points to the hand, to *the formerly whole body from which it was taken.*

. . .

After the Roman soldiers crucified Jesus, they took his clothes.

. . .

In his book *The Cross and the Lynching Tree,* the theologian James Cone wrote, *In the "lynching era," between 1880 and 1940, white Christians lynched five thousand black men and women in a manner with obvious echoes of the Roman crucifixion of Jesus. Yet these "Christians" did not see the irony or contradiction in their actions.*

The lynching tree—so strikingly similar to the cross on Golgotha—should have a prominent place in American images of Jesus' death, Cone wrote. *But it does not.*

. . .

Photographers at lynchings turned their images into souvenirs, postcards that could be sent around the country.

There's a postcard of the lynching of Tom Shipp and Abe Smith in Marion, Indiana, in 1930. In the photograph, the bodies of Shipp and Smith hang from the branch of a tree. It's August, and below them is a large crowd. One man in the crowd, with short dark hair and a mustache, looks directly at the photographer and points to the bodies hanging in the tree, as if the person behind the camera might miss them, as if the person behind the camera might accidentally photograph something else.

In the left-hand corner of the image is a White woman wearing a dark patterned dress. She, too, looks directly at the camera. She's smiling. The White man standing behind her wears a shirt and a tie, and the woman's right thumb rests in the palm of his hand. Her gesture is casual, her body relaxed, as if this is any ordinary summer night.

. . .

Sometimes on their days off, soldiers at Abu Ghraib explored the countryside. Joseph Darby, a military police officer in the army reserve, worked in an office at Abu Ghraib, and he and Charles Graner, a guard at the prison, had traveled together. Darby asked Graner—who was a known camera buff—for pictures of Iraq he could send to his wife to give her a sense of the place, pictures he could keep as mementos. Graner gave Darby

two CDs of photographs, and on the CDs were other photos from Abu Ghraib, the torture photos—hooded and naked detainees stacked in pyramids, men forced to simulate sex acts, a prisoner on the end of a leash. Darby wrestled with what to do. He'd known some of the soldiers in the photographs since high school. Three weeks later, he turned the CDs over to the authorities. He was promised protection, anonymity.

Then prison officials placed boxes around the prison and told the soldiers to put photos, cameras, CDs, and thumb drives into those boxes. Amnesty: No one would get in trouble for what might be pictured there. Whatever was put in those boxes would be destroyed.

· · ·

After the belly is gouged and sanded, shape your bar and affix it to the belly, marking the place where it goes, Ruane wrote. *It will be placed on the right-hand side of the belly as you work on the inside. Mark three small marks at the exact center of the belly.*

· · ·

In *On Longing,* Susan Stewart wrote, *The souvenir is by definition always incomplete.* The material object is a fragment of the thing itself—a ribbon from a bouquet of flowers, a lock of hair from the body of the beloved, a rock from a favorite mountain— and it must remain that way. It must point to the thing, the experience, the place, the body, without fully being the thing, the experience, the place, the body. It is *an allusion and not a model,* Stewart wrote, and its incompleteness is what leaves room for your memories. Into that empty space, you can import desire and longing.

Miles got a two-week leave when he was in Iraq, and everyone told him not to go home. Told him to go to Paris or meet his family somewhere, anywhere, because the military would pay for it, they'd fly him wherever he wanted to go. Miles wanted to go home, but when he got home, all he could do was count the days until he went back. He didn't want to do anything because he didn't want to risk having a good time. How could he have fun when the rest of his buddies were in danger?

That is the hardest thing, he told me. I had a tight group of guys I spent all my time with, every single day for a year, and now they're gone.

. . .

Who doesn't know what it's like to go with a friend to the train station and then watch the train take them away? John Berger asked in *The Shape of a Pocket*. When you walk along the platform and through the station and out into the street, your friend seems more with you than when you hugged her before she boarded the train. This is why we embrace each other when we say goodbye, Berger wrote: *to take into our arms what we want to keep when they're gone.*

. . .

The next page will include details about the ribs, Ruane wrote. *I'll try to write all I can about the sides, corner blocks, fastening neck to body, and gluing the back to the side. Be patient with me.*

. . .

Joseph Darby—the soldier who turned in Charles Graner's CDs with the Abu Ghraib torture photographs on them— described the time a mortar was dropped into the prison, in the middle of a prayer group, men sitting in rows, facing Mecca. *We had fifteen to sixteen dead and a bunch more wounded,* he said. *We had to dig through the bodies, put them in body bags, and take them to the processing area to check them out of the prison. Whenever a prisoner was brought in, we would ID them with a retina scan and fingerprints, so when they died, we had to process them out the same way. Which meant that, for the rest of the day, we were digging through body bags looking for eyeballs.*

. . .

One of the doctors at Auschwitz, Josef Mengele, killed Roma children and took out their eyes. He injected a chemical dye into them to see if he could change their color from brown to blue.

In *Die Wiedergutmachung (Reparations),* the artist Luc Tuymans painted these eyes. *Wiedergutmachung* means *making good again,* and in his painting, the eyes look out, waiting.

. . .

Doctors working with amputees construct a *virtual reality box,* a cardboard box with no lid, into which a mirror is placed. They cut two holes in the front of the box, and they ask the patient with phantom-limb pain to insert her noninjured limb through one hole and her injured limb through the other. When the patient looks into the box, she sees the noninjured limb and its reflection; she sees two healthy limbs. When her

brain sees the phantom limb moving, it's tricked into thinking it has control over the missing part, and the pain pathways are undone by this new information. The reflection of the noninjured limb, in effect, replaces the phantom limb, and *if the phantom is extinguished,* Oliver Sacks wrote, *its pain must also go.* With the mirror in the box, it is as if the doctor has achieved a successful amputation of the phantom limb. This amputation, however, requires no knife—just an image.

. . .

The earliest portable camera obscuras were boxes with mirrors inside. A small hole would be cut into one side of the box, sometimes fitted with a lens. Light from a well-lit scene or object would enter the hole to form an inverted image on the screen inside the box, directly across from the opening. The mirror reflected this upside-down projected image, reversing it so it appeared right side up. The right-side-up image was then reflected onto a drawing surface, where its outlines could be traced.

Aristotle referred to the camera obscura in his writings. The Arabian philosopher Ibn al-Haytham, born in Basra (now in Iraq) in 965, recommended the device to astronomers so they could observe eclipses without damaging their eyes.

. . .

A man in Baghdad is asleep next to his pregnant wife when his door is kicked down by U.S. soldiers, Nick Flynn related in *The Ticking Is the Bomb.* They shine a light in his eyes. Ask him about his neighbor. Threaten to hurt his wife. They beat him.

Shackle him. Hood him. Drag him from his house. Throw him into a Humvee. Drive him to a landing strip. Load him into a helicopter. Lead him into a building.

Inside the building is a large room, the size of a gymnasium, and it is filled with black boxes, lined up in rows. *The boxes are about two and a half feet wide, five feet long.* The man is put in one of those boxes and kept there for days, for weeks, *unable to straighten his body, barely able to breathe.* Every twenty or thirty minutes, someone kicks the box or hits it hard with a club, *and it [makes] his shackled body jump.*

Someone designed this room, Flynn wrote. *Someone fabricated those boxes, a memo went out telling soldiers how often to bang on the side of the boxes, a memo we will likely never see.* Iraqis call these boxes *tawabeet sood* or *nash sood,* which means black coffins.

. . .

I watched a video of a soldier in a doctor's office. One of his legs had been amputated above the knee. Sometimes he felt like he was being stabbed with a poker between his toes. Like his toenails were being pulled back. Like his foot was cramping. He sat on the examination table. The doctor put a mirror between the soldier's legs, the reflective side facing the uninjured leg, doubling it, so when the soldier looked down, he saw two whole legs—one his own and the other its reflection. The doctor told him to move his uninjured leg as if he were pressing on a gas pedal, and when the soldier pressed the imaginary gas pedal, he saw two feet pressing the gas pedal. It feels like your foot is there, the soldier said to the camera.

The visual component modulates the pain response, the doctor explained.

Seeing heals. Seeing your resurrected limb brings the limb back, so it can go more fully away.

. . .

When I was training to be a priest, I was taught that what we do during Communion is to re-member, to put Jesus's body back together. When you eat the bread that symbolizes Jesus's body and drink the wine that symbolizes his blood, you re-member Jesus by taking him into your own body. The bodies of the community, together, become his body on earth. No hands but yours. No feet but yours.

. . .

When Kayleen was a young girl, she found a dead dogfish washed up on the shore of the beach near her family's campsite, its spotted skin still slick. With her new pocketknife, she cut it open and found eggs inside, oblong capsules she carried carefully back to camp, wondering if the new lives might be saved. When Ruane told her the eggs couldn't survive outside their mother, Kayleen brought them back to the opened fish.

I imagine Howard and Ruane kneeling next to her in the sand, putting the eggs back inside. With needle and thread, they stitch leaves together, wrap the dead pregnant dogfish in a green cocoon, then release her in the water, watching her drift in and out, in and out, out and away.

. . .

The interior, Ruane began. *The blocks are the six pieces of wood which, being fixed at the top, bottom, and corners of a violin, serve to*

strengthen the whole structure and thereby give a firm base for the vibrations of the back and belly, and there is no doubt that they perform a considerable duty in transmitting the vibrations of the belly to the back in the same way as the sound post and the sides.

. . .

I can't get one little boy out of my mind, Miles said. The boy's head was flat on one side, like a deflated football. He'd been injured—by gunfire or shrapnel—and American surgeons removed part of his skull to give his swollen brain room. They inserted that piece of bone in between the boy's ribs to keep it alive, as part of his body, while his brain recovered, intending to put it back. But the boy was released before the swelling subsided, and in his village there were no doctors.

I still think about this boy, Miles said.

. . .

The violin is the instrument said to sound most like the human voice.

. . .

A few days before I visited Kayleen to celebrate Howard's ninety-second birthday, both of her sisters had kidney transplants. I'd always assumed kidney transplants went like this: doctors remove the kidney that is no longer working properly and replace it with the donor's healthy kidney. But that isn't how it happens at all. The sick kidney isn't taken out of the body. Doctors leave it in place when they add the new kidney, which they insert through the front of the torso, through the

abdomen. The new kidney stays in its position at the front until the body is ready to receive it, until it makes room, and the kidney that is no longer working is eventually absorbed. It disappears. Becomes something else.

Kayleen told me that every night in the hospital, recovering from the procedure, one of her sisters rocked the new kidney in the front of her body to sleep, like a baby. Kayleen knows the name of her sister's kidney donor. She read about the donor in the paper, about how the person died, about the family's grief at the sudden and unexpected loss. She considered going to the memorial service, but she didn't want to impose her gratitude on their grief.

Organ donation works like an open adoption. You can leave a letter for the donor's family that says you'd like to meet them, thank them, and then you wait, rocking the body of their beloved to sleep.

. . .

When Jesus arrived to visit his sick friend Lazarus, he was too late. Lazarus was dead and had been in the tomb for four days. Jesus wept, and then he ordered the stone in front of the tomb to be removed. *Lazarus, come out,* he said, and when his friend walked into the light, his body wrapped in cloth, his head wrapped in cloth, Jesus said, *Take off the grave clothes and let him go.*

Lazarus got his whole body back.

8.

IN YOUR HEAD

In 2009, I hosted a two-day event at the university to mark the five-year anniversary of the publication of the Abu Ghraib photographs. I screened Rory Kennedy's film *Ghosts of Abu Ghraib*, organized a panel of professors and students to talk about the pictures, and curated an exhibit in the library.

Miles helped. We hung two of his paintings—one of a detainee on the ground in a yellow prison jumpsuit, the other of detainees squatting in front of a line of portable toilets—and we arranged his souvenirs from Iraq in glass display cases—the coins and paper money, the red-and-green knotted bracelets made by prisoners, the rules-and-regulations poster, a Koran, a prayer rug, a yellow jumpsuit.

I invited Miles to be part of the panel, but he wasn't sure

that was something he wanted to do. I don't really have any-
thing to add, he said.

. . .

From the magazine *The VVA Veteran*, I learned this: three thou-
sand years ago, an Egyptian combat veteran named Hori
wrote about what it feels like to prepare to enter battle: *You
determine to go forward. . . . Shuddering seizes you, the hair on your
head stands on end, your soul lies in your hand.*

. . .

Miles arrived late. The panelists had all presented their papers,
and the question-and-answer period had begun. Miles stood at
the back of the room, leaning against the wall next to a student
who'd made it clear she thought my class was anti-American.
If you're going to show the Abu Ghraib photographs, she'd
told me one day, then you should also show the video of those
monsters beheading Daniel Pearl. If you're going to show the
video of Rodney King being beaten by the L.A. police, then
you should also show what happened to Reginald Denny.

I gestured for Miles to join the panel. I pointed to the empty
chair next to me.

He walked to the front of the room, sat down. I introduced
him.

A few minutes later, a woman in the audience raised her
hand. Torture is a problem, she said, and, frankly, everyone
should be worried about this. I'm worried about this, you
know, because these torturers are coming home, and they
might live right next to you.

Miles and I have different memories about what happened next. I remember that Miles said, Murderers are coming home, ma'am, but Miles doesn't remember saying that. He told me he would never say something like that because he doesn't think about war that way at all.

. . .

The Greek historian Herodotus, writing about the Battle of Marathon in 490 B.C.E., told a story about *an Athenian warrior who went permanently blind when the soldier standing next to him was killed,* even though he *was wounded in no part of his body.*

In 1678, Swiss military physicians used the term *nostalgia*— a word made of the Greek root words for *return home* and *pain*—to describe the condition characterized by soldiers' melancholy, incessant thinking of home, disturbed sleep or insomnia, weakness, loss of appetite, anxiety, heart palpitations, stupor, and fever.

German doctors called it *heimweh,* and French doctors called it *maladie du pays,* both meaning *homesickness.*

Spanish doctors called it *estar roto,* which means *to be broken.*

. . .

After one of my classes, Miles drove himself to the VA hospital. His heart was racing. His lungs were tight. He thought he was having a heart attack. He thought he was dying.

Doctors checked his heart, his lungs.

It's all in your head, they said.

. . .

During World War I, the soldiers' symptoms were attributed to the new weapons of war: *shell shock.*

. . .

Many of the symptoms observed in shell-shocked soldiers are identical to those of hysterical women. *Hystera,* Greek for womb. Hippocrates believed the womb could wander, an *independent creature* inside the female body—a body that craves moisture and warmth, that needs sex. Any *unnatural behavior*— celibacy, for example, or living alone—makes the uterus too light, too dry, so it wanders. When it presses against the intestines, the woman chokes. When it sits against the diaphragm, the woman is unable to speak or breathe. When it compresses the arteries, the woman sleeps, her head heavy. When it lands next to the brain, hysteria.

. . .

In the 1880s at the Salpêtrière Hospital in Paris, Jean-Martin Charcot, Freud's mentor, took pictures of women who had been labeled hysterics and locked away. People believed the women were mistresses of deception. Their charade: paralysis, bulimia, abstinence, sensitivity, exaltation, insomnia, sleeping attacks, twisting, panting. Wild-haired. Wild-eyed. Silent. Screaming. Charcot wanted to help—catch the hysteric in the act, fix her on film. Proof! Evidence! He'd make her suffering real, believable. He led each subject into a pitch-black room. The woman was alone in the dark, then the flash of the camera, an unexpected burst of light.

In one of Charcot's photographs, a nurse holds a woman who has fallen back in a dark room. Next to them is a tripod

that must have supported the flash. Stamped across the bottom of the image: *Lethargy. Resulting from the Sudden Extinction of Light.*

. . .

We call it Passing Through Someplace Dark, a woman on the radio said, talking about her husband, who is home from war, who has PTSD.

. . .

A forgetting pill—an experimental therapy doctors are using to help people with PTSD. Scientists used to think memories were stored in the brain like files. Imagine the hard drive of your computer. You need a file, you click on it, and it appears, intact, complete. But they now know memory doesn't work like that: you don't find your memories; you make them. Every time you remember something, you create the memory again, strengthen it, build it up, change it. The act of remembering alters the memory itself. The more often you remember something, the less accurate it becomes. It's called memory reconsolidation. To do this work, the brain needs protein, and the new theory is that if you deny the brain protein, you can get it to forget the things you no longer want to remember.

. . .

Howard's memories were leaving him. Before each memory left, it visited him when he was asleep, its final gift the chance to experience it one more time, he told Kayleen, the details so vivid and exact he could swear he was living it again. He

watched the memory stand and walk out of the room. He said thank you, and waved goodbye.

. . .

In Hades, the underworld, souls were made to drink from the river Lethe—the river of forgetfulness, the river of oblivion—to erase any memory of the lives that came before.

. . .

One of my students told me about her friend who had just come home from war. He was a sniper, she said. Before he killed his target, he had to sit for hours, for days, on a rooftop across from the target's house and watch the person he was supposed to kill, watch him play with his children, eat dinner with his family, hug his parents, kiss his wife good night. But then the order would come, and he'd have to follow it, lift his rifle, put the man in his crosshairs, shoot, watch him die.

He's different now, she said. He ducks below the car window when we drive anywhere. He jumps when he hears any loud sound.

. . .

During the American Civil War, they called the emotional turbulence, paralysis, tremors, self-inflicted wounds, nostalgia, and severe heart palpitations *soldier's heart* or *exhausted heart*. There were so many soldiers whose hearts were exhausted that military physicians, at a loss for what to do, put the men on trains, the names of their hometowns pinned to their clothing.

When detainees asked Miles where he was from, he always answered, Abu Ghraib.

. . .

In World War II, the most common thing the wounded said as they lay dying on the battlefield was *mother*.

. . .

I want to go home, my grandfather said when he was dying of Alzheimer's. Vera, he said, calling out for my grandmother, who had been dead for years.

. . .

Charcot's patient Hortense suffered from photophobia in one eye—hypersensitivity to light. Too much light resulted in that eye's paralysis. She endured hypnosis, hydrotherapy, electroshock, drugs, physical therapy, and being buckled into a leather harness. *The patient remains in all those positions in which she is arranged*, the doctors wrote. If they held her eyes open, they stayed open. If they didn't hold her eyes open, they closed. In Charcot's photograph of Hortense, her velvet coat is buttoned, its collar embroidered with two flowers, and she looks directly at the camera, one eye opened, one eye closed. She winks.

In another photograph, a woman named Augustine stands next to a tripod almost as tall as she is. She's close enough to touch it. Her dress is dark, her hat and apron white, a nurse's

uniform. She leans back, surprised, her left hand at her side, her right hand open. Stamped across the bottom of the image: *Catalepsy. Provoked by a Strong Light.*

. . .

Scientists train rats to be afraid of a particular cage by shocking them and shining bright lights in their eyes every time they are in that cage. But then they feed them an *amnesia cocktail,* beta-blockers that inhibit their brains from getting the proteins they need to remember what happens in that cage, and the fear memories vanish.

. . .

The artist Tejal Shah restaged Charcot's photographs. Using herself and the dancer and choreographer Marion Perrin as subjects, Shah attempted to copy the originals—a *re-enactment of what was already (at least partly) a re-enactment but was presented as a scientifically objective registration,* Shah wrote.

Her re-created photographs—a woman bending backward, a woman with her face poked by a stick, a woman next to a tuning fork, a woman in a nurse's uniform with her eyes closed— were part of Shah's exhibition titled *Pentimento,* named for a term used for changes made in a painting that leave behind traces of figures or objects that have been painted over.

. . .

We think we know better now. Hysteria is not a womb illness. It's a mental illness called conversion disorder: *the loss or alteration of physical functioning without any physiological reason.* The

patient converts emotional problems into physical symptoms. It appears after stressful events.

Your legs may become paralyzed after falling from a horse even though you weren't hurt.

You may lose your ability to walk or swallow or hear.

You may have trouble with balance.

You may forget.

A psychiatrist defines the symptoms of conversion disorder as *a code that conceals the message from the sender as well as from the receiver.*

. . .

Being close to a blast—a suicide bomber or an IED, for example—feels like someone is *punching and squeezing you,* like someone *put a board against your body and then struck it with dozens of hammers,* I read in the newspaper. In the 1950s, scientists thought *blasts would mainly affect air pockets in the body like the lungs, the digestive system and the ears.* They did not think about the brain. But looking at slides of brain tissue from soldiers who've been exposed to blasts, scientists can now see this: war turns the brain to dust.

. . .

If it's just in my head, Miles told me after his visit to the VA hospital, then I don't need to go back to the doctor.

. . .

The university in California where I taught was near a base, and the soldiers I saw going in and out of the base drove big

trucks, and they drove them fast. They whipped around me, passing me on two-lane roads running through farmland, passing me around blind corners, passing me across double yellow lines, a mountain on one side and a cliff dropping down to the Pacific Ocean on the other.

One suicide a month, I read in a magazine when I was waiting in line at the grocery store. If you count all veterans, instead of soldiers on active duty, the number is much higher: twenty-two suicides a day. One every sixty-five minutes. Bullet to brain, rope around neck, needle under skin, drink down throat, exhaust-filled lungs—a different kind of forgetting.

. . .

There is a bridge less than a mile from the house where I live, and from it you can see the whole city. People call it Suicide Bridge because so many people jump from its ledge to the train tracks below. Small blue signs on either side offer a phone number to call and this message: WE CAN HELP YOU CROSS THIS BRIDGE.

. . .

Moral injury: *the emotional shame and psychological damage incurred when a soldier has to do things that violate their sense of right and wrong.* Having killed or tortured, having survived when their friends died, having failed to stop others from doing terrible things—some soldiers believe they *can no longer be regarded as decent human beings.* Even if they know what they did was *warranted and unavoidable,* they feel they don't live in a reliable world anymore.

Reverend Herman Keizer, Jr., a retired colonel and chaplain of the U.S. Army, said: *To violate your conscience is to commit moral suicide.*

. . .

It's like two different worlds, Miles said. Or maybe I'm two different people, or I'm living two different lives: the life of a soldier and the life of a student. Sometimes, he said, I go home and just stare at the wall. I don't know what to do with myself here.

. . .

There's not much to do in this land of drooling drones, Howard said. Which is how they see us, and therefore how they treat us, with their baby talk and their finger exercises and their shower chairs.

Howard, Kayleen, and I walked to the dining hall for lunch.

We don't eat breakfast in the dining hall, Howard said. They bring breakfast to everyone's room at eight, but I'm an early riser, so I make myself toast with apricot jam before they come. They will bring toast, but it's too well done, burned, and I like my toast like a warm blanket.

As we walked to the dining hall, Howard greeted everyone we passed. He said, We're supposed to wear name tags so we remember who everyone is, but no one wears them, so I have to ask names again and again, even when I eat almost every meal with a person and consider him a good friend.

I feel bad about that, Howard said, but I'm not the only one.

. . .

An article about the forgetting pill included a story about a woman whose child died in a car accident, whose husband was abusive and then committed suicide, who was sexually molested as a child, paralyzed by grief, driven to drink, unable to lead a normal life, but doctors worked to help heal her. They asked her to tell her story, and while she talked, they administered the protein blocker. They took the pain of the memories away, the article said.

. . .

I think about Miles's mornings in Iraq, the detainees lined up for shots. I imagine doctors administering beta-blockers instead, plastic cups of pills, plastic cups of water, the doctors thinking themselves generous, kind. We're saving them, the doctors say to one another.

. . .

In 2007, officials from the CIA admitted they had destroyed at least two videotapes in 2005 documenting the interrogation of two terrorism suspects in the agency's custody. Two years later, they admitted to destroying ninety-two videotapes of interrogations. The tapes had been stored in Thailand and were said to depict some of the harshest interrogation techniques, including waterboarding.

Rush Holt, a Democratic member of the House Intelligence Committee, had been pushing legislation in Congress to have all detainee interrogations videotaped. He thought if the interrogations were recorded, officials would be able to refer to the tapes multiple times to glean better information. But Mr. Holt was told the CIA never recorded the interrogation of

detainees. *When I would ask them whether they had reviewed the tapes to better understand the intelligence, they said, "What tapes?"*

. . .

Every image of the past that is not recognized by the present as one of its own concerns threatens to disappear irretrievably, Walter Benjamin wrote.

. . .

Miles was in the army reserve, and he left town once a month to train at a base a few hours away.

When will your time in the military be finished? I asked.

Well, he said, I just reenlisted.

9.

WRITTEN IN THE STARS

My grandfather was a shell-shocked soldier, though *shell-shocked* was never a word he used, never a word I used when I thought about him. He was a navigator in World War II, bent over maps, plotting the ship's course. His ship—*Landing Ship, Medium 51 (LSM-51)*—transported troops to battle: dropped them off, waited, picked them up again, the bloody, the dead, the blown apart.

They also picked up Japanese prisoners of war.

Almost a decade after my grandfather died, my father told me that sometimes my grandfather would wake in the middle of the night and start taking things off the walls—paintings, photographs.

What are you doing? my grandmother would ask, half-asleep.

The Japanese are coming, he'd say. Can you hear them?

In the 1950s my grandfather was hospitalized. He stopped shaving. He wouldn't leave his room.

. . .

Scientists exposed mice to the smell of cherry blossoms and then administered electric shocks. Later they bred the mice, and when they exposed the offspring to the smell of cherry blossoms, the offspring were afraid, though they'd never smelled cherry blossoms before, though they'd never been shocked before, certainly not while smelling cherry blossoms.

. . .

My grandfather was an accountant when I knew him, and after he retired he spent much of his time in a workshop in his garage, among shelves of mason jars filled with screws and nails and washers, everything in its place. He built things for us, his grandchildren—birdhouses, dollhouses, stools we could stand on to reach the sink, tracks for an electric train fastened to a wooden table. He wrapped presents in his workshop, too, and the wrapping paper was striped, red and white, and he'd wrap with such precision, such care, that the stripes would line up on the sides of the box to form a square.

He almost never talked about the war, but when he did, he told just one story, the same story, about a monkey that boarded his ship, about how it made everything feel like a carnival.

. . .

The offspring of the shocked mice showed a fearful response to the odor of cherry blossoms. And their offspring, too. The

effect continued even if the mice had been fathered through artificial insemination.

Another study showed that the ability of mice to remember can be affected by what's in their mother's milk.

. . .

There was a story my relatives told about my grandfather's time at war. I remember it this way: my grandfather is on an aircraft carrier, second in line for takeoff, and the plane in front of him takes off, but instead of lifting into the sky, it falls into the sea, and the person directing the planes motions to my grandfather, tells him it's his turn for takeoff, but my grandfather refuses. He gets out of his plane and never flies again. He becomes a navigator instead of a pilot, stationed on a ship in the South Pacific, watching the stars.

. . .

Into fabric she's hand-dyed black, the artist Anna Von Mertens stitches the rotation of stars. A computer program lets her calculate the position of the stars at any time, in any place, and this is what she chooses: the first sighting of land by Columbus off the coast of the Bahamas, the Battle of Antietam, Wounded Knee.

Every stitch on Von Mertens's quilts is made by hand. She uses no machines, prefers what she calls *an uncertain line*, the dotted line of a hand stitch rather than the solid line of a sewing machine. Her quilts are memorials.

Tet Offensive shows the stars you would have seen had you been standing on the roof of the U.S. embassy in Saigon, Vietnam, on January 31, 1968, looking north, from 2:45 A.M. until sunrise on Tet, the Lunar New Year. A group of Viet Cong

blasted a hole through one of the walls of the U.S. embassy, a surprise attack on this holiday of the moon, part of a larger coordinated attack in urban centers throughout South Vietnam. Later, a Viet Cong captain would be executed in the street by a South Vietnamese general—a photograph you no doubt have seen, a photograph that helped turn American opinion against the war, the man's head moved by the force of a bullet, a man between the living and the dead.

Most military offensives take place in the final hours before dawn, Von Mertens learned during her research for the project. Dawn or dusk, the ending of one thing and the beginning of another. These are the stars above moments of rupture, she said, pivot points, when what came before is different from what follows.

. . .

The brains of the mice scientists shocked while they smelled cherry blossoms showed structural changes to the area used to detect odor. And the brains of their offspring had the same structural changes. The shocked-mice's DNA also exhibited chemical changes, known as epigenetic methylation, on the gene responsible for detecting odor. Scientists said these findings revealed that trauma can be transferred from one generation to the next, and the next, and the next. An inheritance written right into the body.

. . .

Before people donated their bodies to science, when dissecting human bodies was taboo and autopsies were not a routine part of medical training, doctors attended the public executions of

criminals, standing on the side, waiting with bags to collect the dead. They ferried the bodies from town to town, opening criminals' corpses in front of audiences, exposure a kind of last punishment, as if to say, Not even your death belongs to you. Anatomy theater. Some collectors, when dissecting bodies, looked for physical evidence of corruption, in the liver, lungs, spleen, in the heart or the bones, as if crime were hiding inside, waiting to be acted out.

. . .

I have the letters my grandfather wrote home to New Orleans during the war—some written while he is still stateside at the naval flight preparatory school in Liberty, Missouri, and the rest sent from the Philippines. My cousin bound copies of seventy-five of his handwritten letters and gave navy blue books to my siblings and me. *Here is Grandpa before any of us knew him,* he wrote in the inscription.

My grandfather's first letter (May 7, 1943) is mostly about food—*After arriving here we ate—what a meal—all you can eat— including meat . . . milk at every meal*—which gives the impression that there must not have been enough food at home, not enough meat, not enough milk. He was the oldest of seven children, and there was a war on, rations, and some of his letters suggest his family didn't have enough money for a stamp. *Hi Folks: I've been writing for a week almost, yet no letter in return—can anyone write, or is it that a stamp costs money and money is scarce?*

Whenever I'd leave my grandparents' house after a visit, my grandmother would stuff a twenty-dollar bill in the pocket of my jeans. Buy yourself a Coke, she'd say.

. . .

The most existential form of mapping is looking up at the stars and knowing where we fit in the giant puzzle of things, Von Mertens said in an interview. During many of the title events of her quilts, the stars would not have been visible to the human eye, but they were still there. *I am simply documenting an impassive natural cycle that is oblivious to the violence below,* she said.

. . .

I never asked my grandfather about what happened on the aircraft carrier that day, when the plane took off in front of him and fell into the sea. Did the other pilot die? Did they retrieve his body? Was he my grandfather's friend? Did my grandfather cry? Did he get in trouble for refusing to take off? My grandfather was still alive when I realized there were questions to ask, but it was already too late. He had Alzheimer's. And now he is dead.

P.S. *Yesterday I—never mind. I'll tell you next letter.*

. . .

A few months ago, I asked my father all the questions I should have asked my grandfather, and I learned the story I remembered wasn't right at all. My grandfather never saw someone take off from a flight carrier and crash. He was never next in line. He never refused to fly. It didn't happen that way. It was a friend in flight school who died, someone he knew, someone he liked; something went wrong during an operation and the wing of his plane came off and he died. That was when my grandfather decided to be a navigator, even though in flight school, navigation was the one course he was afraid he wouldn't pass.

In a letter to his brother, dated March 4, 1944, my grandfather mentioned a plane crash: *One can never tell what an airplane will do—they're O.K. while flying but when the wings lose their lift and they quit flying all hell breaks loose and they fall like a brick.*

. . .

Von Mertens's decision to make quilts was influenced by moving-company blankets, those blue padded coverings stacked in the back of trucks. The blankets protect objects in times of transition, as they're carried from a familiar place through the unfamiliar.

For *September 11*, she stitched the movement of the stars above New York City, looking toward Boston, between 8:45 A.M. and 10:28 A.M., the time between when the first plane struck the first tower and the second tower collapsed.

And then there is *Baghdad*, the stars on March 20, 2003, at 5:34 A.M. as seen from the Palestine Hotel looking toward the Presidential Palace on the Tigris River. You can make out the constellation Scorpio tracking across the southwestern sky, though any starlight would have been eclipsed by bombs, which lit up the early dawn.

. . .

I found a website about the ship on which my grandfather was stationed. There were photographs, videos, battle stories, tales about practical jokes—and an anecdote about the monkey my grandfather sometimes talked about. But it wasn't anything like the version of the story he used to tell. It was a different kind of story altogether.

The captain of my grandfather's ship (*LSM-51*) and the cap-

tain of another ship (*LSM-318*) were good friends *and when possible nested the 51 and 318 together,* the website said. The *318* had a mascot—the monkey—and sometimes the monkey would visit my grandfather's ship. *Now that monkey was an all right guy except he was not too careful where he urinated, which usually was on someone's bunk.*

On December 7, 1944, the *318* got stuck on a sandbar with three other ships. The captain of the *51* didn't want to leave his friend stranded, a sitting duck for kamikazes, so he brought his ship alongside, tied the boats together, and tried to pull the *318* off the sandbar. While the two ships were tied next to each other, the monkey came aboard the *51*. *We caught the monkey and tossed him back to the guys on his ship.* But then the monkey was back on the *51*. Again, they caught him and tossed him back aboard the *318*. It was a game—the monkey going from one ship to the other, then getting thrown back again—until they received a message from the task unit commander to *get the hell out here with the convoy,* and they had to leave the *318* behind, marooned on the sandbar. As they pulled away, much to their amazement, they discovered *an extra hand on board.*

That darn monkey.

He'd abandoned his ship.

But that's not the end of the story. A photograph on the website shows black smoke billowing from the *318*. It was struck and sunk by a kamikaze.

After his friend's ship was attacked, the captain of the *51*, my grandfather's ship, decided *the monkey deserved no better fate than the shipmates he deserted.* The sailors were ordered to capture the monkey. *A chase ensued . . . monkey here and monkey there. At last he was taken into custody.* They held a trial. The monkey was found guilty of desertion. The captain gave the

order for the monkey to walk the plank. *The last we saw of him he was swimming like the devil for shore.*

. . .

My grandparents lived a mile and a half from my house. When I ran or rollerbladed there, my grandmother would answer the door and say, I've been needlepointing—or saying the rosary, or making spaghetti sauce. My grandfather would be in his workshop or his office, and if he wasn't too busy he'd let me make copies on his copy machine, my hands, my face, a dollar bill.

On the mantel of my grandparents' fireplace sat a battery-operated toy monkey. Red-and-white-striped pants. A yellow vest. Two cymbals, one in either hand. When you wound the switch in his back, the monkey would hit the cymbals together, making a terrible clanging noise, and his eyes would grow wide, his mouth even wider, baring his teeth.

. . .

In my family, there are sentences that are repeated though they are never explored, never expanded, and the failure to ask questions—my failure to ask questions, to grieve—reveals a failure to see my relatives as fully human, as people who lived long and complicated lives before I showed up on the planet, people in pain, carrying things I could not see. Trace any line of my family tree, and almost everyone was in some kind of battle.

One of the repeated sentences about my grandfather was this: *Your grandfather's father died while your grandfather was away fighting the war.*

. . .

The monkey incident happened on December 7, 1944, during the period of time in which my grandfather stopped writing letters home—or the period in time from which I don't have any of the letters my grandfather wrote home. If he wrote any, they are not in the book bound by my cousin.

There is a ten-month gap between the letter dated June 11, 1944, and the letter dated April 18, 1945, so I don't know if my grandfather was on the ship when the *318* was hit by a kamikaze, and I don't know if he was involved in making the monkey walk the plank or if he tried to save the monkey, and I don't know if he watched the monkey fall into the water or turned away because he couldn't bear it. I do know my grandfather liked that monkey. I know he smiled when he talked about him, clapped his hands in delight.

After I found the website about my grandfather's ship, I went back through the letters to see if I could find any mention of the monkey, any mention of the ship hit by the kamikaze. On March 29, 1944, my grandfather wrote about receiving a telegram telling him his uncle Walter had died. *Sorry I couldn't get to come home,* he wrote. *There wasn't much I could have done but just being there would have meant a lot to me. . . . Did my flowers arrive on time?—I do hope so—that was the most I could do to express my feelings in an outward sign, although inside no one knew but myself how I felt of the whole situation, especially being away from home.*

From a letter dated May 9, 1944, I learned his father had been sick: *How is Dad feeling these days—bet he's raring to get out of that miserable hospital. He'd better stay there for a while yet and catch up on some of his loafing.*

Then there is a letter written only to his father, dated June

11, 1944: *Tell Mom you received a letter from me and the boy seems to be in the best condition.*

And then there are no letters at all until one written to his mother on April 18, 1945. *Dear Mom,* he wrote. *Payday for the crew today and now everyone has lots of money and nowhere to spend it. I'll send $300 in money order just as soon as I am able to get one. . . . Do you think it would be possible to send me some hot peppers?*

All of his letters before this April letter were signed *Bro,* but this April letter, written only to his mother, was signed *Irwin,* which is my grandfather's name, which is his father's name, which is my father's name, which is my brother's name, and because he signed his letter this way, using his father's name, I know his father is dead.

. . .

If a traumatic event can alter the brains and DNA of mice and their offspring, if a fear of cherry blossoms can be passed from one generation to another, what else can be passed down?

Darold A. Treffert, a psychiatrist in Wisconsin, keeps records about people who, through a head injury or dementia, acquire skills they were never taught. *Conceivably,* he says, *those skills, like music, mathematics, art and calendar cutting, were buried deep in their brains.* Treffert calls it *genetic memory* or *factory-installed software,* dormant knowledge that emerges when a damaged brain *rewires itself to recover from injuries.*

Unearthing hidden information that has been passed down does not always require trauma. Treffert pointed to birds born knowing migration patterns for places they've never been and to monarch butterflies that make a 2,500-mile trip from Canada to a small plot of land in Mexico and take three generations to return.

. . .

In that April letter to his mother, the first letter signed *Irwin*, my grandfather wrote this: *A memo on the bulletin board tells us that we'll be allowed to write more facts about our last operation in about 3 weeks. Several of the boys had their mail returned because they have written too much restricted information. Have any of my letters to you been cut? I try to write as much as I possibly can without breaking the boundaries.*

. . .

In a quilt titled *Hiroshima*, Von Mertens stitched the stars as they would have appeared on August 6, 1945, between 8:00 A.M. (when the air raid alarms were lifted) and 8:15 A.M. (when the bomb was dropped). It was daylight, so no stars would have been visible, but here, *the stars act as a witness to the new world dawning below.* The air raids were lifted, the warning called off, because the radar operator saw only a handful of aircraft approaching—three airplanes, to be exact: the *Enola Gay* (which was carrying the bomb), a surveying craft, and a plane transporting a crewman whose job was to take photographs—and the radar operator couldn't imagine that three planes could carry such destruction.

. . .

This is the *last operation* my grandfather referred to in that letter to his mother: the day President Roosevelt died, April 12, 1945, my grandfather's ship was sent on a mission. Sixty Japanese survivors of a previous attack had taken refuge in Fort Drum, El Fraile Island, at the mouth of Manila Bay in the Phil-

ippines. Called the concrete battleship, the fort resisted all efforts of infantry, engineers, and artillery to penetrate it. The Japanese soldiers were using the fort as a lookout, reporting on the movement of ships. So American soldiers came up with a plan to destroy the fort—and they practiced *until they could do it in their sleep.*

On the day of the attack, a Friday, my grandfather's ship pulled up alongside Fort Drum and lowered a ramp the crew had constructed, so men from the ship could board the fort. Some carried strong lines, which they fastened to Japanese-held gun turrets to make the boat secure, though their lines did not stop the boat from pitching and rolling. They unloaded six hundred pounds of explosives and placed them so they'd do the most damage in the least amount of time.

While they sited their explosives, other men ran a hose from the *LSM-51* to the fort and pumped a mixture of diesel oil and gasoline into Fort Drum through an air vent. *It was like a high colonic enema given at sea to some ugly, gray Jap monster of the deep,* the website said. Three thousand gallons *squirted into the bowels of Drum.*

In ten minutes, with all the explosives planted, the thirty-minute fuses were lit. The men walked the ramp back to the ship.

But the line they were using to pump oil and gasoline into the air vent broke, stopping the flow, and men were sent from the ship back onto the island to extinguish the fuses and repair it. While they worked, a Japanese sniper from Fort Drum fired on my grandfather's ship. The men could not fire back for risk of igniting the leaking oil and blowing themselves up. *The sailors held their fire.* The sniper fired again, and *a bullet cut through the fatigue jacket* of the colonel's driver and radio operator. Another man was shot in the hand. Shrapnel *embedded in the throat*

of a third. Three casualties: *a bargain-basement price to pay for Fort Drum.*

When the leak was repaired, the men relit the fuses on the island and re-boarded the ship. The lines connecting my grandfather's ship to Fort Drum were cut. The ship moved away.

Thirty minutes later, there was a small explosion, *not much more than a 4th of July token.* Then, nothing. The soldiers and sailors were disappointed; they'd have to do the whole thing again. But then, a second explosion. And in *the time of an eye-wink,* the whole island fort was *blown out of the sea.* Clouds of smoke. Showers of debris. Concrete slabs exploding hundreds of feet into the air. Sailors cheering.

This language—*blown out of the sea*—is not an exaggeration. You can watch a video of the invasion. You can watch the men walk the ramp from the ship to the fort. Watch them carry the line through which they will pump the gasoline. Watch the mixture of diesel and gasoline pour through the vent. Watch the first explosion. Watch the second, the whole island coming apart. The sea, alive with rubble, appears to be boiling.

I studied the video again and again, looking for my grandfather, pausing it every few seconds to stare at the screen, but it was impossible to find him.

. . .

Two days after they blew up Fort Drum, a Sunday, April 15, the men went back to the fort to see if they could get inside to assess the damage, but *wisps of smoke still curling through the ventilators* made it clear that oil was still burning inside. They tried again on Monday, April 16, but there was still too much smoke, though they found eight bodies, *dead of suffocation.*

Two days after that, April 18, the island had cooled enough

to allow a landing party to explore what was left. *The bodies of 60 Japs—burned to death—were found in the boiler room on the third level.* The fort was in shambles. Everything blown to pieces or burned.

It had been a successful operation in every way but one, the website reported. *The souvenir hunting wasn't very good.*

Had my grandfather been part of the landing party? Did he look for something to keep? Did he find the burned bodies? Did he count them? Did he touch the smoldering remains? Did the smell stay in his nose long after he was back on the ship?

On April 18, the day the landing party explored the island, my grandfather wrote that letter to his mother, the letter on which he signed off as *Irwin* for the first time and asked, *Do you think it would be possible to send me some hot peppers?* He suggested the best way to send them. *They would have to be preserved in vinegar, or something, well sealed, packed in a strong box, preferably wooden, and wrapped. Half a pint or pint jar would be plenty—I'm dying to eat some with a steak!*

. . .

In her book *Precarious Life*, Judith Butler wrote, *My body both is and is not mine. Each of us is implicated in lives that are not our own.* To make her point, she pointed to grief: *If I lose you, I become inscrutable to myself. I think I have lost you but "I" have gone missing as well.*

. . .

My grandfather put hot sauce on everything—eggs, peanut butter sandwiches, even ice cream, to make his grandchildren laugh. He ate hot peppers straight from the jar, licking his fin-

gers, smacking his lips. No pepper was ever hot enough for him. On Christmas and his birthday, we'd give him the spiciest things we could find—sauces, peppers, marinades—and he'd open our presents and hold the jars up to the light and say, *Hot damn,* something he continued to say even when he had Alzheimer's, even when he didn't know where he was and cried out from his bed that he wanted to go home and called for my grandmother, forgetting she'd died years before.

Now I wonder whether every time he ate a hot pepper he thought of Fort Drum and those bodies on fire.

. . .

If fear of cherry blossoms can be passed to your children if you've been shocked while smelling them, can the fear ever be lifted? Can trauma be undone? Can you put the children of those who've been shocked in an orchard of cherry trees in bloom, in springtime, the sun warm, the still-cool air sweet, the ground pink with petals, and can you let them run free until they are no longer afraid, until their children are no longer afraid, and their children, and their children? Can it be passed back, that kind of healing? Can it be offered to previous generations? Can the children say, *Ours is a different kind of world,* and can that be enough?

. . .

In the stairway of our house hang photographs of my ancestors. In one, my grandfather wears his naval uniform: dark tie, white shirt, light jacket with dark fabric and shiny buttons on his shoulders, hat with a dark brim and an anchor. He is young,

younger than me by two decades, and he is just about to go to war.

. . .

Miles is a father now, and sometimes when we Skype, I get to see his son, also named Miles, the spitting image of his father, sitting on his lap, both of them smiling.

. . .

I once asked my grandfather if he was ever scared during the war, and he described a time his ship was stranded on a sandbar and he watched the sky, looking for kamikazes.

Decades later, my father will tell me that because my grandfather's ship was stuck, they missed a major battle. A bloodbath, my dad will say. A slaughter.

. . .

In a letter dated July 5, 1945, my grandfather wrote this: *Someone started the scuttlebutt about the war being over in two months or thereabout, and now many of the boys including myself are talking about the possibilities and probabilities of that dream. Tomorrow would be 3½ years too late.*

10.

CALL OF DUTY

When did you know you were against war? I asked Howard the first time I visited.

Is there anyone who's for it? he said.

. . .

The commercial for the videogame *Call of Duty: Black Ops* shows people in their work clothes—suits, aprons, scrubs, short-sleeved knit shirts, suspenders, football jerseys—firing machine guns, throwing grenades, running for cover in a burned-out, blown-up, rubble-filled landscape that in the end bursts into flames. In letters across the screen: *There's a soldier in all of us.*

. . .

Starting in October 1940, after Congress passed the Selective Training and Service Act—the first peacetime draft in U.S. history—American men could be drafted by lottery and, if drafted, had to serve in the military for twelve months, a year of training and preparing for a war that the country wasn't yet involved in. In the early summer of 1941, Roosevelt asked Congress to extend the twelve-month time limit, and the bill squeaked through the House by one vote; the Senate approved it by a wider margin. Roosevelt signed the extension into law.

Soldiers across the country registered their protest on the walls of their barracks and inside latrines and on the hoods of trucks, painting the letters o h i o, which stood for *Over the hill in October* and indicated they intended to desert when their original time was up.

Then, on December 7, 1941, Japan bombed Pearl Harbor.

. . .

Caddis flies—small winged insects closely related to butterflies and found in almost every river on the planet—lay masses of eggs in a jelly that swells when it contacts water. The larvae hatch within a few days.

Some species of caddis fly larvae protect their bodies by spinning tubular silk cases that enlarge as they grow. The larvae add natural material from their environment to the cocoons—grains of sand, twigs, leaf fragments, fish bone. The cocoons are portable, dragged around by the larvae like snail shells. Before the last molt, they attach solid objects on both ends for further fortification.

. . .

After the bombing of Pearl Harbor, Gordon Hirabayashi—Howard's former college roommate—applied for and was granted conscientious objector status. Two months later, Roosevelt issued Executive Order 9066 and Japanese Americans on the West Coast were removed from their homes.

Hirabayashi continued to go to school at the University of Washington in Seattle. There was a curfew—an hour by which all Japanese Americans had to be off the streets, in their own houses—but he refused to follow it. He also refused to report to an internment camp. *As an American citizen*, he said, *I wanted to uphold the principles of the Constitution, and the curfew and evacuation orders which singled out a group on the basis of ethnicity violated them.*

The day after Japanese Americans were removed from Seattle and sent to a temporary prison camp at the Puyallup Fairgrounds, Hirabayashi stayed in the city illegally. He went about his business, *living and moving about freely as a law-abiding citizen.* He later turned himself in to the FBI because he wanted to be arrested to create a test case for the government's right to incarcerate its own citizens without due process. When they searched his home, FBI agents found his diary, in which he'd written about his intentions to disobey curfew. He was indicted, arraigned, and convicted in October 1942.

. . .

In the year 295, Maximilian, a twenty-one-year-old from Numidia, in North Africa, the son of a soldier, refused to join the Roman army. He said that as a Christian, he could not use violence.

He was executed, beheaded by sword.

. . .

In *Call of Duty,* your point of view is the point of view of a person holding a gun. First-person shooter. You come to a door. *Shoot the hinges on the door,* read the directions on the screen. When you don't shoot the hinges, a voice says, *Shoot the hinges.* You move your gun around to see what is next to you. Other soldiers. Some kind of balcony. *Shoot the hinges,* the voice commands. You move your gun again, to determine what else you can see. A mountain. Clouds. *Shoot the hinges,* the voice says. And then the written directions again: *Shoot the hinges on the door.* There are at least three other soldiers with you. One wears a face mask. You point your gun at the soldier wearing a knit cap and sunglasses. You put his face in your sight so it is magnified. And then you see the voice is his. *Shoot the hinges,* he says. *Shoot the hinges.* You point your gun down and over the balcony. You are on the side of a mountain. There are evergreen trees. It is snowing. *Shoot the hinges.* You walk out into the snow. The voice sounds farther away. *Shoot the hinges.* You keep walking into the snow.

. . .

Did I tell you about when we decided to get married? Howard asked.

He was home on furlough from the CPS work camp in San Dimas, and he and Ruane were walking along the shore of Green Lake in Seattle, waltzing, skipping down the shore, and Howard said, You know what?

What? Ruane said.

I think we oughta get married.

I think so, too, she said.

And they walked back to Howard's house and asked his sister to be the observer, registered for a marriage license, and married the next day, February 8, 1942, in the basement of the Methodist church down the street. They wrote their own vows.

We married ourselves, Howard said, and the priest was glad about it. He thanked us.

It worked, Howard said. It stuck. We celebrated our sixtieth anniversary right before Ruane died.

The people gathered in the basement of the church that day found the whole thing so lovely they didn't throw rice, Kayleen told me. They handed it to them.

. . .

When conscription was introduced in Egypt in the early 1800s, men injured themselves so they'd be declared unfit for military service. Some had limbs amputated. Others blinded themselves in one eye. Still others pulled out their own teeth (teeth being essential for tearing open shot packets) or cut off their trigger fingers. But the army didn't let them off the hook; instead, it set up a corps for disabled musketeers.

. . .

After he was convicted of disobeying the internment order, Hirabayashi was the first Japanese American imprisoned at the Tucson Federal Prison Camp, in Arizona. The number of inmates soon grew as other Japanese Americans arrived, some of whom were resisting the draft. Strange as it seems, it was possible to be forced out of your home and into an internment camp because of the possible military threat you posed—and

then to be drafted into the military by the government that had interned you. Some draft resisters were transported to Tucson by train in iron chains.

The Tucson Federal Prison Camp was a minimum-security penitentiary. Barracks, kitchen, mess hall, power plant, sawmill—but no fences, no barbed wire. It was called an honor camp, painted white lines the only things used to keep the prisoners inside.

The prisoners were free labor. They worked to build a road on the south side of Mount Lemmon, near the prison. They busted rocks, jackhammered, set explosives.

Every month during the war, prison officials gave the inmates the chance to commute their sentences if they would join the military. The War Department—for the first time in history—granted all nonviolent offenders early parole from prison if they enlisted. None of the forty-four Japanese Americans who'd refused to follow Executive Order 9066 accepted this offer.

I was able to hold my head up high, Hirabayashi said, *because I wasn't just objecting and saying "no," but was saying "yes" to a prior principle, the highest of principles.*

. . .

During the Civil War, Congress took over the administration of conscription from the states. The first national draft, signed by Abraham Lincoln in March 1863, provided an exemption for anyone who could find a substitute or pay a $300 commutation fee. The poor called conscription a *rich man's act.*

In the Confederacy, the draft law of 1862 exempted certain occupations from service—newspapermen, lawyers, school-

teachers, and shipbuilders, among others. *Fraud was rampant,* Lillian Schlissel wrote in *Conscience in America.* Schools were opened without students, newspapers printed without readers.

Quakers, Mennonites, Brethren, and Nazarenes were also exempt, with the understanding that they would hire a replacement or shell out $500. But many conscientious objectors couldn't afford to pay a fee or hire someone to go to war for them. Some were tortured, hung by their thumbs or pierced by bayonets for refusing to carry a musket. Many were imprisoned. With few options, some joined the military as cooks. They shot over the heads of their enemies to avoid killing anyone. Mennonites in Virginia hid out in the hills until the war was over.

· · ·

The artist Sabina Haque was raised in Karachi, Pakistan, by an American mother and a Pakistani father. *Call of Duty: Modern Warfare* uses her hometown as a location for war—aerial and reconnaissance images, an invented military map, flat, drained of color, labeled in Arabic, though the official languages of Pakistan are English and Urdu.

In a series titled *War Games,* Haque enlarged and printed the videogame's imagined landscapes, and then she painted over them, adding sky, trees, buildings, stars, swirling blues and pinks and oranges.

· · ·

Conscription in World War I was *universal and absolute.* You could not hire a substitute. You could not pay a commutation

fee. Regular citizens carried out *slacker raids,* challenging any man of draft age on the street still wearing civilian clothes.

Some men claiming conscientious objector status accepted noncombatant status and served in medical or engineering corps. Others were granted farm furloughs. A few refused both conscription and alternative service and were court-martialed and imprisoned, with sentences averaging sixteen and a half years. Guards admitted to feeding prisoners only bread and water, placing them in solitary confinement, hanging them by their thumbs.

One conscientious objector refused to wear an army uniform while he was alive. When he died in prison, guards dressed his body in uniform and sent him home to his parents.

· · ·

To hatch, caddis flies cut themselves free of the cocoon and emerge as fully formed adults still inside thin, flexible pupal skins. They generate air bubbles inside this skin, which allows them to float and drift in river currents, where they are vulnerable and helpless, until they reach the water's surface, shed their skins, and rise.

· · ·

In World War II, 72,354 men applied for conscientious objector status. Of these, some 25,000 served in the military in noncombatant roles. Another 27,000 failed the basic physical examination. There were also conscientious objectors who refused to register for the draft, believing the draft itself supported killing; 6,000 of these men went to jail. Roughly 20,000 conscientious objectors worked in Civilian Public Service on the home

front. Some, like Howard, fought forest fires. Others built conservation projects in rural areas, took care of the mentally ill in hospitals, or participated as guinea pigs in medical and scientific research. By 1947, CPS men had logged over eight million days of work in more than 150 camps.

. . .

In October 1942—eight months after they were married, the same month Hirabayashi was convicted—Howard and Ruane decided conscientious objection with alternative service in the CPS camp was no longer protest enough. Now that their country was interning its own citizens, they could not support the war effort in any way.

War is an institution, and institutions are external expressions of previous inner attitudes and ways of thinking, Howard wrote. *To try merely to alter the institution is like locking the barn door after the horse is stolen.*

They made a plan and drafted a letter:

October 22, 1942

Mr. Oscar O. Marshburn, director
San Dimas C.P.S. Camp
Glendora, California

Dear Oscar:
Just as I would have no intention of keeping from you my thoughts and criticisms which concern you, so must I inform you of my intended action. This will let you know that I shall be absent without leave from San Dimas Civilian Public Service Camp starting Monday, October 26, 1942.
I have no residence address to give but I shall keep you in-

formed of my whereabouts and notify you of an address as soon as possible.

> *Sincerely:*
> *Howard B. Scott*

. . .

The French artist Hubert Duprat collected caddis fly larvae and relocated them to his studio. He removed their natural cocoons and placed them in aquariums with materials they could use to re-create their protective coverings—gold, turquoise, opals, lapis lazuli, coral, pearls, rubies, sapphires, diamonds. A laboratory in which they have no choice but to construct their shells out of gold, Duprat said in an interview. You can watch videos of the caddis fly larvae at work. Watch their six thoracic legs hold one gold flake after another. Watch as they secrete silk they use like mortar.

A few weeks later, winged, the larvae left their homes, and Duprat saved their tiny jeweled cocoons to display on pedestals in museums.

. . .

Howard walked out of the CPS camp on Monday, October 26, 1942. Ruane picked him up and drove him to a friend's house, where they stayed until he was arrested.

When Howard was in jail awaiting trial, a minister visited the locked-up men, all of whom were there for crimes other than resisting the war. He went from cell to cell, telling the good news he believed would save the souls of the prisoners,

whom he saw as sinners. When he reached Howard's cell he asked, Are you saved?

I would question why you question me, Howard said. I'm here because I refuse to kill people. Why are you here?

The minister said nothing. He turned and left.

Don't come saving souls before you know what the story is, Howard told me. The minister was worried about the wrong sins. He was looking for repentance where he'd never find it.

We each have exchanges to make, Howard said. Every life is valuable in its own way.

. . .

The trailer for *Call of Duty: Infinite War* extends war into space. Planets. Moons. Spaceships. No landscape untouched. David Bowie's *Space Oddity* plays in the background: *Planet Earth is blue and there's nothing I can do.*

. . .

Ruane went to visit Howard at the jail, but when she arrived, he was gone and no one would tell her where they'd taken him. It was February 8, 1943—their first wedding anniversary— and with the only money she had left, she bought skeins of blue wool and a bus ticket home.

. . .

At the beginning of *Call of Duty: Advanced Warfare,* your character's best friend dies—and then you attend the funeral. A coffin. A photograph of your dead friend in uniform. Flowers.

Soldiers with guns ready to salute. Sunlight. A tree in bloom. Dark cars lined up on the street. White tombstones in green grass as far as you can see. Then these words on the screen: *Hold X to pay respects.* If you want the game to continue, you have to press the X button on your controller. That is the only way to mourn, and mourning is the only way to keep playing.

. . .

On the Selective Service System's website, I read this: *a man's reasons for not wanting to participate in a war must not be based on politics, expediency, or self-interest. In general, the man's lifestyle prior to making his claim must reflect his current claims.*

. . .

I broke the law because I had to, Howard said.

In the middle of the trial, when the prosecutor was going after Howard, calling him a criminal and a traitor, the judge interrupted him. This is a man of conscience, the judge said, beating on his desk with his fist. This is not a criminal. You will not speak to him that way again. And then he sentenced Howard to prison in Tucson. That's what civil disobedience is. You break the law to make a point, and you accept the consequences.

While Howard was in prison, Ruane knit him a blue cardigan from the wool she'd bought outside the jail.

Howard was released four and a half months later, and he and Ruane moved to a farm near Newberg, Oregon, that belonged to Paul and Margaret Michener. Paul had been a conscientious objector during World War I. Howard worked in the dairy.

A few months after he was released from prison, in November 1943, Howard was drafted a second time. He wrote a letter to the draft board, reminding its members he was a conscientious objector, that he would not fight, reminding them he would not report to the CPS camp either, in protest of both internment and conscription.

If the people were convinced of the rightness of militarism and this war, then there would be no need for conscription, he wrote. *The people would volunteer. . . . I believe in the supreme worth and divinity of human personality. . . . I believe, too, that war and its methods are no solution to the conflict situations which confront us. In the end we shall find that love and kindness is the only creative way to solve our problems. It seems to me, then, that I can best serve my country and my people through disobedience to something so counter to our way of life.*

Ruane was pregnant with their first child when Howard was sentenced to prison again. They asked for his prison term to be delayed until their child was born. Howard was granted a few months with his daughter before he was sent to McNeil Island Penitentiary, in Washington. He was there for almost two years.

11.

SMALLEST POSSIBLE WEAPON

At McNeil, Howard worked in the prison's dairy. He tended the cows' hillside trails, which allowed him to spend time outside, learning the names of plants, birds, constellations.

Interested in your desire for study of the constellations, Ruane wrote in one of her letters. *I, too, want a deeper understanding of stars. I think it is important to ever keep aware of the greatness that exists around us. It is so easy to become entangled in personal cares and wants. . . . There is something in this angle of thought that lifts us beyond ourselves and helps us see the greater truths in living.*

Walking the trails, Howard came across an abandoned building that looked like an old barn. The padlock on the door was broken, so he stepped inside and found old tools and benches for woodworking.

He talked about what he'd seen with one of the prison of-

ficials, who shook his head and told Howard he shouldn't have been out there.

I told him I wanted to do something, contribute, create opportunities for the people incarcerated there, Howard said.

Howard and the prison official drew up plans for turning the building into a woodshop. Eventually, it was made into a well-equipped place, Howard said.

. . .

At Baghdad International Airport, Miles walked blindfolded detainees up ramps to board planes that would transport them to different prisons.

I felt like Noah, herding animals onto the ark, Miles told me.

One of the men was so afraid while walking up the ramp, his whole body shook. Miles wanted to tell him it would be all right, but they didn't speak the same language, and even if they had, Miles didn't know the right words to say, so he put his hand on the prisoner's shoulder, hoped he could communicate everything in that touch.

It was loud on the planes. The detainees opened and closed their mouths to try to pop their ears to adjust to the changing pressure, and it looked funny, so the soldiers laughed at them. Miles laughed, too, not because it was funny but because he was nervous, because it was absurd.

One of the detainees urinated on himself. Another threw up.

They were strapped down like cattle, Miles said.

. . .

When Howard wasn't in the dairy, he worked in the prison woodshop, where he made things to send to Ruane and his

new daughter. Wooden buttons. Teething spoons. A wagon with wheels fashioned from a crate that held apples. Puzzles. Blocks. A little bird with a long beak.

One of the prisoners who also spent time in the woodshop was making a violin. He and Howard became friends, and watching him work on the instrument, Howard decided he'd like to build a violin, too, but before Howard could learn everything he needed to know from his fellow inmate, the man was released.

There are no books on violin making here nor do I know of any, Howard wrote to Ruane. *Chances are that my first product will turn out poorly, but I should learn many lessons.*

He asked her to send materials—tailpiece, fingerboard, bridge, set of strings, pegs, chin rest, glue, shellac. Then he asked her for a book that might have instructions he could follow to make an instrument from scratch.

Ruane found a library book—*Violin-Making*, by Edward Heron-Allen, published in 1885—and copied out the directions for Howard, cramming as many typed words as possible into the two pages she was allowed per letter, three letters per week: *Wood most generally employed for backs of fiddles is maple, though pear and sycamore are sometimes used. White pine is best for belly. . . . Maple should be sound, without knots or cracks, grain run evenly and not in curves or waves. If wood is too hard, tone will be hard; if too soft, tone dull. . . . I'm keeping the folks awake, so I will have to continue tomorrow. Oh, I wish you had this book.*

She drew diagrams for the violin in pencil. Body. Back. Neck. Belly. Bridge.

At the end of each letter, Ruane included news about their daughter. *She walked the length of the room today unassisted and several times went at least 15 steps all alone.*

I can feel the love that went into the drawings and explanation,

Howard wrote back. *And now since I have the new pattern I intend to discard the one I made.*

. . .

We are at war, Barack Obama said, accepting the Nobel Peace Prize in 2009. *And I'm responsible for the deployment of thousands of young Americans to battle in a distant land. Some will kill, and some will be killed.*

. . .

The first time Miles thought he was going to die in Iraq was his third day there. He was on the lead bus in a convoy of many buses bringing prisoners to the airport. The driver didn't speak English. He was Iraqi, and he was driving super slow, Miles told me. Miles yelled at him to drive faster, but he wouldn't.

No one had told Miles the rules. No one had explained to him what to do on a bus with a man driving it too slowly. There were so many people on the bus—fifty detainees, Miles and another American soldier, two Iraqi policemen. Miles didn't know if he was supposed to shoot the driver for endangering them.

He didn't shoot the driver.

. . .

In Rory Kennedy's *Ghosts of Abu Ghraib,* a soldier says he was told this when he arrived in Iraq: *If it looks like the enemy, shoot it.*

. . .

A professor of mine, a theologian, showed signs of dementia, and when he realized he was losing his mind, he stopped teaching, but he kept reading. Philosophy. The Bible. Poetry. When I visited him, there were books stacked on side tables and laminated notes pinned to the walls, reminding him what to do. *Turn off the stove. Turn on lights. Brush teeth.*

He was a Mennonite, had been a conscientious objector during World War II, and after he died, I heard this story from a friend: My teacher was eating lunch at home one day when the doorbell rang. He answered the door, and a stranger was standing on his front steps holding a scythe he'd taken from a neighbor's garden shed.

Come in, young man, my teacher said. Are you hungry?

He made the man with the scythe a sandwich, and they sat at the kitchen table, a table my teacher had built, and ate.

Where are you headed? my teacher asked.

I plan to take a bus north, the man said.

Let me drive you to the station, my teacher said.

The man laid the scythe against the back wall of my teacher's house, and then sat in the passenger seat of my teacher's car and rode to the bus station. They shook hands at the station, standing on the curb. Best of luck to you, son, my teacher said.

When his daughter heard what had happened, what my teacher had done, she was furious. That guy could have killed you, Dad, she said. Why didn't you call the police?

Why on earth would I have done that? he asked.

. . .

Absolute pacifism: Some pacifists refuse even self-defense. Others allow for personal self-defense but reject the impersonal and political violence of war.

Every defender of pacifism recognizes the impossibility of life without violence. Even Gandhi knew you can't live, not even for a moment, without committing *himsa* (violence). Nevertheless, if the actions of a person dedicated to *ahimsa* (nonviolence) spring from compassion, if she tries, to the best of her ability, to avoid destroying even the tiniest creature, if she tries to save it, striving to be free from *the deadly coil of himsa,* she remains true to her faith.

. . .

Howard found a fallen maple tree on his walk to the dairy and asked a guard for permission to use the wood for the violin. The guard agreed. Howard took the wood to the prison's piggery and boiled out the sap to speed up the conditioning process.

Howard worked on the violin every day. He made his own calipers. He drew, cut, carved, whittled, glued. Other inmates helped. Howard found discarded metal fragments, which the prison blacksmith forged into tools for him—three knives, a few chisels.

The violin became a bridge, planks of wood laid across the water, Ruane and their daughter on one bank and Howard in a prison cell on the other.

Ruane sang to her children all the time when she was alive, and she still sings now, Kayleen told me. Songs come to Kayleen and her sisters like messages. One hums a few bars, the next sings a verse or two, and the third puts it all together.

. . .

Perhaps the most profound issue surrounding my receipt of this prize is the fact that I am Commander-in-Chief of the military of a nation

in the midst of two wars, Obama said, accepting the prize for peace. *War, in one form or another, appeared with the first man. . . . We must begin by acknowledging the hard truth: We will not eradicate violent conflict in our lifetimes. There will be times when nations—acting individually or in concert—will find the use of force not only necessary but morally justified.*

. . .

When Kayleen was in high school, she and her fellow students gathered to watch a documentary about the Nuremberg trials. Kayleen sat next to her friend Ruth and watched the black-and-white 16mm film: The courtroom. An assembly of men. Nazi defendants in suits, hands folded in laps, a row of soldiers in uniform behind them.

Military photographers serving with the Allied armies had captured footage of the death camps—and these films were projected onto a screen during the trials, the lights dimmed, the courtroom turned into a theater. Hearing about the atrocity is not enough, a voice on the film shown in that courtroom said; you have to see it.

First a map with the names of prison camps fills the screen. Then a room with a pile of bodies stacked high. Close-up of a face, decomposed, nose gone. A layer of dead bodies along the ground, striped clothing, ribs, knees. A man in a suit jacket wearing a beret, holding a naked man by the forearm and the upper arm, and the naked man's ribs and hips are visible, as if they will soon rupture his skin, wounds under his eye, on his cheek, and the camera zooms in, close to his face, no tenderness offered by the man in the beret, no tenderness offered by the camera, the man's naked body on display, an exhibit, evidence of what has been done, his eyes wide. Then an American soldier is inter-

viewed, a prisoner of war. He's from Hollywood, California, he says, *but believe it or not this is the first time I've been in a movie.* Then more dead bodies, their outlines visible beneath blankets, and someone lifts a blanket to show a dead man's belly, on which has been tattooed a number and the name of the place he was from. Piles of dead bodies. Piles of dead bodies. Piles of dead bodies. Then the extermination plant and its crematorium. Two men stand on either side of two ovens and open the doors at the same time, synchronized, as if they've practiced. Inside, bones. Ribs, skulls, vertebrae. Then an aerial view of Dachau. Enormous compound. Thin lines of buildings that go on and on and on. More bodies. Lines of empty clothing hanging on hooks on the front of a building, clothing the prisoners removed because they were told they were taking a shower, before they were given towels and soap. Then a man driving a bulldozer, holding his shirt over his nose and mouth because of the smell. He bulldozes bodies, pushes them in front of him, and they roll on top of one another, some falling away, heads disappearing under legs and arms and chests and feet, and this man driving the bulldozer and this man filming him behind the camera, these are the liberators, and this is what they do, bulldoze bodies, record their work. Then the film is done and the lights come back on in the courtroom and the men in dark suits shift in their seats.

. . .

As a child I wondered why political conflicts couldn't be solved by playing a game instead of fighting wars. Why not chess? Football? Monopoly? Soccer? I grew up during the Cold War, and I'd imagine the Russians on one side and the Americans on the other, the players in their uniforms, the referee firing a gun in the air to start the match, the only shot fired.

I've called myself a pacifist for most of my life. I thought it let me off the hook somehow, as if being against the wars my country fights means they have nothing to do with me.

. . .

I know it is futile to attempt to extricate myself from the evils in which we are involved, Howard wrote in a letter to Ruane. *I remain a part of the crimes committed by us. . . . And I do not wish to separate myself from society or my group. I need to intentionally make myself more a part of it.*

. . .

Watching the film at school, sitting next to her friend Ruth, Kayleen vomited. Threw up again and again.

Ruth's grandparents had been made to run for their lives in a farm field in Germany, chased by a hay baler driven by Nazis, until the machine caught up with them and ran them over.

. . .

Pacifism is a *pathology of the privileged,* Ward Churchill argued. It's *easy for those who are not oppressed to advocate nonviolence, easy for the powerful to use the ideology of pacifism as a tool with which to further oppress those who are unwilling to take up arms to* defend human rights.

The weaker parties in social conflict are always forced by the stronger party to employ nonviolence, Herbert Marcuse insisted.

. . .

Most of Emmanuel Levinas's family was killed in the Holocaust. A philosopher, Levinas wanted to create an ethical system that might make future genocide impossible. He started with the face of the other: *The face as the extreme precariousness of the other. Peace as awakeness to the precariousness of the other.*

In class, to explain what he meant, I drew two stick figures on the whiteboard, facing each other—labeled one *I,* labeled one *Other.* For Levinas, when you encounter an other, you recognize your own vulnerability—the other could kill you—and you also recognize your power—you could kill the other. The impulse to kill must be resisted, he argued. *I could kill you* must be replaced with *Thou shall not kill.*

I drew lines from the head of the figure labeled *Other* on the whiteboard, as if the face were a sun, my lines its rays. From the face of the other shines that which makes one person unlike anyone else, I said—*irreducible alterity,* Levinas called it—an otherness that cannot be replaced, that cannot be understood or contained, that once lost can never be recovered. You are held hostage by that otherness, which you must protect at all costs, even at the cost of losing your own life, because, for Levinas, that otherness is God.

. . .

Critics insist pacifism results from an internal contradiction: pacifists claim to be against using violence because they respect life, yet how can you claim that life is an absolute good and then be unwilling to defend lives threatened by aggression?

But advocates of pacifism point out that pacifism is no more contradictory than the idea that you must kill life to defend life, that you have to destroy the village to save it.

I still see those images from the films in my head, Kayleen told
me. I still have nightmares.

After Kayleen saw the footage from the death camps, she
asked her father, How could you not go to war?

I can't kill because others are killing, Howard said.

But how could you not go to war?

All killing has to stop, he said. It is a sickness all over the
earth.

. . .

I projected a photograph of an Iraqi girl splattered with her
parents' blood onto the screen at the front of the classroom.
The girl is young—five years old—and there is blood in her
hair, on her hands, on her dress. Her mouth wide open, she
screams.

She'd been riding in a car with her family to take her brother
to the hospital when American soldiers at a checkpoint opened
fire, killing her mother and father. I didn't yet know the girl's
name (Samar Hasan), but I wanted my students to look at her.
To look at her gray dress patterned with flowers as red as the
blood on her body, on the concrete, on the toe of the boot of
the soldier standing next to her, who is holding a gun and shin-
ing a light in the dark.

The students' desks faced the screen onto which all semes-
ter I'd projected image after image of other people's pain. Men
lying facedown in the dirt next to a bus, hands cuffed behind
them, shot in the head. A body floating in the water after Hur-
ricane Katrina. A man falling headfirst out of the towers. A line
of dead bodies, each partially covered by a white sheet. A skel-

etal child curled up on the ground, a vulture waiting. The girl in the flowered dress.

A student raised her hand. But what are we supposed to do? she asked.

Through the classroom window, blue sky, sunlight, palm trees, birds-of-paradise, succulents growing out of the university's tiled rooftops. The sound of someone cutting the lawn in the quadrangle just out of sight. The smell of pepper trees, eucalyptus, ocean.

I don't know, I said.

· · ·

A skeptical version of pacifism can develop *from the worry that when we choose to kill in self-defense, we can never know whether this killing is in fact justifiable.* At the level of personal violence, you can argue that an aggressor deserves the violence inflicted on them, but at the level of war, the personal element is lost. Masses of people are killed without any concern.

· · ·

At Auschwitz, where the ashes of victims, scattered by the wind, are still part of the fields and rivers and ponds, there were six orchestras. There was music in those camps, prisoners forced to play while people marched to their death. They played for jam, for bread, for cigarettes. They played for their lives. The instruments' f-holes, open to the sky, must have caught ashes falling like snow, becoming caskets, urns, tombs, the only burial given.

Years ago, Amnon Weinstein, an Israeli violin maker, was working in his shop when a man brought in an old instrument

and told Weinstein it had been played at a death camp. When Weinstein separated the belly from the back, he found the wood inside black and lined with ash.

He and his son have restored more than sixty instruments from the camps. *Each violin like that that you are going to play,* Weinstein said in an interview, *it's for millions of people that are dead.*

. . .

Transformational pacifism: a broad framework of cultural criticism that includes efforts to reform educational and cultural practices that tend to support violence and war. In the future, people will look back at war and violence as *archaic remnants of a less civilized past.*

. . .

I believe we can best witness for truth by transforming lives in the light of the truth we see, Howard wrote to Ruane. *Of course, I must begin with myself.*

Surely civilization will perish if we rely on war.

. . .

My father went to prison for peace, Kayleen told me. He wanted to demonstrate with his life that taking up arms is the problem. If we continue to take up arms, how do we do anything but contribute to the Holocaust? For him it was a clear commandment: Thou shall not kill.

I still wrestle with my dad's decision not to fight, Kayleen said. I am appalled by the annihilation perpetrated by the

Nazis. It's hard not to want to do the same thing to the people who do these things, she said. But I believe wholeheartedly that my dad's stand was the right stand to take.

It would be my stand, she said, though I'm amazed at what it takes to make that stand heard, for it to have any impact at all.

. . .

The religious discourse prior to all religious discourse is not dialogue, Levinas wrote. *It is the "here I am," said to the neighbor to whom I am given over, and in which I announce peace, that is, my responsibility for the other. . . . "Peace, peace to him who is far off, and to him who is near."*

. . .

I watched a video of Hirabayashi talking about his time in prison. His mother wrote him once a week, a half page of typed words, a summary of events at Tule Lake, where she was interned. In one letter she told this story: When she first arrived at Tule Lake and was unpacking, a knock came and she opened the door, and there stood two women, shoes dusty. They said, *We heard that the family of the boy that's in jail is arriving today, so we came out to welcome you and to say thank you for your son.*

When Hirabayashi read these words in his mother's letter, a weight left his shoulders that he hadn't realized he was carrying. His mother had pleaded with him to go to Tule Lake with her. *I admire what you've done,* she'd said. *I agree with you, but if we get separated now, we may never see each other again. If the government could do this sort of thing, they could keep us apart, so please come with us.* Hirabayashi told her he couldn't go with her.

I wouldn't be the same person if I went now, he said. *I took a stand and I can't give it up.* Even her tears couldn't change his views, but he felt guilty. He had failed to respond as a dutiful son.

When he read the letter about the women visiting his mother, he said, *I knew standing there next to her wouldn't have given her the same kind of lift.*

. . .

Here I am, says every prophet called by God in the Bible, a phrase that is an English translation of the Hebrew word *hineni,* which means *ready,* a word the prophets speak before they know what they're being asked to do.

. . .

Will they send you a letter if you have to go back? I asked Miles when he told me he'd reenlisted in the army reserve.

They'll just call me, he said and held up his phone.

Can you say no?

. . .

Kill or be killed—some pacifists argue this is a false dilemma, insist there are nonviolent alternatives. Resorting to violence is a failure of imagination, they say. You abandon hope for more humane ways to solve conflict.

. . .

Our weapon is the smallest possible, Ruane wrote to Howard. *Nobody can find it. Even with all their brainpower and ingenuity the*

task would be impossible. The effect of the weapon is visible and traceable, but the weapon itself is never found. In an age of swords, its effect is peace, joy, frankness, and faithfulness to what is holy. No other weapon can compare with it. It melts ice, spreads light, brings warmth. It creates and alters, drives out doubt and despondency, and stands guard. It marches victoriously through locked gates, so that he who sits in prison finds consolation.

. . .

In a greenhouse, scientists divided plants into two groups, lined them up along walls of glass and light. Assigned to the first group were volunteers whose job was to look at the plants with love for hours at a time; assigned to the second group were people told to watch the plants with indifference.

After a few weeks, researchers discovered the volunteers' gazes had affected the structure of the plants' cells. The plants looked at with love had strong cell walls, while the cell walls of the plants looked at with indifference had collapsed.

. . .

I watched my father drown, Howard said. On the shore. Jumping up and down and waving.

We all have secrets inside, shame covering them like dirt.

When Ruane died, her body gave off so much heat we sang songs about snow, Howard said.

There's more than one way to fight.

PAINT THE TARGET

Before Eric and I moved to Portland, Oregon, people warned us about the weather, the ceaseless rain, but when we lived there, it didn't bother me. In the low gray light, the green moss that covered the tree trunks outside my window turned as yellow as sunlight. Our house backed up to the woods. Douglas firs, maples, ferns—everything green. A creek ran through the ravine behind the house, and at night we heard coyotes and owls.

I got a job teaching critical theory at an art school. My new students were makers—animators, painters, sculptors, performers, video artists. On their hands, paint and charcoal; under their fingernails, clay.

. . .

Many of Miles's friends who'd been stationed with him at Abu Ghraib got tattoos of the prison's guard tower when they returned home. Before Miles left, they asked him to draw it for them—the tower, the circular balcony, the flag—and he did, and they made copies of his drawing on the machine in someone's office and passed them around. They agreed they'd all get the same tattoo when they got home. They sent pictures of themselves sitting in chairs in tattoo parlors, pictures of biceps flexed, of the tower black and tall on their shoulder blades.

. . .

The word *tattoo* is said to come from the Polynesian word *ta,* meaning to strike, or from the Tahitian word *tatau,* meaning to mark. Before people used ink to tattoo, they used ash, soot. Some mourners, bereft, saved the ashes of the dead and marked their skin with them.

. . .

Seymour Hersh recounted this story in a 2007 lecture in Washington, D.C.: A female member of the army reserve, *a weekend warrior who joined the Reserves to get a little extra money for school, clothing or whatever,* had just gotten married when her unit was sent to Iraq a few months after the war began, in 2003. She was trained as a military police officer, and her main skill was directing traffic, but in Iraq, at Abu Ghraib prison, she was a guard. She came home in March 2004, two months before the public knew anything about Abu Ghraib. She *returned as a different person . . . sullen, withdrawn, depressed.* She wouldn't talk to anyone. She left her husband. She moved to a different city.

She *filled her body up to her neck with large black and blue tattoos. . . . She wanted to change her skin.*

. . .

There is a *hierarchy of grief,* Judith Butler wrote in *Precarious Life.* Some lives count more than others. Some lives don't even count as lives, so when violence is done to lives-not-counting-as-lives, it is not seen as violence by those who commit the violence, and it is not seen as loss by those who cause the loss, and the death of life-not-counted-as-life is not counted as death and is therefore not grieved by those who did the killing. *That is why there are no obituaries for the war casualties that the United States inflicts, and there cannot be,* Butler wrote. *If there were to be an obituary, there would have had to have been a life, a life worth noting, a life worth valuing and preserving, a life that qualifies for recognition.*

Come on, one of my students said when I taught Butler's text. Of course we're going to mourn our dead more than theirs.

But another student asked, Who counts as our dead?

. . .

In 2010, during a live performance in New York City titled *. . . and counting,* the artist Wafaa Bilal stood at a microphone and read the first name on the list of the dead: Samir Azeez. Then Bilal took off his sweater and sat in a black leather chair. His back had been tattooed with a borderless map of Iraq, the names of Iraqi cities in black ink. For the next twenty-four hours, thousands of dots representing Iraqi and American casualties were tattooed near the names of the cities where

they'd been killed. The five thousand American casualties were represented by red dots—made with permanent visible ink. The one hundred thousand Iraqi casualties were represented by dots of green UV ink, invisible, appearing only in black light.

. . .

The critique of violence must begin with a critique of seeing, Butler wrote. What allows one life to be *visible in its precariousness and its need for shelter* and what keeps us from seeing other lives in that way? It is *our inability to see what we see* that is of critical concern.

. . .

Photographs are like tattoos, the photographer Hulleah J. Tsinhnahjinnie wrote, which sometimes go *under the skin to survive, encoded beneath the skin, programmed to resurface when the time is right.*

. . .

Wafaa Bilal grew up in Iraq under Saddam Hussein and spent time in refugee camps in Kuwait and Saudi Arabia. He came to the United States and became a professor and an artist. His brother Haji was killed in 2005 at a U.S. checkpoint in his hometown in Iraq by a missile from a drone. His father died from grief two months later.

In 2007, Bilal constructed a prison-cell-sized room in a gallery and lived in it for a month, alone. The white-walled room was in the line of fire of a paintball gun and a camera. The

paintball gun pellets were yellow. The camera broadcast Bilal to Internet viewers around the world, so people could use their computers to shoot at him twenty-four hours a day. He offered himself up to anyone who wanted to *shoot an Iraqi*.

News about his project, *Domestic Tension*, spread virally and the Web server was constantly on the verge of crashing. People wrote things in the chat room: *Too bad we can't waterboard him* and *Motherfucking Iraqi die!* and *I hope this situation gets better in Iraq*. People hacked into the site and wrote code to make the gun's trigger automatic so it would fire continually at Bilal. Other people, calling themselves the *Virtual Human Shield*, co-ordinated efforts to keep the gun pointed away from Bilal. Over the course of the month, the website received eighty million hits. Sixty-five thousand individuals from 136 countries fired the gun at him.

· · ·

Laser beams guide Hellfire missiles carried by Predator drones to their targets. Sensors on the drones calculate wind speed, direction, and other variables, gathering data into a firing solution. The Predator fires a laser. The beam, invisible to the naked eye, lands on the target and pulses. These pulses attract the laser seekers at the end of each Hellfire missile, telling the missile exactly where to go. The process of marking the target with light—which can also be done by soldiers on the ground with handheld infrared lasers—is known as *painting the target*.

· · ·

Naval warships were first painted gray so they would blend into the water and the sky, but their smoke and their size and

the ever-changing weather at sea made them hard to hide. In World War I, to confuse German U-boats, they were painted red and orange and green instead of gray—a technique called dazzle camouflage or razzle dazzle.

During World War II, the military hired artists to paint U.S. warships. Black-and-white zebra stripes. Triangles. Repeating lines and patterns. And though it was called camouflage, the dazzle didn't hide the ships or render them invisible. Instead, the paint disguised what kind of ship it was, or in which direction it was traveling, or at what speed—information you need to know if you plan to attack a ship, to shoot at it.

. . .

In war, the goal of every strategic decision is to *actively withhold meaning from the opponent,* Elaine Scarry wrote. She paraphrased Stonewall Jackson's motto: *Mystify. Mislead. Surprise.* At the center of the language of war: lies. *The enemy must believe you are telling the truth when you are lying and, equally important, must believe you are lying when you are telling the truth.* Each side perceives its own accounts of events as real and others' accounts as lies, yet each side also knows their words include inventions designed to deceive. *Codes* render meaning incomprehensible. *Camouflage* constructs a material lie, making the enemy think you're not there when you are. *Bluffing* promises more destruction than you may be capable of. The whole enterprise, a kind of fiction.

. . .

There was no dazzle camouflage on my grandfather's naval ship, but once, as a practical joke, sailors painted it. Several

men had gotten into trouble, and the captain had ordered them to scrape and paint the side of the ship as punishment, an enormous task. While working, two of the sailors had an idea: they used bright red-orange chromate, a rust inhibitor, to spell out F O R S A L E.

A few days later, the captain of the ship received a message: *How much do you want for it?* The captain had no idea what the message meant. He asked that it be repeated. *I see your ship is for sale. How much do you want for it?* When the captain realized what had happened, he was furious and vowed to kill whoever had done it, but no one would tell him their names.

· · ·

In his sworn statement detailing what he endured at Abu Ghraib, a detainee named Hiadar Sabar Abed Miktub Al-Aboodi said, *They were laughing, taking pictures, and they were stepping on our hands with their feet. And they started taking one [photograph] after another and they wrote on our bodies in English.*

Sometimes the soldiers wrote made-up names on the prisoners' bodies. Knowing the prisoners only by the numbers assigned to them, the soldiers gave them nicknames based on how they looked or behaved: a prisoner who cut himself with a razor blade was called Slash; a prisoner who constantly sprayed himself and his cell with water and always asked for a broom was called Mr. Clean; a prisoner who soaked his own mattress with water was called Swamp Thing; a prisoner with no fingers on one hand, only a thumb, was called Thumby. The list of names went on and on—Shank, Dr. Claw, Santa Claus, Snowman, Taxi Driver, Mr. Burns.

· · ·

Iraq is in the Fertile Crescent, once known as Mesopotamia, where agriculture began, where people have been farming since at least 8000 B.C.E. and likely for thousands of years before that. Iraq's most well-known indigenous wheat variety is called Abu Ghraib.

. . .

For Tsinhnahjinnie, the photograph is *like a message, or like a seed: an object to be transmitted to the future, ready at any moment to burst forth.*

. . .

Before it was known for its prison, the town of Abu Ghraib was known for its seed bank, started by local farmers in the 1970s. Before the 2003 U.S. invasion, Iraqi scientists sent a black box containing the country's seed stocks across the border to the International Center for Agricultural Research in the Dry Areas in Syria, a gene bank that holds samples of 131,000 discrete types of seeds for plants that support the diets of the nearly one billion people living in central and western Asia, the Middle East, and North Africa. Barley, beans, chickpeas, lentils—the seeds are *catalogued and stored in sealed plastic bottles inside giant refrigerated vaults.*

In 2004, Paul Bremer, the top civil administrator in charge of Iraq's Coalition Provisional Authority, imposed more than one hundred laws on Iraq. Order 81 stipulated that genetically modified organisms could be introduced and plants could be patented, though Iraq's constitution had previously prohibited private ownership of biological resources. Farmers were no

longer allowed to save or reuse their seeds. They had to destroy them each year and repurchase seeds from licensed, authorized U.S. distributors. The ancestors of those who cultivated humans' first crops were now forced, every year, to buy seeds and the pesticides those seeds require from American companies like Monsanto, Dow, and Cargill. Penalties for not following Order 81 included fines or jail time.

. . .

Just before the camps were liberated, Nazi soldiers planted trees to hide what they'd done. All that killing, all that burning, then shovels, then feet on shovels to push them deep inside the earth, making sure the hole was big enough to give the roots room, spacing the trees evenly so they could grow, their branches reaching toward the light.

. . .

In the film *Soldiers of Conscience*, veteran Kevin Benderman said, *We were in the area of Iraq that was supposed to be the Garden of Eden, the cradle of civilization where mankind began. I had to ask myself, Why am I carrying around an M16 in the Garden of Eden?*

. . .

One of my students collected logs, branches, and bark he found in Portland's Forest Park. He reassembled the material as trees in the school's gallery, hung stumps from the ceiling, branches on the wall, reminding us what this land used to look like, what it used to be.

. . .

The science of camouflage, once inspired by peppered moths, is now inspired by computer images. Universal Camouflage Pattern (UCP) is pixelated like an overblown photograph. The old woodland print has been deconstructed into small squares. The U.S. Army designed UCP *based on the dream of a single outfit that could be worn in every terrain.*

. . .

As soon as people on the ground know they can be seen by aerial reconnaissance, they train in the counter-art of camouflage. They work *to evade the sky's eyes.* Visibility incites invisibility, Paula Amad observed. Seeking always produces hiding. *The photo-interpreters and the camoufleurs . . . became locked in a visual game of perception-deception in which each side was constantly finding flaws in the others' manufactured reality.*

. . .

On the seventh day of Desert Storm, CNN's Peter Arnett reported that an infant formula plant in Abu Ghraib had been bombed. *It is not an infant formula factory,* Colin Powell said. *It was a biological weapons facility, of that we are sure.* Intelligence analysis had identified the plant as one of thirteen biological weapons sites. The four-acre compound was painted in camouflage. There were guards, a fence.

After the bombing, U.N. inspectors and U.S. intelligence *concluded the Abu Ghraib bombing was in error.*

. . .

Again and again we mis-see and misunderstand, the biologist Jakob von Uexküll pointed out. We smuggle our *petty everyday worries* into the lives of those we watch. Our world imposed on their world. We don't really see them at all.

. . .

Some soldiers prosecuted for what happened at Abu Ghraib tattooed images of rotten apples on their bodies to protest what they understood as scapegoating.

. . .

Miles is a tattoo artist; clients visit him in his garage studio. He had an appointment scheduled for after our phone call one afternoon.

What tattoo will you give him? I asked.

I don't know, he said. That's what we're talking about today: design.

I reminded him about the guard tower he'd drawn, how people he'd been stationed with got his drawing tattooed on their bodies. What kind of tattoos do you have? I asked.

Nothing like that, he said. No tattoos about the military.

Why not? I asked.

What if you get captured? he said.

. . .

Sabrina Harman got her first tattoo when she came home on leave in 2003. *It's of me in a straitjacket with tape over my mouth and my eyes wide open, meaning I can't talk about what I was seeing,* she told the sociologist Ryan Ashley Caldwell, a research

assistant to an expert witness for the defense at Harman's court-martial.

On one arm, she had a tattoo of the man on the box.

Harman later covered that tattoo with an image of a gas mask. *I didn't want people asking what it was,* she said.

. . .

I found a drawing the other day, Miles said when we talked using FaceTime. A sketch I made. I want to show it to you.

I watched my computer screen as he looked around his home office, lifted up papers, scanned shelves.

I can't find it, he said. Then he said, My unit closed down Abu Ghraib.

You never told me that, I said.

Our mission was to close it down because it had such a bad reputation, transfer everyone out, turn it over to the Iraqis.

Miles had spent nine months of his yearlong deployment at the prison, and the other three in the Green Zone.

In the Green Zone they asked me to make a painting, he said, something to mark closing the prison. I made a sketch for the painting while I was there. It was a soldier holding something, with one hundred names written around the soldier, the names of all the people I was there with.

What was the soldier holding? I asked.

An MP dog.

A military police dog? Like the dogs in the photographs?

Yes, but now that I think about it, that's probably not a good image to paint, he said. Maybe I won't show it to you.

13.
WAR TOURISM

Taped to the wall to the left of my desk is a copy of a drawing from the Civil War made by Andrew McCallum: *Siege of Petersburg: A Night Attack, March 31, 1865.* McCallum worked for *Frank Leslie's Illustrated Newspaper*—one of the special artists, as they were known, sent to the battlefield with drawing supplies, dependent on the Union army for their safety. After the battle was over, they often returned to the scene to talk to survivors and revise and annotate their drawings. When the artists were lucky, they worked inside cold, wet tents; when they weren't, they worked outside on the ground, surrounded by the dead.

In McCallum's drawing, cannon fire arcs across the page like rainbows. He made the white arcs by erasing the dark sky he put down first with graphite. Long trenches run through the landscape from front to back. Men stand alone or in groups

of two or three or line up inside a trench. Triangular tents are clustered under a patch of trees. The moon lights up the clouds that hide it. The right half of the sky is dark, dotted with clouds or puffs of smoke from the explosions. In the distance, along the horizon, houses and church spires. Looking at the drawing, I can't tell which cannonballs are being launched and which are landing because both ends of the white lines explode. Union and Confederate soldiers had been fighting near Petersburg for nine months—thousands killed on both sides.

When he drew this picture, McCallum must have been sitting away from the gunfire, away from the dead and dying, though the sound must have been terrible.

. . .

I heard a man on the radio talking about his company: War Zone Tours. It's for people who like being on the edge, he said. People who like adventure. People who know the news isn't giving them the whole story.

I was driving home from teaching when his voice came over the radio, and then I was home, and I pulled into the garage and kept the car on so I could listen to the rest of the story, and when he finished talking, I went into the house and looked up his company online.

The website's home page showed a car that appears to have been blown up. It's still on fire, smoking. In the background audio, sounds of gunfire. A jet. A helicopter. Explosions. Voices. Four locations are advertised: Iraq (*This is one of our most popular destinations. Iraq is a beautiful but potentially dangerous place*); Beirut (*If your idea of a good time is driving through a Hezbollah rally, then going to get some sushi, Beirut is definitely the edge Mediterranean destination for you*); Mexico (*This region has*

drastically changed in its recent history. Kidnappings, unrivaled bru-
tality, combined with military weaponry have plagued Mexico over
the past few years); and Africa (*Where wildlife, oil, and AK 47s*
abound; how can this region be anything but fascinating). These are
just a few examples, the website said. *Tour locations are limitless.*

. . .

In the audience, Kayleen watched a play about the life of Gor-
don Hirabayashi. The curtain opened. On the stage, two ac-
tors tossed a ball back and forth. The man playing Gordon
threw the ball to the other man and called him Howie.

Kayleen gasped.

Are you all right? the woman next to Kayleen, a stranger,
asked.

Howie is my dad, Kayleen said.

After the play, the woman told Kayleen to go on the Mini-
doka Pilgrimage in Idaho. You must, she said.

. . .

In *The Civil Contract of Photography*, Ariella Azoulay proposed
that documentary photographs generate a new kind of citi-
zenship. Photographs can make us responsible for one an-
other, she said. Photographers and the people who let
photographers take their picture assume there will someday
be spectators who will take an interest in the image and do
something in response to what they see.

Yes, photographs do violence to their subjects; yes, they ex-
ploit. But they also protect. They reveal injuries, uncover
harm, expose violations that violators would rather remained
hidden.

. . .

On a hilltop near the Syrian-Israeli border, whenever a battle rages below, a crowd gathers. *People come out to see the show,* Kobi Marom said. A retired Israel Defense Forces colonel, Marom is now a tour guide. He brings people to the hill *to gaze down on Syria's bloodletting.*

Wineries, cherry markets, artisanal chocolate shops—then a visit to the hilltop. *[Tourists] stop here by the dozens each day armed with binoculars and cameras, eager for a glimpse of smoke and even carnage.*

. . .

Humankind used to be *an object of contemplation for the Olympian gods,* Walter Benjamin wrote, but it has now become an object of contemplation for itself. *Its self-alienation has reached the point where it can experience its own annihilation as a supreme aesthetic pleasure.*

. . .

And we: always and everywhere spectators, Rilke wrote.

. . .

Thomas wasn't there when Jesus first appeared in the room with locked doors. He didn't hear Jesus say, *Peace be with you.* He didn't see Jesus show his hands and his side. He didn't hear Jesus say, *Peace be with you* a second time. So he didn't believe what his friends told him. He said he wouldn't believe it until he saw the marks of the nails, until he touched the wounds.

A week later, Thomas and his friends were in the same room with the same locked doors and Jesus appeared again. *Peace be with you,* he said. He told Thomas to reach out his hand and put it in his side, but Thomas didn't need to touch him to know it was Jesus.

Jesus chided him. *Have you believed because you have seen me?* he asked. *Blessed are those who have not seen and yet have come to believe.*

. . .

Susan Sontag wrote, *To suffer is one thing; another thing is living with the photographed images of suffering, which does not necessarily strengthen conscience and the ability to be compassionate. It can also corrupt them.*

Azoulay argued that Sontag focused too much on the viewers' feelings. What matters is not how the viewer feels but what she does. It is not compassion that is called for but citizenship—*the spectator's responsibility toward what is visible.*

. . .

After the play in which she heard her father's name, Kayleen bought tickets for the Minidoka Pilgrimage. Minidoka: an internment camp in Hunt, Idaho, near Twin Falls. Thirteen thousand Japanese Americans were sent to Minidoka in 1942, from Washington, Oregon, and Alaska, most of them American citizens.

Kayleen and Paul boarded a bus, and Kayleen read *A Principled Stand,* a collection of writings by Gordon Hirabayashi, including selections from his journals and letters. In her bag she carried letters Gordon had written to Howard and Ruane when Gordon was in jail for refusing to follow curfew, for re-

fusing to be interned, and a letter he'd written to Howard's mother: *Howard always has been, and is more than ever now, an inspiration to me. I have my hands full trying to be like him. Enclosed please find a hand-made shell corsage. It is sent with best wishes from my mother. (The shells are from the dry lake bottom of Tule Lake.)*

At the camp, there was not much to see: a storage house, a root cellar, a couple of wooden-framed barracks covered in tarpaper, nothing to protect its occupants from summer's brutal heat, from winter's brutal cold.

The internees transformed the landscape, irrigated the desert and turned most of the thirty-three thousand acres into farmland. In 1944, they harvested more than seven million pounds of produce, making the camp completely self-sustainable. They brought beauty to the land that wasn't there before, Kayleen said.

Kayleen told me she walked through the camp with a woman whose face was so serene it drew Kayleen to her. Later that day, the woman shared her story with people on the pilgrimage. She was born in the camp, she said. Her mother died there. Measles. A preventable death. The woman came back to Minidoka to grieve.

I'll never stop learning from my parents' lives, Kayleen said. There are more and more pages to turn.

. . .

Photographs are *transit visas,* allowing viewers to see places they have never been, people they have never met, times in which they were not yet alive. *Photography reorganized what was accessible to the gaze,* Azoulay wrote. It gave people the chance to share their visual field with one another, to see more than they could see alone.

Adolf Eichmann sat in a bulletproof glass box during his 1961 trial in Jerusalem for crimes against humanity, including the murder of millions of Jews. He designed the deportation plans, coordinated the removal of Jews and Romas from countries all over Europe, organized everything down to the last detail, including seizing the dead's confiscated assets. In the courtroom, Eichmann's voice came out of a tape recorder, from a previously recorded interview, so he sat in a glass box listening to his own voice describe what he saw in the camps.

Hannah Arendt wrote about Eichmann's trial for *The New Yorker* in 1963. On trial, Eichmann insisted he did not support using gas to kill. To hear him tell it, he is faint of heart. Even just hearing about the gas plan *left behind a certain inner trembling.* He said, *For me, too, this was monstrous. I am not so tough as to be able to endure something without any sort of reaction. . . . If today I am shown a gaping wound, I can't possibly look at it.*

Arendt wrote about the Nazis' attempts to make the perpetrators seem like victims. Instead of saying, *What horrible things I did to people!* They said, *What horrible things I had to watch.*

. . .

Viewers' revulsion at images of suffering has been coded as proof of empathy. Discomfort-when-looking signals the viewers' sensitivity, their humanity. It is a sign of enlightenment that is often relished because it feels like penance, Rebecca Adelman noted.

But what does that discomfort do for the people in the picture?

. . .

For a class I taught called Art & War, one student made three paintings, each based on a photograph of a victim of U.S. drone violence.

I wanted to process their deaths through my own body, she said when she presented her work. I wanted to grieve. From eye to mind to heart to hand to brush to paint to canvas.

. . .

Sontag argued that photographs of people in pain grant a sense of closeness that is illusory. Images offer *imaginary proximity to the suffering inflicted on others.* They suggest *a link between the far-away sufferers . . . and the more privileged viewer that is simply untrue, that is yet one more mystification of our real relations to power.*

Images that show suffering seem to bring the pictured people near. You hold them in your hands. You see them on the television in your living room or on the computer screen in your office or bedroom or kitchen or on the screen of the smartphone you carry in your pocket. You are a good person. You feel. You grieve. You are sympathetic. You have done your part. *Our sympathy proclaims our innocence as well as our impotence,* Sontag wrote. It lets us off the hook: *So far as we feel sympathy, we feel we are not accomplices to what caused the suffering.* But sympathy is an impertinent response to images of suffering, an inappropriate response. Set sympathy aside, she wrote. Admit, instead, *how our privileges are located on the same map as their suffering.*

. . .

Explaining to Diane Sawyer on *Good Morning America* in 2003 why she doesn't watch television, Barbara Bush said, *Why*

should we hear about body bags, and deaths? . . . It's not rele-
vant. So, why should I waste my beautiful mind on something like
that?

. . .

In the series *House Beautiful: Bringing the War Home* (1967–72), Martha Rosler collaged photographs of injured Vietnamese citizens from *Life* magazine with photographs of the homes of rich Americans collected from *House Beautiful*. This is *living-room war* made literal, according to MoMA's website. This is the violence and carnage that *filtered into tranquil American homes through television reports*. Viewers are asked *to reconsider the "here" and "there" of the world picture*.

In *Balloons*, a Vietnamese woman carries a baby. The expression on the woman's face is pained, urgent. The baby is naked, arms spread, head back, hanging down in a way babies' heads are not supposed to hang. The woman carrying the baby appears to be walking up the stairs of a house. The walls of the stairway are sleek, one steel gray, the other cream, the banister a clean diagonal line. A square cut out of the cream wall forms a shelf for lush potted plants. You can see the living room—its white shag rug, its patterned chairs and ottoman, its see-through coffee table, its white walls. Sliding glass doors open to a covered porch with a railing and a hanging chair with a cushion in it, a chair you could sit in and swing your feet, and behind the chair you can see trees in the yard, tall trunks and greened branches. In the far corner of the room, a pile of multi-colored balloons, as if there had been a party.

. . .

Fanny Howe: *War can make people sick and defeat them even if they aren't stuck right in it.*

. . .

Eichmann was taken on a tour of the death camps in 1941; he was sent by Heinrich Müller to inspect the killing centers. He saw the preparation for the carbon monoxide chambers at Treblinka, where several hundred thousand would die. He visited Chelmno, a death camp in Poland, where three hundred thousand Jews would be killed by 1944—not in gas chambers but in mobile vans. There, Eichmann saw Jews in a large room; they were told to strip. Then a van arrived, stopping at the entrance to the room, and the naked people were told to board it. The doors closed, and it drove away. *I cannot tell [how many Jews entered], Eichmann recalled. I hardly looked. I could not; I could not; I had had enough. The shrieking, and . . . I was much too upset.* Eichmann drove after the van. *And then I saw the most horrible sight I had thus far seen in my life. It [the van] was making for a long open ditch; the doors were opened and the corpses were thrown out, as though they were still alive, so smooth were their limbs. They were hurled into the ditch, and I still have visions of how a civilian with tooth pliers made the extractions. And then I was off—jumped into my car and did not open my mouth anymore. . . . I only remember that a physician in white overalls told me to look through a hole into the truck while they were still in it. I refused to do that. I could not. I had to disappear.*

Müller then sent Eichmann to Minsk, where in a nearby death camp Nazis killed Jews by shooting them. When he arrived, most of the shooting had been done, and he saw just *a few young marksmen who took aim at the skulls of dead people in a large ditch.* But then, in the ditch, he saw a young woman with

her arms stretched backward and *his knees went weak* and he left.

Then to L'viv, where the leader of the camp wanted to show him something Eichmann didn't want to see, but the camp leader was proud, *delighted,* and brought him to a ditch. *A ditch had been there, which was already filled in [with bodies],* Eichmann said. *And there was, gushing from the earth, a spring of blood like a fountain.*

Eichmann could not sleep. He had terrible dreams.

Eichmann often visited Auschwitz, but the enterprise was huge, nearly eighteen square miles, so he could see what he wanted to see, avoid what he didn't. He never saw the shooting, never saw the gassing, never saw the selection of the fit from the unfit. He learned how the *destruction machinery worked,* knew *elaborate precautions were taken to fool the victims right up to the end.*

· · ·

When Sontag saw two photographs of Bergen-Belsen and Dachau in a bookstore in Santa Monica in July 1945, her life was cut into *before* and *after.* She looked at them and *something broke. Some limit had been reached . . . something went dead; something is still crying.* But she asked, *What good was done by seeing them?*

· · ·

I saw Howard in a photograph, and I went to his house. Now when I visit, there are photographs of Howard and me arranged on a shelf.

· · ·

Photography was invented at the moment when a large number of people picked up cameras and began to take pictures, Azoulay wrote. The invention of photography was not merely a technological invention—not just the introduction of a new machine; rather, it was the *invention of a new encounter*. Ordinary people can take pictures of other ordinary people—but they can also take pictures of dictators and fascists and states committing violence. With the camera, *the body of citizens was given the means to instigate change.*

. . .

Most prisoners at Abu Ghraib lived outside in tented compounds called camps. Camp Ganci, named after a New York City firefighter killed on September 11, could hold forty-eight hundred prisoners in twenty-five-man tents surrounded by sandbags and concrete bunkers to protect the prisoners from mortar attacks. Camp Avalanche had nicer tents than Camp Ganci. There were wood floors and electricity, fans for cooling the detainees, and several showers.

After the Abu Ghraib photographs were printed in newspapers, the name of Camp Avalanche was changed to Camp Redemption. Detainees were provided with cots. When families visited, a soldier would take a picture of the detainee with his family, and everyone would be given copies of the photograph to keep.

. . .

In 1987, the Supreme Court reopened Gordon Hirabayashi's case and overturned his conviction. The area where the Tuc-

son Federal Prison Camp used to be is now called the Gordon Hirabayashi Campground.

Hirabayashi died in 2012. Later that year he was awarded the Presidential Medal of Freedom, the highest civilian award.

. . .

Miles told me that when families visited detainees at the prison, the soldiers would tear up. We'd have to turn away, he said.

. . .

In 2004, Rosler made a series of images called *Bringing the War Home*. Again she combined news photographs of war—this time the Iraq War—with photographs of architectural interiors she found in magazines. In *Photo Op*, a tall, thin woman with a long blond ponytail and bangs, wearing a light pink backless dress, holds her cellphone with both hands in front of herself. Her mouth is wide open. There are two images of this same woman in the same dress with the same phone, next to each other. On the screens of both phones, faces.

The woman stands in a living room. The arm of the couch is visible. A fireplace. Pale wood floors. Chairs. A coffee table on which five white vases are arranged. On a side table, a small vase of orange daisies. There is an Eames lounge chair, and in the Eames lounge chair is a dead body. In another chair is a dead girl in a pink dress, her eyes closed, her arms open at her sides. Behind her, through the floor-to-ceiling plate-glass windows, you can see the silhouettes of a tank and soldiers. You can see fires.

. . .

On the wall next to my desk in Portland hangs a painting I bought when I lived in California. I'd been walking down the street, running errands, when I passed a gallery. Through the glass doors I saw an image of a soldier, and I knew Miles had painted it.

The background is flame-like, red and orange and yellow. The soldier in the painting wears green fatigues and a green helmet, and on his back he carries an enormous green bag, his hands clasped over the strap that runs diagonally across his body. A few strands of black hair are visible under the helmet. His skin is brown. His eyes are sad. It's called *The Surge*.

I would have given it to you, Miles said when I told him I bought it.

Later, when we Skyped, I turned my computer around so Miles could see his painting, so he would know I look at it every day.

It's not finished, he said.

14.

WATCHER OF HUMANITY

It is a queer experience, lying in the dark and listening to the zoom of a hornet which may at any moment sting you to death, Virginia Woolf wrote in "Thoughts on Peace in an Air Raid." She was listening to the sound of German warplanes above London. She may have been listening to rudimentary drones; Hitler was among the first to use them—V-1s, more commonly known as doodlebugs, a *bomb with wings.* Pilotless, doodlebugs flew until they ran out of fuel, then fell to the ground and exploded.

. . .

I downloaded an app called MetaData+, which sends an alert to my phone every time there is a report of a U.S. drone strike.

In my pocket or on my desk or on my nightstand, my phone vibrates: *Five people driving. A buzzing above. A missile arrived, ending the lives of all five passengers.*

. . .

Doodlebugs made a droning sound, and when the noise stopped, people had fifteen seconds to escape from the blast that followed. *It is a sound—far more than prayers or anthems— that should compel one to think about peace,* Woolf wrote.

. . .

Umwelt—German biologist Jakob von Uexküll's insistence that there is no single world in which all beings are situated. The fly, the dragonfly, the bee, the bird, and me watching them—we all live in different worlds, different *umwelten*. Every being's *umwelt* is composed of *carriers of significance*—what von Uexküll called *marks*. The marks are musical, a song only the animal can hear. The smell of butyric acid contained in the sweat of mammals, a temperature of thirty-seven degrees centigrade, skin and hair—for these, ticks drop from their branches. The night moth hears one sound: the high tone of the bat. To all else, night moths are virtually deaf. The moth and the bat constitute two elements in a musical score, a *symphony of signification*.

. . .

Children who live in North Waziristan can identify the sound of drones. *Zung, zung, zung,* Zubair Rehman said. *It's something a two-year-old would know. We hear the noise twenty-four hours a day.*

Zubair and his sister Nabila, aged thirteen and nine, were harvesting okra with their grandmother when Zubair heard two clicks—then darkness, heat. Their grandmother, Momina Bibi, a midwife, was killed by the strike. Zubair and Nabila were both injured by shrapnel.

On October 29, 2013, Zubair and Nabila spoke to a group of lawmakers on Capitol Hill, an opportunity for Congress to hear from Pakistani victims of U.S. drones. Only five members of Congress showed up for the hearing.

Nabila held up a pencil drawing she'd made of the attack. A house. A wall. Three hills. Three trees. A road. Two people running on the road. Two clouds. Two drones in the sky, their wings drawn with jagged lines.

I no longer love blue skies, Zubair said. *In fact, I now prefer gray skies. The drones do not fly when the skies are gray.*

. . .

The Predator drone appears faceless. On its gray body, no windows where the cockpit would be, because there are no pilots on the plane. They are in a temperature-controlled box in a desert thousands of miles away. The cameras hang down below the nose of the plane, a collection of eyes in the shape of a globe: a full-color camera the remote pilot uses for navigation; a variable-aperture camera that is the drone's main set of eyes; an infrared camera for seeing in the dark; and a synthetic-aperture radar for seeing through haze, clouds, smoke. The Predator is loaded with two Hellfire missiles. The Predator is easily moved. It breaks down into six pieces that are packed into a crate called the coffin.

. . .

Never before has an age been so informed about itself [visually] . . . [while knowing] so little about itself, Siegfried Kracauer wrote.

. . .

In *GQ* magazine, I read this: Brandon Bryant sat in a dark box in the Nevada desert and watched three men walk down a dirt road in Afghanistan. The men didn't know they were being watched by him. None of the people he watched knew they were being watched, he said. They went about their lives. Drank tea. Played with their children. Fucked on rooftops. Played soccer. Got married. Bryant's hours were long, boring, tedious. Sometimes he read *Ender's Game* while monitoring the seven screens of his station.

He'd been told the men walking down the road were carrying rifles, but he wasn't able to tell. They could have been carrying shepherd's staffs. But then there was a countdown— 3, 2, 1—and then *missile off the rail*. The screens lit up on impact. When the smoke cleared, he saw a crater and one of the men holding what was left of his leg, rolling around, blood everywhere. *It took him a long time to die,* Bryant said. *I just watched him.* The blood's color on the monitor changed, the heat of the blood cooling, turning the same color on the screen as the dirt onto which it pooled. That was his first time, but he sat in the box with those monitors for almost six years, until he turned down a $109,000 bonus to continue.

When he left, he was given a document totaling the number of people killed in missions in which he'd participated: 1,626.

He's been diagnosed with PTSD.

. . .

What do you think about drones? I asked Miles.

If you can play videogames, he said, you can man a drone.

I'd rather send a drone than send you, I said.

I don't want people to get hurt, so maybe drones are good for that, he said. But people get hurt either way.

. . .

It is not with metal that the pilot is in contact, wrote Antoine de Saint-Exupéry, the author of *The Little Prince,* who flew reconnaissance missions for France during World War II. The machine does not isolate the pilot from *the great problems of nature.* Rather, it *plunges him more deeply into them.*

. . .

The first aerial photographs were taken by birds, by pigeons sent on reconnaissance missions, automatic cameras tied to their bodies.

In the early 1900s, Julius Neubronner, a German apothecary, trained carrier pigeons to bring him prescription orders from the nearby sanatorium, then used the birds to deliver the requested drugs. One of his pigeons stayed away for a month before returning. Curious about where his bird had been, Neubronner strapped a small, timed camera to the pigeon to track its travels.

Neubronner liked the pictures taken by the bird's camera, so he worked to improve his invention, building an ultralight camera and an aluminum harness. He trained his birds to carry the extra load. A pneumatic system controlled the time when the picture was taken: each camera had an inflated air chamber designed to deflate over the course of the bird's flight,

moving a piston that triggered an aperture and then a small shutter. Neubronner would drive his birds sixty miles away and then release them to photograph the landscape below. Wanting to be relieved of their burden, the birds usually flew the most direct route home.

. . .

When Howard was seven or eight years old, a group of neighborhood boys were playing outside. One of them had a BB gun, and he shot at the swallows lined up on a wire across Howard's backyard. He missed.

Now you try, the boy said to Howard, and Howard took the gun. He aimed and fired, watched the swallow drop to the ground, just a few feet away.

I resolved then that I would never do that kind of thing again, Howard said.

. . .

If birds believed in God, God would be winged, the theologian Ludwig Feuerbach wrote, for the *bird knows nothing higher, nothing more blissful, than the winged condition.*

. . .

You have searched me out and known me. You know me when I sit. You know me when I rise up. You know my thoughts when you are far away. You know my path. You know my lying down. You know all of my ways. Even before I say a word, you know it. You hem me in. You are behind me. You are in front of

me. You lay your hand on me. Where can I go? Where can I flee from your presence? If I go to heaven, you are there. If I make my bed underneath the earth, you are there. If I fly to the furthest sea, you are there. Your hand leads me. Your right hand holds me fast. Even darkness is not dark to you, and night is bright as day, for darkness is like light to you. You formed me. You knit me together in my mother's womb. I am fearfully made. I am wonderfully made. Even when I was being made in secret, I was not hidden from you. Your eyes saw me before I was formed. In your book, you have written all of my days. Your thoughts are vast. I cannot count them. They are more than the sand. I come to the end and I am still with you. Oh that you would kill the wicked. Oh that the bloodthirsty would leave me alone. I hate those who hate you. I loathe those who rise up against you. Search me out. Know my heart. Test me. Know my thoughts. See if there is any wicked way in me. Lead me. Lead me.

. . .

Neubronner brought his pigeons to photography fairs around Germany, where he released the camera-laden birds into the air. Crowds gathered to watch. Once the pigeons were back on the ground, he removed each harness and developed the images onsite, selling the photographs to curious onlookers. Some of the pictures won prizes in Dresden and Paris.

Recognizing the military potential for aerial photography, Neubronner retrained his pigeons to return to mobile shelters, easily transported dovecotes. Soon, the birds returned to the dovecotes no matter where he placed them, the entry holes large enough for a pigeon with a camera strapped to its breast to fit through.

At the breakout of the First World War, Neubronner donated his flock to the German army.

. . .

Aerial vision is not human vision, wrote Saint-Exupéry. It is bird vision that trains us *to see from the non-human perspective and route of the "flying crow."* Leonardo da Vinci, in the late fifteenth and early sixteenth centuries, studied the flight of birds, drew designs for flying machines, painted bird's-eye views of landscapes. Now planes controlled remotely are called drones by the public, but in the military, people call them *birds.*

. . .

At a writing residency on Whidbey Island, I took a long walk and watched blue herons, their upside-down twins reflected in the shallow water. On my way home, I saw eight herons flying above me in formation, one bird in the lead, the others following close behind, dark against the lit-up sky, but then I heard a deafening roar and realized my mistake. Not herons. Fighter jets.

. . .

Aerial photography allowed people to see that human beings were part of the whole—mountains next to bridges next to houses next to rivers next to roads. *The tiny, fragile human body* in an enormous world, Walter Benjamin wrote.

. . .

On my phone, a drone alert: *Six missiles extinguished 15 people as they slept in tents and mud houses.*

. . .

The passenger pigeon once numbered in the billions.

In 1866, people in southern Ontario reported watching a flock of passenger pigeons fly overhead that was so big it took fourteen hours to pass, an enormous canopy, the sound all those wings made, the flashes of blue, of rose, the darkness of a sun eclipsed by birds.

Passenger pigeons were communal. You might find one hundred nests in a single tree. Farmers considered the birds and their mounds of shit a threat to crops.

People liked to eat the birds. To catch them, they fed the pigeons alcohol-soaked grain, because intoxicated birds were easy to kill.

Others lit the pigeons' nesting trees on fire, driving them out and into the air.

Still others would catch a single pigeon and blind her, sewing her eyes shut using a needle and thread. The blinded bird's feet would then be attached to the end of a stick that could be raised five or six feet into the air, high enough for the bird to think she might be flying, and when the stick was lowered, close to the earth, the bird would believe it was time to land, so she would flutter her wings, trying to find the ground, though she was blind, though her eyes had been sewn shut, and the bird's furious flapping would attract the attention of other birds flying overhead, birds who would then approach this decoy bird, coming close, not knowing the hunters had set nets, nets that would trap the birds, whose heads the hunters would crush between their forefingers and thumbs.

From billions to one to none.

The last passenger pigeon—they named her Martha—died alone at the Cincinnati Zoo in 1914. Her body was frozen in a three-hundred-pound chunk of ice and sent by truck to the Smithsonian. She was put on display.

. . .

Does something mechanical like a camera teach its user how it works? Fanny Howe wrote. *It feels as if it knows more than I do all the time because it contains the collective intelligence of the people who made it.*

. . .

Project Pigeon: American behaviorist and Harvard professor B. F. Skinner joined forces with the U.S. Army to train pigeons to guide missiles. Skinner used operant conditioning, a method for modifying behavior he'd developed in 1937, rewarding the birds whenever they pecked an image of a target he'd projected onto a screen.

Skinner designed a nose cone for missiles, fitted with three small electronic screens and three pigeon cockpits. On the screens, an image of the ground in front of the rocket. The pigeons, trained to recognize the pattern of the intended target, pecked the screens, and cables harnessed to each one's head mechanically steered the missile until it reached its mark.

There was no escape hatch.

Pigeons process visual information three times faster than humans do. When they practiced in the simulator, their missiles rarely missed their targets. But Project Pigeon was can-

celed in October 1944. No one felt comfortable trusting missile guidance to birds.

. . .

Many birds of prey do not hunt near their nests. A neutral zone. It is thought this arrangement developed so birds of prey don't accidentally hunt their own offspring. Songbirds nest within this protected territory where birds of prey won't hunt. Under the aegis of the great hunter, they bring up their young in safety and fill the air with song.

. . .

Scientists developing drone technology are studying birds, bats, fish, insects. Watching their travel patterns. Learning how bees adapt to windy conditions. Making handheld drones that mimic the echolocation ability of bats. Miniature drones inspired by hummingbirds.

Hawk moths are known for hovering, for swift flight patterns. They pollinate orchids and petunias while sucking the flowers' nectar. They feed on honey from beehives. They chirp and squeak. Scientists attached reflective beads to their wings and then filmed their flights with high-speed cameras. The moths, they found, react quickly to disturbances in the air. When they collide with anything, they recover with just one wingbeat. Scientists developed algorithms based on the moths' flight patterns and programmed them into a new quadrotor drone called InstantEye. It weighs just over a pound and can fly in winds of more than fifty-five miles per hour. The drone operator uses a joystick to move InstantEye in the desired direc-

tion, and then the autopilot system works out the best flight path, paying attention to the weather. The blades of the rotors, however, are proving more fragile than the wings of moths.

. . .

Have no fear. For nothing is covered up that will not be uncovered. Nothing secret will not be known. What I say in the dark, tell in the light. What you say in the dark will be heard in the light. What you hear whispered, proclaim from the rooftops. What you whisper will be shouted by others. Do not fear those who kill the body but cannot kill the soul; fear the one who can destroy both. Do not fear those who kill the body and then do nothing more; fear the one who has authority, after he has killed, to cast into hell. Are not two sparrows sold for a penny? Are not five sparrows sold for two pennies? Yet not one of them will fall to the ground apart from God's sight. Even the hairs on your head are counted. Do not be afraid. You are of more value than many sparrows.

. . .

John Berger asked, *Has the camera replaced the eye of God?*

. . .

After I gave a talk outlining my concerns about the use of weaponized drones by the United States, a man in the audience said, But when a drone dies, you don't have to send a letter to its mother.

. . .

In Islam, bodies are washed and covered and buried as soon as possible after death. But Hellfire missiles fired from drones incinerate bodies. Leave them in pieces. Unidentifiable. Traditional burials are impossible. When a man went to the site of the strike that killed his father, he found the place burned so completely that even the stones had turned black. Sometimes funerals for all the victims of a strike have to be held at the same time, at the same place, in the same grave, because you don't know whose bones and skin you are burying. Even when the bodies can be identified, there is often no funeral, because U.S. drone strikes appear to target people in groups, including families gathering to mourn the dead.

. . .

Unless we can think peace into existence we—not this one body in this bed but millions of bodies yet to be born—will lie in the same darkness and hear the same death rattle overhead, Woolf wrote.

. . .

The photographer Tomas van Houtryve bought a drone, a small quadcopter, on Amazon.com and modified it to accommodate a still camera and a system for transmitting video back to him on the ground. He flew his drone over the sorts of gatherings in the United States that have been targets for drone strikes in other countries. One photograph shows people exercising outside in Philadelphia. Some stand and reach for their toes. Others sit on the ground and twist, their shadows long.

Another photograph shows a wedding, also in Philadelphia, a line of men and women in dark dresses and suits. The bride in the middle, her dress white, her flowers visible. A small girl in white, looking up at the sky. A third photograph shows people practicing yoga in a park in San Francisco. Dozens of bodies in child's pose on their mats, hands in front of them, heads down, as if they are praying.

. . .

An experimental weapon designed by the United States during World War II, the bat bomb consisted of a bomb-shaped casing surrounding several compartments, each housing a Mexican free-tailed bat. Medium-sized, with reddish-brown or gray fur, broad black forward-pointing ears, and long narrow wings, free-tails are known as the jets of the bat world. Each bat was attached to a small incendiary device, a pill-shaped case filled with kerosene. A capsule on the side of the device held a firing pin.

To lower the bats' body temperature and force them into a state of hibernation, the compartments were refrigerated. Just before dawn, the bat bombs would be dropped from a plane, their descent slowed by parachutes. Then a timed trigger would open the compartment doors, releasing the bats.

In sunlight, bats look for dark places to roost. In attics. Under the eaves of buildings. Under bridges. The incendiaries were set to go off simultaneously, after the sun was up, with the goal of starting multiple fires at once. The designers thought bat bombs would be effective in Japan, where many buildings were made of wood and paper.

During testing, some of the bats bearing incendiary canisters escaped, and part of the military base in New Mexico where the bat bomb was being tested burned down.

Double tap: the practice of hitting a targeted strike site multiple times in quick succession. The secondary strikes often kill people who come to help the injured and retrieve the bodies of the dead.

A man talked about a drone strike at his in-laws' house in North Waziristan. Neighbors and friends came to help any possible survivors, *looking for the children in the beds,* but they were killed by a second strike.

Now, after a strike, no one goes near the site. They wait.

. . .

Do not think I have come to bring peace to the earth. I have not come to bring peace, but a sword. I have come to set son against father. Daughter against mother. Daughter-in-law against mother-in-law. Whoever loves father or mother more than me is not worthy of me. Whoever loves son or daughter more than me is not worthy of me. Those who find their life will lose it. Those who lose their life will find it. Those who try to make their life secure will lose it. Those who lose their life will keep it. If you knew the hour the thief was coming, you would give everything away.

. . .

Anticipatory traumatic stress disorder (ATSD): People who live in Pakistan's Federally Administered Tribal Areas lock themselves in rooms. They do not go out. They do not gather. They do not walk with friends. They take tranquilizers. They run. They hide. They faint when a drone appears above them.

They startle easily. They jump at any loud noise. They are irritable. They have no appetite. They can't keep anything down. They have nightmares. They struggle to sleep. They wake in the middle of the night screaming. They see drones in their beds, on the ceiling, near the stove, on the ground, in the sky. They are uneasy. They are afraid. *The drones are all over my brain,* one man said.

. . .

Job talked to God: Remember my life is a breath, he said. My eye will never see good. The eye that watches me will see me no more. While you watch me, I will be gone. The cloud fades and vanishes and those who go beneath the earth will not come up. They will not return to their houses. Am I the sea that you watch over me? Am I a dragon? I say that my bed will comfort me, but then you scare me with dreams and terrify me with visions. I would rather choose strangling and death than this body. I loathe my life. My days are a breath. What are human beings that you make so much of them? That you set your mind on them? Visit them every morning? Test them every moment? Will you look away from me for a while? If I sin, what do I do to you, you watcher of humanity? Why have you made me your target?

. . .

The world is the world—for ant, for dragonfly, for bee, for drone, for me. Is it possible to see that my world is not the only world—or if not to see, then to remember that other worlds exist, as vivid as mine, as real? Can I remember that the stem of the wildflower is part of one world for the girl picking it,

another for the ant crawling on it, and for the wildflower it-self, still another world entirely? Think of it this way, Giorgio Agamben wrote: *There does not exist a forest as an objectively fixed environment.* Rather, there exists *a forest-for-the-park-ranger, a forest-for-the-hunter, a forest-for-the-botanist, a forest-for-the-wayfarer, a forest-for-the-nature-lover, a forest-for-the-carpenter, and finally a fable forest in which Little Red Riding Hood loses her way.*

. . .

What is it like to be home? I asked Miles the first time he sat in my office, with the sound of students' voices in the hall.

I see no sign anywhere that we are at war, he said.

. . .

The day and hour no one knows, not the angels, not the son, only the father. Remember: Before the flood, they were eating and drinking, marrying and giving in marriage, and then all were swept away. Remember: Before it rained fire and sulfur and destroyed all of them, they were eating and drinking, buy-ing and selling, planting and building. It will be like that. Any-one in a house. Anyone in a field. Anyone in a hallway. Anyone on a street. Do not turn back. There will be two in the garden. One will be taken; one will be left. Two grinding meal to-gether. One will be taken; one will be left. Two at the table. One will be taken; one will be left. Two in a car. One will be taken; one will be left. Two in the woods. Two walking the streets with their hands in the air. Two in a meeting hall. Two at the market. One will be taken; one will be left. Two at the town hall, at the grocery store, at the cinema, at the park, on the swing set, on the slide, on the merry-go-round. One will be

taken; one will be left. Two at a bookstore, at a café on a sidewalk under the shade of an umbrella, at a wheel spinning wool, at an easel holding a palette and paintbrush. One will be taken; one will be left. Two in the car-pool line, two baking bread, two picking up dry cleaning, two in a schoolhouse. One will be taken; one will be left. Two watching stars, two tracking the moon, two waiting for comets. One will be taken; one will be left. Two in a bed under thick blankets, two sleeping on rooftops, two lying on their backs on the earth. One will be taken; one will be left. Keep awake.

15.

REENACTMENTS

In my classroom one afternoon a student talked of smashing animals' skulls on the side of the road. Called them mercy killings. Described lifting the rock and bringing it down on the heads of deer, raccoons, rabbits hit by cars. The sound bones make breaking.

The classroom had only one door. The classroom, which I'd requested for its multiple whiteboards, for its size, big enough for group work, was below the street. I'd have to stand on a chair to touch the sills of the windows, and even then I wouldn't be able to escape. The walls were concrete, painted white, and the room was in the back corner of the building.

I'm a hunter, he said. I hunt as much as I can.

For meat? I asked.

Yes, he said, and for trophies.

Weeks before, when asked to prepare a presentation about the work of an artist, he showed us photographs of bodies in Rwanda. Bodies on the ground. Piles of bodies on the ground. Piles of bodies on the ground with machetes in their heads. Piles of bodies on the ground with machetes in their heads and their skin dried out by the sun.

Most people don't want to look at this, he said. Most people want to turn away.

. . .

In *The Cruel Radiance*, Susie Linfield wrote directly against Sontag's charge that all images displaying *the violation of an attractive body are, to a certain degree, pornographic*. Photographs of war, Linfield wrote, are dismissed as *war porn*, photographs of the poor dismissed as *development porn*, photographs of famine victims dismissed as *social porn*—but such accusations, she insisted, depend on *an essential confusion*. You can make the argument that sex should remain private, Linfield wrote, but when it comes to torture or hunger or genocide, *privacy is an integral part of the problem*. It is the opposite of privacy that is demanded. It is visibility. It is light.

. . .

Did I tell you about getting married? Howard asked.

Yes, I said. Tell me again.

. . .

Before my student mentioned mercy killings, we'd been discussing the forgetting pill, how researchers shocked mice, then

administered beta-blockers, then put the mice back in the cage where they'd been shocked and discovered the mice were unafraid—they'd forgotten what had happened in that cage. Such experimentation on animals troubled some students, and the conversation veered into questions about the ethics of scientific research on animals.

I'm all for it, the student said. He'd barely talked all semester, but now he had a lot to say. I hate rats, he said. I'm okay if scientists experiment on them. But I'd be equally fine with experimenting on humans.

. . .

The Box—a military training facility in Fort Polk, Louisiana. Eighteen mock Iraqi villages on one hundred thousand acres of land. Soldiers are sent to the Box for a week or two before deploying to Iraq so they can *learn about the culture*. There are similar training camps in New Mexico and Michigan and Indiana. A $31 million complex opened in 2011 in Camp Pendleton, California. There is another set to open in Hawaii.

The fake villages are populated with Arabic speakers and actors hired to simulate Iraqi civilians and insurgents. Some of the actors are Iraqi immigrants, hired to act "Iraqi" as a full-time job. They perform the lives they left behind—or how they imagine Americans imagine their lives. Other actors are residents of the towns where the training camps have been built—active-duty army spouses, veterans of the wars in Korea and Vietnam. Some actors are amputees, hired to play the wounded. In the long stretches between training exercises, the actors keep playing their roles. They police the towns. They run cafés. They plant gardens, which they later harvest, eating the fruits and vegetables for lunch or dinner.

They paint murals on the walls to make their surroundings more beautiful.

<p style="text-align:right">. . .</p>

At the end of "Looking at War," Sontag described Jeff Wall's staged photograph *Dead Troops Talk (A Vision After an Ambush of a Red Army Patrol, near Moqor, Afghanistan, Winter 1986)*. Wall constructed the Cibachrome transparency—seven and a half feet high, more than thirteen feet wide, mounted on a light box—in his studio. He'd never been to Afghanistan. He read about the conflict, then created this imagined scene: thirteen Russian soldiers in bulky winter uniforms and high boots, *a pocked, blood-splashed pit* and *the litter of war: shell casings, crumpled metal, a boot that holds the lower part of a leg.* Afghans in white strip the dead of their weapons. With wounded stomachs, missing legs, and heads partially blown off—the dead soldiers talk with one another.

One could fantasize that the soldiers might turn to talk to us, Sontag wrote. *But no, no one is looking out of the picture at the viewer. These dead are supremely uninterested in the living.*

And why should they be interested in us? Sontag asked. We don't get it—and by *we* she meant everyone who has never been in war. *We can't imagine how dreadful, how terrifying war is—and how normal it becomes. Can't understand.*

<p style="text-align:right">. . .</p>

I was also in Vietnam, Howard said on the phone the first time I called him, and he said it again when I visited.

You weren't in Vietnam, Dad, Kayleen said.

In the fall of 1966, Howard was invited to a local high school

in Tacoma to talk about alternatives to the draft, about conscientious objection. He was working with the Tacoma school district as a psychometrist at the time, responsible for administering and scoring psychological tests, and he was about to be promoted to assistant superintendent. But after he talked to the high school students, some people in the community didn't like what he said, and when they learned he'd been in prison, they printed a story about him in the paper calling him a felon, a convict, an ex-con. They took away his promotion. There was a hearing about whether he should be allowed to continue working with the district.

They ran us out of town, Howard said. Ruane and Howard left Tacoma and moved to Ellensburg. A friend helped Howard find a job at Central Washington University.

It's happening again, he said.

. . .

Frances Glessner Lee re-created unsolved crime scenes in miniature, using a toy scale to better examine the world—*The Nutshell Studies of Unexplained Death*. Born in 1878, Lee had been taught the domestic arts—interior design, metalwork, sewing, knitting, embroidery, painting, and miniatures. Her first miniature, a birthday present for her mother, was a re-creation of the Chicago Symphony Orchestra—ninety musicians, their instruments, sheet music on music stands. But after becoming friends with a medical examiner who told her about crimes he was trying to crack, Lee began to build crime-scene dioramas. They are tiny, precise, detailed—shades raise and lower, whistles blow, whisks whisk, pencils write, everything works as it should. She thought re-creating the scenes would force her to notice details that might have been overlooked. Lee was

convinced careful observation could help bring justice for the victims.

. . .

Looking at a photograph of a veteran of the First World War whose face had been shot away, Sontag argued, *Perhaps the only people with the right to look at images of suffering of this extreme order are those who could do something to alleviate it.* The surgeons at the military hospital, she suggested. *The rest of us are voyeurs.*

. . .

I discussed the things my student said in class with a colleague. I told her about the Rwanda photographs, about animal experimentation, about mercy killings, about the fact that he was a hunter, which meant he had a gun. She suggested moving my class to a different classroom, more public, not so isolated. The next time your class meets, she said, leave your classroom door open so people can hear you.

. . .

For a series titled *Theater of War: The Pretend Villages of Iraq and Afghanistan,* the photographer Christopher Sims took pictures of the Box, the fake Iraqi villages staged in Fort Polk. In one photograph, a young blond man wears a brown tunic over brown pants and a white skullcap and green Converse sneakers. He holds a rifle in one hand and a cigarette in the other, which he brings to his lips. Next to him is a rocket launcher. And next to the rocket launcher is an older woman, also blond,

her head wrapped in bright blue flowered fabric that matches the loose tunic she wears. Resting in her lap is a green plastic circle loom, a ball of light blue yarn in the striped bag on the ground. In the background, pine trees.

In another photograph, a woman wears glasses with round black frames, the lenses so thick they distort her eyes, rendering them enormous. Her clothing is bright blue, the scarf around her head bright blue, the sky visible through the tall pines bright blue. She holds up a basket so the camera can see the two dolls she carries.

Sims also photographed interior spaces in the villages. In one photograph, you can see a desk and a table, pushed close together, both covered in dust. Someone has painted a vase and flowers on the wall above a shelf. The vase is blue, the flowers pink and blooming, roses or peonies. A floor lamp has also been painted on the wall. On the lamp's yellow shade, written in red: J I H A D.

· · ·

I emailed my students to tell them we'd switched rooms, though I didn't say why, and during our next class I left the door open. The student was late and there was only one chair left at the table, so he had to sit next to me. He didn't talk during class, but he made drawings in his notebook: a hunting knife, a severed arm with the skin pulled back so that muscle is visible, a cleaver, the words *butcher* and *destroy*. He could shoot us, I thought. He could unzip his backpack and take out a gun. I wanted there to be someone watching, someone to save us.

· · ·

Every time we talk, Miles reminds me that he thought I hated him on the first day of class. It's the story of how we met.

Remember? he says. I was late, and you said, Don't be late to my class again, and I thought, Great, it's the first day, and she already hates me. Then you talked about the syllabus, he says, about having to learn about the photographs from Abu Ghraib, and I thought you were condemning all soldiers.

The last time we talked, Miles brought up the first day of class again, and I asked, Do you remember when we discussed those images in class?

No, he said.

Did I already know you'd been at Abu Ghraib when I taught about them, or did you tell me afterward?

I don't remember, he said.

I don't remember, either. How can I not remember whether I knew I was teaching about the photographs in a classroom with a soldier who'd served at Abu Ghraib?

What did you think when I talked about those photographs? I asked.

I don't remember, he said.

. . .

Of Frances Glessner Lee's twenty completed Nutshells, only eighteen survive. Eleven of the victims are women. One Nutshell depicts a strangled woman found on the floor of her bathroom. No signs of forced entry. *Close observation of the diorama reveals small threads hanging from the door that match the fibers found in the wound around the dead woman's neck.* Witnesses' reports and those threads pointed to the fact that the woman was not murdered; she hung herself from the bathroom door. No crime to be solved.

. . .

Outrage generated by documentary photographs of violence is always belated, Rebecca Adelman argued, because *the image of the grievous thing can circulate only after the harm has occurred.*

. . .

My student and I met. You've been talking a lot about violence in class, I said. Are you okay?

I've had this conversation before, he said. I'm not going to hurt anyone. I'm a good person. I'd help anyone who needs it.

I have some concerns, I said.

I'm open-minded, he said. I'm not a feminist, but I don't care if you are. My girlfriend told me about feminists who refuse to wear tampons. They let blood run down their legs. If that's what they want to do, I'm fine with it. I just don't want to ride the bus after them.

I'm concerned about some of the comments you've made about animal experimentation, I said.

I hate rats, he said. We used to have them in our house, and one night I could hear them in the ceiling above my bed, running in circles. Then, all of a sudden, the ceiling gave way and they poured onto my bed.

I'm sorry, I said. That sounds terrifying.

And then I said, We need to talk about your final project, about the kinds of images you will show. You've told me you think violence is beautiful.

It can be beautiful, he said. Death can be beautiful. That's what so much art is about.

But this is a classroom, I said. A learning community. There are other students in the room who might not want to look at

what you want to look at. You'll need to give them an option not to look.

I'd never want to make anyone else uncomfortable, he said.

He promised he wouldn't show anything graphic for his final project, that any images of violence he showed would be obscured, layered, impossible to see, that he'd give the class a warning, a chance to look away.

. . .

Throughout the semester I assigned readings by theorists who raised ethical questions about the aestheticization of violence—turning the suffering of others into an image, into something beautiful to look at. What does it mean if a photograph of someone starving is well composed, the light and the dark, the angles of his body just right? Craft, care, visual power, framing—all of it is suspect when the subject is in pain.

But in *The Cruel Radiance,* Susie Linfield pointed out the problem with such arguments. If a well-taken picture of pain is a *moral affront,* then what is the solution? she asked. A hastily composed image? Sloppiness? Ugliness? *It is as if we, the relatively safe and relatively well-off, can atone for our good fortune only by delving into the visual equivalent of sackcloth and ashes: if a picture seems sloppy, it's okay to look,* Linfield wrote. But this is a mistake, she insisted: *This is the aesthetic not of commitment but of guilt, tinged with a peculiar narcissism. It confuses moral weight with aesthetic clumsiness, and it is more concerned with the clear conscience of the viewer than with the plight of the injured subject.*

There is no unproblematic way *to show the degradation of a person,* no untroubling way *to portray the death of a nation,* no inoffensive way *to document unforgivable violence,* Linfield ar-

gued. Longing for a perfect photograph of pain reveals something troubling: *a desire to not look at the world's cruelest moments and to remain, therefore, unsullied.*

. . .

On the last day of class, the student was late, and when he finally showed up, he put a sculpture in the shape of a human body, two feet long, eight inches wide, on a pedestal at the front of the room, and when the other students moved toward it to take a closer look, they saw that it was collaged with photocopies of photographs: disemboweled bodies, disemboweled children, women naked and split open, women dead in the street in their underwear. He sat at the front of the room on a stool, his face serious, his notebook open, pencil ready, listening.

Where did you find images like this? another student asked.

I have a cache of them, he said.

. . .

Photography makes violence visible, Linfield wrote in *The Cruel Radiance,* but *seeing does not necessarily translate into believing, caring, or acting. . . . This is the failure at the heart of photographic suffering.*

. . .

Sometimes to really see a photograph, Roland Barthes wrote, *it is best to look away or close your eyes.*

. . .

A few years before the student made the sculpture of the body covered in images, I taught the same class to a different group of students and assigned a chapter from James Elkins's book *The Object Stares Back.* Hysterics were not the only people kept in the Parisian hospital La Salpêtrière, Elkins explained. There were others locked inside—prostitutes, the mentally disabled, the criminally insane, madwomen—and in the nineteenth and early twentieth centuries, doctors who worked at the hospital published an academic journal.

Reading issues of the journal, Elkins came across a photograph of a eunuch, which he included in the book. The person in the image is Black, graying hair cut close to his head, shoulders rotated forward, arms hanging down, fingers lightly touching the sides of his legs just above his knees. There appears to be a bracelet around his left ankle. *This is the violent side of seeing,* Elkins wrote. *The mere act of looking . . . turns a human being into a naked, shivering example of a medical condition.*

I took notes to prepare for class. *The violent side of seeing,* I wrote. I made a list of everything Elkins compared looking to. *Looking is like hunting, like loving, searching, possessing, using.* I kept track of what he wrote about how seeing works. *Seeing controls, objectifies, denigrates. It creates pain.*

Let's talk about Elkins, I said in class, and then I saw that one of my students had covered the photograph of the eunuch with a large green Post-it note. And when I saw she had covered the image, I understood I had done the opposite. I had scanned it, asked my students to print it, turned it into an electronic document that could be emailed and reproduced. Now there were nineteen more copies of the photograph, nineteen more people who'd spent time looking at this person, naked,

alone, exposed, because I had asked them to, because I had required it.

The student who used the Post-it is a veteran. She fought in the Gulf War. Her hair is pink. On the first knuckle of each of her fingers is tattooed a letter. If she were to make a fist with each hand and then put them together, her hands would spell a message: B E I N L O V E.

. . .

In *Beyond the Checkpoint,* Adelman argued against *the logic of illumination,* the assumption that visual evidence of state-sanctioned violence will cause informed citizens to hold their government accountable. Illumination would seem to be *a logical curative for opacity,* she wrote, but pictures don't work that way.

More often they work like this: the viewer's repulsion or horror or outrage becomes proof of the viewer's empathy and concern—confirmation of her essential goodness. But something else happens, too: the viewer's outrage verifies not only her own goodness but also the goodness of her nation. Her protest against the state becomes patriotic.

Adelman called this *the paradox of illumination:* protesting images of state-sanctioned violence reveals Americans' freedom to dissent. Challenging the state, viewers end up championing the *mythic greatness of the nation.*

. . .

I talked again with my colleague. I told her about the sculpture and the images of eviscerated bodies. I told her several stu-

dents cried. I told her some students were afraid. I told her I was scared about what this student might do. She asked if it was possible I might be overreacting. Maybe you're being triggered? she asked. She reminded me about freedom of expression, about the dangers of censorship. Look, she said, I was really angry in college, too. I spent a lot of time drawing nooses. I covered pages and pages of my notebooks with hanged bodies.

. . .

Though I long for the perfect image of pain that might make the viewer *feel the urge to enter and put right the world,* there is no perfect image. And even if there were, there is no perfect viewer. Every photograph taken of another's suffering is insufficient—and so, too, every response. Viewers arrive too late and empty-handed, but, Linfield wrote, *that is not an argument for not looking, not seeing, or not knowing, nor for throwing up one's hands or shielding one's eyes.*

. . .

My friend is a poet and writes about war. During a reading for her recent book, a man in the audience asked, Who are you to write about war?

What else would you like me to write about? my friend asked.

. . .

The Barbie Liberation Organization—an activist group of feminists, parents, artists, and veterans—switched the voice boxes for talking Barbies and G.I. Joes. Then they put the doc-

tored toys in their original boxes and placed them back on store shelves.

Dead men tell no lies, Barbie says.

I love to shop with you, G.I. Joe says. Will we ever have enough clothes?

Vengeance is mine, Barbie says.

Math class is hard, G.I. Joe says.

Eat lead, Cobra, Barbie says.

The beach is the place for summer, G.I. Joe says. Let's plan our dream wedding.

Attack, Barbie says. Attack. Attack.

. . .

I invited my class to meet again after the semester ended—without the student. I reserved a room with two doors, put chairs outside both doors, and wanted armed security guards to sit in them, but no one at school had a gun. We had strawberry popsicles because it was almost summer. I waited for my students to talk, to tell me how they felt.

. . .

I read this. *In behavioral reenactment of trauma the self may play the role of either victim or victimizer.*

. . .

I scheduled a meeting with the student. He didn't show up. No one knew where he was, though when I called him, he told me he was at the airport. He said he'd be back in a week.

Classes were over by then, school out for summer, but I still

had work to do on campus, so the security team at my school followed me around. No matter where I went, someone always knew where I was.

. . .

Sometimes when he visited the simulation of the Iraqi villages in Indiana, Christopher Sims took part in the charade, and instead of being an artist, he performed the role of *war photographer*. He photographed mock insurgents planting fake bombs in an ambulance, a suicide bomber fake blowing herself up outside a mosque, fake soldiers fake negotiating with the fake mayor, fake villagers erupting in a fake anti-American riot. He watched the fake death count rise, and *by day's end, hundreds of soldiers and civilians lay dead.*

. . .

Torment—long a canonical subject in art—is often presented as spectacle, Sontag argued, as *something being watched (or ignored) by other people. The implication is this: No, it cannot be stopped.*

. . .

While I waited for my student to return from his week out of town, I consulted a friend, a psychologist who works in mental health, and she asked me questions about the student's behavior, about things he'd said, art he'd made. If I were to evaluate him, she said, it sounds like he'd be a very low risk. And *low risk* is the lowest possible score, she added. There's no such thing as *no risk.*

In college, Miles worked at a university office dedicated to supporting students who are veterans. A few years after he graduated, he visited the office. It's much bigger now, he told me. There's a lounge, a coffee machine.

On the wall are nameplates for all the students who've worked there. Miles was the first student, but his nameplate is not on the wall because he kept it. He wants to bring it back, hang it up.

I'm going to donate some of my artwork if they want it, he said. I'm going to donate the yellow jumpsuit, put it in a frame. All that stuff I brought home is just in a box in my garage. The bracelets. The rules. The paintings.

Do you think about your time at the prison? I asked.

No, he said. I don't think about it.

Does anyone ask you about it?

It comes up during drills on my weekends away, he said. The soldiers are kids, eighteen, so young. They were eight or nine when the photographs came out. They want to know where I've served, and when I say Abu Ghraib, they have no idea what I'm talking about. No one knows what it is.

16.

LET THERE BE

In the beginning God speaks words to bring the world into being. Let there be light, God says, and there is light. Let there be a dome in the midst of waters. Let dry land appear. Let there be plants yielding seeds, plants bearing fruit. Stars. Moon. Swarms of living creatures. Flying birds. Sea monsters. Cattle. Creeping things. Wild animals. Let there be humankind, God says, and let them have dominion. Let them be fruitful and multiply. I have given them everything, and they will subdue it.

. . .

You have asked for this Office's views on whether certain proposed conduct would violate the prohibition against torture, Assistant At-

torney General Jay S. Bybee wrote in a 2002 memo to John A. Rizzo, acting general counsel of the CIA.

The 1984 United Nations Convention Against Torture and Other Cruel, Inhuman or Degrading Treatment or Punishment defined torture as: *any act by which severe pain or suffering, whether physical or mental, is intentionally inflicted on a person for such purposes as obtaining from him or a third person information or a confession.* The key word in this definition for Bybee and other U.S. government officials was *intentionally.* If torture is torture only when the torturer *intends* to inflict severe pain or suffering—then: no intention, no torture.

. . .

At what point . . . does the renaming of things actually transform the world around you? Fanny Howe asked.

. . .

A drone alert on my phone: *Eight men gathered in a courtyard. Above them, a U.S. drone. Two missiles came out of the sky.*

. . .

For the artist Ann Hamilton's installation *tropos,* an attendant sat at a small table and read a book while searing each line of text she read with an electric burner, filling the air with smoke. The pages of the book became black lines, charred. Sometimes the heat burned right through, turning the page into thin strips, as if it had been sliced with a knife.

. . .

At the McNeil prison, Howard was allowed visitors once a month. When Ruane came, she brought the baby with her. During one visit, Ruane carried a diaper bag, inside of which she'd hidden plans for the violin. A prison guard opened the bag to search it, but a minister who'd come with Ruane to visit Howard said, *I don't think you want to do that. She just changed that little tyke.*

The prison censors who read Howard's mail thought Ruane's typed instructions for the violin were a kind of code. They drew thick black lines through parts of the letters, as if Howard and Ruane were plotting his escape.

. . .

In a 2002 memo, Bybee outlined ten techniques the government wanted to use when interrogating a prisoner he called Zubaydah: *(1) attention grasp, (2) walling, (3) facial hold, (4) facial slap (insult slap), (5) cramped confinement, (6) wall standing, (7) stress positions, (8) sleep deprivation, (9) insects placed in a confinement box, and (10) the waterboard.*

Bybee described each technique in detail.

Facial hold: *One open palm is placed on either side of the individual's face. The fingertips are kept well away from the individual's eyes.*

Facial slap or insult slap: *The interrogator slaps the individual's face with fingers slightly spread. The hand makes contact with the area directly between the tip of the individual's chin and the bottom of the corresponding earlobe.*

Cramped confinement: *The confined space is usually dark.*

Some of the memo is redacted, lines of text blocked out: *You would like to place Zubaydah in a cramped confinement box with an insect. You have informed us that he appears to have a fear of insects. In particular, you would like to tell Zubaydah that you in-*

tend to place a stinging insect into the box with him. You would, however, place a harmless insect in the box. You have orally informed ▮▮▮▮▮▮ *that you would in fact* ▮▮▮▮▮▮▮▮▮ *a harmless insect such as a caterpillar in the box with him.* ▮▮▮▮

▮▮▮▮▮▮▮▮▮▮▮▮▮▮▮▮▮▮▮▮▮▮

▮▮▮▮▮▮▮▮▮▮▮▮▮▮▮▮.

. . .

Negative theology is the name given to the work of theologians who recognize the impossibility of ever naming the divine because the divine, by definition, must transcend all human names given. With every act of naming, a correction must follow: God is light and God is not light. God is love and God is not love. God is air and God is not air. God is mercy and God is not mercy. God is darkness and God is not darkness. The Greek word for this kind of language is *apophasis,* which means *unsaying* or *speaking away. Apophasis* is usually paired with its opposite, *kataphasis,* which means *saying* or *speaking with. Every act of unsaying demands or presupposes a previous saying,* Michael Sells wrote. *It is in the tension between the two propositions that the discourse becomes meaningful.*

Fanny Howe put it another way: *Doubt allows God to live.*

. . .

When iconoclasts took hammers to statues, they removed noses first, the place where breath enters and leaves the body. They didn't destroy the statues. They didn't leave them unrecognizable. They simply made them incomplete, broken, missing something essential, and the holes, the emptiness, made sure no viewer would forget they were artifice, constructed,

lest people get confused, lest people think the painting of the saint is the saint herself, the statue of the saint the saint himself. The break renders the statues holy, iconic, makes them point elsewhere, so people don't confuse the finger pointing to the moon for the moon.

. . .

In some religious traditions, it is forbidden to write the name of the divine. You write YHWH, which needs breath to animate it, you write G–d or G*d or "God," or you write nothing at all.

. . .

One of my students went from hospital to hospital, from doctor's office to doctor's office, to collect the medical history of his mother, who is dead. Records. Notes. Observations. The way doctors described her. The questions doctors asked. The answers she gave. Symptoms. Measurements. Prescriptions. He brought the pile of paper to class. He set it on a stool. He stood next to it.

. . .

Another drone alert: *Paper is all that remained. Dollars, leaflets. And a car—charred. Four people were killed.*

. . .

Though negative theology seems to be about the failure of language—the inadequacy of words for speaking about

God—it is about language's success. When spoken correctly—God is light and God is not light, God is love and God is not love—words can effect a mystical union. In *Mystical Languages of Unsaying,* Sells called this the *meaning event,* the moment when words and meaning are fused, when essence is identical with existence. The meaning event doesn't *describe* a mystical union; it *is* a mystical union. Negative theology becomes religious experience. Through theological language, the structures of self and other, of subject and object, fall away. Rather than keeping you away from God, language draws you near.

. . .

Though Howard worked on the violin every day in prison, he was released before he finished the instrument. Prison officials let him take home the wooden calipers he'd made and pieces of the violin—belly, back, sides, scroll.

Decades later, after he and Ruane had four children, after their children had children, Howard showed his grandson Nolle the shoe box of violin parts in the back of his closet.

. . .

In the back of my closet is a cigar box filled with coins my grandfather saved for me, as many as he could find marked with the year of my birth.

. . .

Theology—from *theo* and *logos*—means words about God. *Theology is a science without instruments,* Fanny Howe wrote.

Only words. Therefore words present its greatest danger. No tele-scopes, no tables, no beakers or microscopes. Its vocabulary is its everything.

. . .

Bybee determined there was no intent to inflict prolonged mental or physical harm on the detainees, so what the inter-rogators did or would be instructed to do would not violate the prohibition against torture. *Moreover, we think that this rep-resents not only an honest belief but also a reasonable belief based on the information that you have supplied to us,* he wrote.

Please let us know if we can be of further assistance.

. . .

The theologian is an artist, my teacher Gordon Kaufman said, and like the artist, the theologian constructs a picture of the world. But the theologian's finished product is not something to hang on a wall. It is a work of art to be lived in.

The question to ask is what the world of the text does to someone who submits to its vision.

. . .

For more than a decade, the artist Jenny Holzer has been mak-ing paintings based on declassified, redacted documents from the wars in Iraq and Afghanistan. Her 2013 series *Dust Paintings* reproduced documents investigating the death in 2003 of Jamal Naseer—eighteen years old, a newly recruited Afghan soldier—in U.S. custody. She rendered in paint the handwritten testimony

of men who'd been detained with Naseer. Her work recalls the practice of calligraphy—which in Arabic is called *ghubar,* literally translated as *dust writing.*

Not electrocuted or burnt, no toenails removed, I read in a painting.

Window that my neck was tied up to, I read in another.

The men described being beaten—on backs and faces and legs—and being forced to kneel in snow for hours, in freezing temperatures, while cold water was poured on them.

Officials said Naseer's death was a result of natural causes, a kidney infection.

To us they did oppression.

. . .

In the summer of 2004, Howard's grandson Nolle, thirty years old, was a student at the North Bennet Street School in Boston, studying furniture making. He was repairing a ceiling at the school, part of the work he did to pay his tuition. He talked with a student named Jess Fox while he worked. Jess was studying violin making and repair. She asked Nolle if he'd be willing to build two nightstands for her. If he needed work done on a violin, she joked, they could trade skills.

How many people have violins lying around in need of repair?

That night Nolle remembered his grandfather's violin in the shoe box at the back of the closet.

The next day Nolle told Jess about the violin, and he and Jess made a pact: he'd build the nightstands if she'd finish the violin.

Nolle called Kayleen and asked her to send the violin parts.

The pieces of the violin and Ruane's violin letters were

shipped from west to east. When they arrived, Jess found inside the box a rib structure, the front and back plates arched and graduated, and a scroll fully carved.

Jess worked on the violin for months, deciphering Howard's handwritten notes and Ruane's typed instructions and her sketched drawings and diagrams. Jess didn't undo any of the violin's idiosyncrasies. She left the burn marks on the instrument from whatever tool Howard had used to bend the wood. He'd needed water and heat, so she guessed he'd used a radiator.

Jess glued the bass bar, set the neck. Added linings and sound holes. Repaired the bridge. Scraped and sanded and varnished. She could tell the neck, scroll, and sides were made of maple, but she couldn't tell what wood he'd used for the other parts of the instrument.

A prison meat crate, Howard later told her at his birthday party before she played the finished instrument.

. . .

Let's say you miss your friend, so you think of your friend, imagine him, but the imagined friend pales in comparison to the real friend, so you conclude imagination is a disappointment.

You have misunderstood how the imagination works, Elaine Scarry wrote in *The Body in Pain*. You shouldn't compare the imagined friend to the real friend. You should compare the imagined friend to no friend at all. It is better to have an imagined version of your friend in your mind than to live in a world without your friend, to live in a world *utterly devoid of his presence*. Imagining your friend might help you make your real friend present, Scarry wrote.

This is how it works: You're hungry, and you imagine an apple. You walk to the kitchen, and if there is no apple in the bowl on the table, you walk to the store to buy one, and then you eat it, and you're no longer hungry.

When the world fails to provide an object, the imagination is there, Scarry wrote. The imagination is the first step for generating the objects we need, the objects we don't yet have. *Missing,* she wrote, *they will be made-up.*

. . .

In *Notes from No Man's Land,* Eula Biss quoted lyrics from a Yoruba song: *We always greet hunger with a basket.*

. . .

In her diary, Virginia Woolf wrote: *Thinking is my fighting.*

. . .

The artist Josh Azzarella doctored the Abu Ghraib photographs. Gone are the hooded man, the prisoner and the leash, the line of naked men. Instead there is a cardboard box in an empty room and a man looking through images on his digital camera. Instead there is Lynndie England standing alone, Lynndie England smiling and giving the thumbs-up.

. . .

In "Potential History: Thinking Through Violence," Ariella Azoulay wrote about a new way to read historical photographs. She used an archive of images taken between 1947 and

1950, during the formative years of Palestine's transformation into Israel, to illustrate her point. Instead of reading the images of the past through the lens of future categories—that is a *refugee*, that is an *oppressor*, that is the *oppressed*, that is my *enemy*, that is my *friend*—she read the photographs as capturing moments of transition, when everything was still possible: those people are *neighbors*.

She called this work with photographs *potential history*. Azoulay used the word *potential* to expose unrealized possibilities. It was Walter Benjamin's *incomplete history* she was after, in which those of us in the present can see the violent achievements of power in the past and render them potentially reversible.

When I taught Azoulay's article, a student asked, Reversible? Is she saying looking at a photograph can change the past?

Another asked, Is she talking about time travel? And everyone laughed.

You can't change the past, the first student said. And isn't the idea that you can change the past offensive to people who were harmed in the past? Aren't you pretending their suffering isn't real?

That's not what she's saying, another student said. She's asking you to imagine things turning out differently. And if you can imagine things turning out differently in the past, even for a second, then maybe you can make the world different in your present.

· · ·

I reimagine Bybee's torture memos, replace the euphemisms for torture, insert words where the redactions are: *You would*

like to place Zubaydah in a BEAUTIFUL GLASS HOUSE. *You have informed us that he appears to* LIKE BUTTERFLIES. *In particular, you would like to tell Zubaydah that you intend to place a* CATERPILLAR *into the* HOUSE. *You have orally informed* HIM *that you would in fact* PLACE A COCOON IN *the* HOUSE *with him.* AND HE WILL WATCH THE COCOON, PAY ATTENTION TO IT, WAIT PATIENTLY UNTIL THE BUTTERFLY EMERGES. *Finally,* THE BUTTERFLY *would use a technique called "*FLIGHT.*"*

. . .

Art—bringing a physical object into the world where there previously was not one—illustrates on a small scale what's possible on a larger scale, Scarry noted. You imagine _____, and you paint _____. You take something from inside your mind and put it out in the real world—from my head to my hand, from my head to your hand—which means that what was once inside your mind is now shareable. Imagining a city, you make a house, Scarry said. Imagining a political utopia, you help build a country. Imagining the elimination of suffering in the world, you nurse a sick friend.

Scarry called the creation of an artifact—a sentence, a cup, a piece of lace—a *fragment of world alteration.* And if you can make these smaller changes, she wrote, if you can alter the world in fragments, just think what can be imagined together, what might be possible in community: *a total reinvention of the world.*

. . .

Miles told me he wants to be a middle school art teacher. He plans to enroll in a credential program in the fall. The army will pay his tuition.

When did you know you wanted to be an art teacher? I asked.

I used to hang out in the classroom at Abu Ghraib, he told me.

What classroom? I asked.

They used to pull the younger guys out and bring them into a room set up like a classroom for two or three hours a day, he said. The juveniles, the ones who were under eighteen.

What did you teach? I asked.

I wasn't the teacher, he said. I had no idea what was going on because the teacher was speaking Arabic. But there would be breaks, time for the kids to play chess or board games, and I played chess with them, Miles said. They were good at it. They beat me.

. . .

Our real lives hold within them our royal lives; the inspiration to be more than we are, to find new solutions; to live beyond the moment, Jeanette Winterson wrote. *To see outside of a dead vision is not an optical illusion.*

. . .

I don't pay attention to the news, Miles said. I don't think about the army when I'm at home. You could never tell, when I'm walking down the street, that I'm part of the military. I don't wear army T-shirts or anything. I don't flash it.

Miles was wearing a flannel shirt, red-and-blue plaid, his hair cut close, a little more gray.

I'm like Clark Kent, he said. The military is my secret identity. The uniform changes my personality.

In what way? I asked.

When I wear it, I don't smile. It gives me a sense of authority. It's my armor.

They'd just had a holiday party at the base, families were invited, and all the soldiers wore their civilian clothes. I felt insecure, he said. I felt weak.

. . .

In her directions for building the violin, Ruane wrote: *The imaginary lines on the drawing which I am sending in will denote where the thicknesses merge into one another. The purfling is the edge which overlaps the sides. That and the button have no influence on the vibration of the plates and are left to the discretion, or instinct, of the fiddle maker; but a good strong obtuse edge has a tendency to strengthen the entire instrument.*

. . .

Words can take away humanity, and words can give it back.

. . .

We understand from you that no detainee WILL BE *subjected to this technique by the CIA* AND THAT NO ONE WILL SUFFER *any harm or injury, either by falling down and forcing the handcuffs to bear his weight or in any other way. You have assured us that detainees are continuously monitored by* PEOPLE WHO LOVE THEM, *so that if a detainee were unable to stand, he would immediately be* GIVEN A BED IN WHICH TO LIE DOWN *and* SOMEONE WOULD COVER HIM WITH WARM BLANKETS AND HE *would not be permitted to dangle*

by his wrists. *We understand that standing sleep deprivation may cause edema, or swelling, in the lower extremities* SO IT IS NOT GOOD TO FORCE *detainees to stand for an extended period of time,* NOT THAT WE'D NEED TO REMIND YOU ABOUT THE HARM IT COULD CAUSE, FOR EVERYONE *has advised us that this condition is painful, and that the condition disappears quickly once the detainee is permitted to lie down.* YOU WILL PLACE YOUR HAND GENTLY ON HIS HEAD. YOU WILL WHISPER IN HIS EAR, THERE IS NOTHING TO BE AFRAID OF.

. . .

Theology is, and always has been, fundamentally a work of the human imagination, Gordon Kaufman wrote. God is serendipitous creativity, and humans can participate in divine creative activity by working transformatively within the context of the already created world, but *the human creation of trajectories of massive destructiveness must be put out of bounds.*

The philosopher Richard Rorty said it differently: Stop worrying about whether what you believe is true, he wrote. Stop worrying about whether it can be proved. Worry about whether you have been imaginative enough to think up good alternatives.

. . .

Inside the finished violin, there is a label: *Made by Howard B. Scott, Federal Prison Camp, McNeil Island, Washington, 1945, and completed by Jess Fox, Boston, 2005.*

. . .

In the catalog essay for Jenny Holzer's *Dust Paintings*, Henri Cole wrote, *Standing before Jenny's dust-paintings, if I squint my eyes and let my imagination run wild, I can hear a call to prayer.*

. . .

It is our understanding that HARMFUL *techniques are not used* ANY-MORE, *but* INSTEAD YOU USE *a full course of* TENDER *conduct to resemble a real* HEALING. SOMETIMES YOU JUST LISTEN. SOMETIMES YOU SHARE A MEAL. *You have found that the use of* OTHER *methods together or separately, including the use of the waterboard, has resulted in* TOO MANY *negative long-term mental health consequences. The continued use of these methods without mental health consequences,* AS SHOULD BE CLEAR, *is highly improbable.* YOU WILL OPEN THE BOX. YOU WILL LET EVERYONE GO.

. . .

I took the train from Portland to Seattle and the ferry to Bainbridge to celebrate Howard's birthday with him. The next morning, I walked from the studio to the main house for breakfast, and Kayleen handed me the newspaper she'd been reading.

Look, she said. They're closing McNeil.

McNeil: The prison where Howard spent two years of his life. The prison where he met the violin maker. Where Ruane sent him letters and directions for building the violin. Where he tended cows and walked trails and found a fallen maple tree.

After breakfast, we drove to the new place where Howard was living, a house in the woods near the water, run by a couple who believe God called them to care for the elderly. The

place Howard had been living before had insisted it was time to move him to end-of-life care, but when Kayleen and her sisters talked with Howard about it, he said, I don't want to go to prison.

We sang "Happy Birthday." We ate coconut cream cake, which I knew was his favorite because Ruane had written about it in a letter: *Were you here, Mister, I'd try to bake a big cake. I'd plant a little bird in the middle, just to prick the conscience a little. A little red bird. Then I'd put an aspirin beside your plate, 'cuz a cake of mine is not what the doctor orders, and you would indeed need help to get through the rest of the day. Then, I'd put a kettle on the stove, and heap some roasted gold in it, so that you would have some way of washing down the cake. Yes, and I'd put four tablespoons of sugar in, so that coffee wouldn't be too bitter. Nope, I've changed my mind: we'd have some cherry mixture. That would go better with a coconut cream cake, anyway. Then it would be fun after we'd made ourselves sick on this, to go on a good spree . . . hope to find a Symphony concert, or a real good play, and really splurge while we were at it. Then after the concert the two of us could go . . . have a good feast! Sure, we don't really care if we miss the last P.E. home. We've stayed all night before in cities.*

We talked in the living room, listened to music. Then Kayleen said, Dad, I want to show you something. She sat next to him on the couch and opened the newspaper, pointed to the headline.

They're closing McNeil, she said.

Finally, Howard said and cried.

17.

DRAW YOUR WEAPONS

In the spring, Kayleen called to tell me Howard was dead.

Howard and Ruane had asked that their ashes be scattered together on Mount Rainier, also called *Tahoma*, which means *the mountain that was God*.

I took a train to Seattle and rode a boat across the water, and Kayleen and Paul picked me up and drove me to their house. I slept in the studio, a few pictures of Howard and me on the bookshelf next to the bed. I'd asked Kayleen to take those pictures on my first visit, Howard and me standing with our arms around each other.

. . .

Miles's parents spend months at a time in Mexico, and he had just returned from a visit the last time we Skyped. He was there right before the Day of the Dead, and he watched the preparations, altars filled with papier-mâché skulls and marigolds, the bright orange said to guide the spirits of the dead to altars tended by the living.

He brought home a tablecloth so he could make his own altar. On the tablecloth, an image of a skeleton couple.

I like the tradition, though I don't want to have to add people I love to the altar, Miles said. But that's how life will go.

In the background, I heard the voice of a child waking. His two-year-old daughter had been sleeping on the couch in the other room. She had a fever. While we talked, he'd been listening for her. Miles left the room and carried her back in. She yawned, still half-asleep, put her head on his shoulder. He held her close.

. . .

Another drone alert on my phone: *Ahmed was in the forest. Four drone missiles came out of the sky. Up to eight people killed.*

. . .

Abraham packs a knife, packs a rope, climbs the mountain, ᵗhers wood, places his son on top of the wood, raises the above his son because he thinks this is what God wants ᵗo, because he thinks he has to prove his faith, act it out ᵗy of another.

. . .

What's the problem, Scottie? they asked when Howard was lined up at the firing range.

I can't kill, he said.

. . .

Abraham lifts the knife and sees the ram. He unbinds his son. He binds the ram. Abraham lifts the knife and sees a tree. He unbinds the ram and places a block of wood under his knife instead.

Let there be an angel. Let the angel come. Let there be a ram. Let even the ram be let go. Let him walk down the mountain. Let him kiss his son. Let him fall down at the feet of his son. Let him fall down at the feet of his son. Let him fall down at the feet of his son.

. . .

Kayleen, Paul, and I arrived at the memorial service early, and I helped arrange family photographs for the reception—pictures of Howard and Ruane and their children and their children's children. Soon their faces filled the room.

. . .

What are you painting these days? I asked Miles.

I haven't painted much since I became a dad, he said. Haven't had time. But I'm ready to start again. I just bought some paint. He held a white box up to the camera so I could see it. Acrylics, he said. He held up another white box. Oils.

I'm hoping my daughter will like to paint, he said. I bought her an easel. We're going to try this weekend.

What will you paint?

I don't know yet, he said. Did you ever see the painting I made of the hands holding a Koran?

No, I said. What made you paint that?

I thought it was a beautiful image, he said.

I've only seen a few of your paintings, I said. *The Surge*. The line of detainees squatting on the ground in front of portable toilets. The detainee in the yellow jumpsuit, the one your nephew posed for.

Those are all in the garage, he said.

What made you paint what you painted when you got home? I asked.

Maybe it was my way of telling someone, Miles said. I try to hide it.

. . .

Howard and Ruane's grandchildren helped scatter their ashes on Mount Rainier. Releasing a handful on the trail, one of them said, I know why Nana and Boppa want to be here. This is where you see the birds.

. . .

Another drone alert: *Nine people were killed in a house.*

I cut strawberries. Lean my hip against the sink. Trim the green tops, the leaves sticking to my thumb, to the knife, which is sharp and pointed, rounded back like the wing of a swallow. I put the green tops in the compost bin, as if I'm doing my part, as if I'm responsible for something.

The summer has ended and we are not yet saved, Jeanette Winterson wrote.

On the corner, a man held a cardboard sign: *Anything helps*. It only takes one contaminated seed to kill a songbird.

. . .

Alfred Stieglitz offered this: *Wherever there is light, one can photograph*.

. . .

One of my students tried to explain quantum theory to me. She talked about superpositions, about particles holding all possibilities at the same time, about how light affects the way particles behave. Light counts as an observer, she said.

. . .

The artists Adam Broomberg and Oliver Chanarin traveled to Afghanistan to embed with the British Army in Helmand Province in 2008. To get access to the front lines, they had to sign a form that banned them from taking images showing the conflict—no dead bodies, no wounded bodies, no evidence of enemy fire. Instead of cameras, they brought a roll of photographic paper inside a lightproof box.

The first day they were embedded, a BBC fixer (a journalist's interpreter, guide, source finder, and, sometimes, guard) was dragged from his car and executed, and nine Afghan soldiers were killed in a suicide attack. Three British soldiers died the next day. A suicide bombing killed eight Afghan soldiers the day after that, and when news of his brother's death in that ambush reached another soldier the following day, he put his gun to his chest and pulled the trigger. On the fifth day, no one died.

In response to each event, at the moment when a traditional photojournalist would take a photograph, the artists unrolled a six-meter section of the light-sensitive paper from the light-proof box and for twenty seconds exposed it to the sun.

The images in their exhibition, *The Day Nobody Died*, are abstract, nonfigurative. Darkness opens to waves of green and red and blue and yellow and white. Those pieces of paper were there in that place, the artists said. The images are real witnesses. They bear the effects of the light.

· · ·

Bring your sorrow / for everyone out into the street, / in the sun, the poet Matthew Zapruder wrote in "Come On All You Ghosts."

· · ·

What if instead of a knife, Abraham had used a drone? Imagine him in a windowless room in the desert, watching several screens at once. There he is, he says and points to the monitor that shows his son. He does not see the ram. There is no time to change his mind.

· · ·

On the edge of the Predator drone's gray wings are microscopic holes. A solution seeps through them that melts any ice that forms during flight. They're called *weeping holes*. The whole body of the thing an eye.

· · ·

All seeing is heated, James Elkins wrote. There is a force to looking, and the force works in both directions: light pushes its way into your eyes; your eyes push their way into the world.

. . .

The first photograph I saw of Howard in the newspaper holding the violin at his birthday party was taken in the moments right before Jess Fox leaned the violin against her chest, placed it on her shoulder, rested her cheek on its hollowness, lifted the bow, and drew it across the strings.

. . .

Sympathetic strings: when you play one string, another string vibrates.

. . .

Would you let Miles Jr. be in the military? I asked Miles.

Yes, he said. Two years of service is a good idea for everyone. I'm in favor of it. Besides the war part, it matures you.

You'd let him enlist even knowing all the things you saw?

I was prepared mentally, he said. I knew what to expect.

. . .

When Jess played the violin, everyone sitting in the circle of chairs in the basement of the nursing home stood. They danced. Howard cried and clapped his hands to the rhythm of the music. Jess played "Wayfaring Stranger," one of Howard's

favorite songs: *I'm just a poor wayfaring stranger / Traveling through this world of woe / There's no sickness, toil nor danger / In that fair land to which I go.* That the violin had reappeared in its completed form to be played seemed like magic to Howard.

This is the gift of angels, he said.

. . .

When Isaac comes back down the mountain, he is not the same. He will never be the same. He keeps a notebook, carries it everywhere he goes. He draws what people want to pretend never happened, what they explain away as evidence of faith. He draws the bundle of wood his father made him carry up the mountain. He draws rope. He draws the altar. He draws the flames. He draws the knife, again and again. He draws trees. He draws the leaves he heard rustling in the wind when his eyes were closed. He draws the angel. He draws ropes untied. He draws the ram. He draws birds he feeds with his open hand. He draws the sky and clouds and stars and moon. He draws hillsides. Mountaintops. Plants and flowers blooming. Ancient trees. Rocks. Valleys. He draws his brother banished in the desert. He draws friends. He draws neighbors. He draws people far away who come to sit for him, who line up for miles. He draws gardens. He draws bones. He draws his children. He draws his mother. He draws his father.

. . .

Next to Howard's bed there was a pencil drawing Ruane made—a diagram of the violin, all the parts labeled, directions for how to build it.

It's a love story, Kayleen's sister said when she saw me look-

ing at the drawing. The threads of this instrument passed through all of us. Three generations, all connected.

. . .

The world is made. And can be unmade. Remade.

My grandfather made birdhouses, train tracks, chairs, tables, dollhouses. Howard made a violin—back, belly, neck, ribs. Miles makes paintings. I make sentences.

. . .

The student still trying to explain quantum theory to me sent links to videos and articles about the *double-slit experiment*. Scientists built a tiny device, a thin rectangular plate with two narrow vertical openings. They directed a current of electrons toward the plate. When no one was watching, the electrons behaved as both particles and waves and the plate recorded the hallmark signature of an interference pattern: bright, dark, bright, dark. But when there was an observer—and in this experiment the observer was a camera—the electrons behaved only like particles and not like waves. I don't understand the science or what the scientists are saying, but I do understand their conclusion: The act of watching affects what's being watched.

. . .

My friend is preparing to be a Buddhist chaplain, and her teacher took the group of chaplains in training to a medical school to meditate on corpses. The doctor unzipped two body bags; one body had just arrived, and the other had already

been dissected, each organ visible—heart, spleen, liver, lungs. The students stood around the table.

. . .

Now this alert: *Five people gathered for a meeting. They were inside a house. A drone strike ended their conversation.*

. . .

Miles is still in the army reserve. He enlists in three-year increments. When he reenlisted this time, he was promoted and transferred to a new unit.

Why did you reenlist after you got back from Iraq? I asked Miles.

People, he said. I have good friends.

You stay for your friends?

My unit is depending on me, he said. And I'm close to twenty years of service. It would be silly to stop now. I'll get a pension. It's a good safety net.

Before the transfer, he'd been in a mortuary unit, working as a cook. Now he's in a hospital, training a combat support unit—the people who will take care of the wounded. Miles is in charge of more than three hundred soldiers.

They didn't really tell me the truth about the new position, he said.

Miles had agreed to the transfer because the unit had just returned from Kuwait. Deployment happens on a five-year rotation, so he figured by the next time they were up for deployment, he'd be retired. But after they hired him, they told him they'd adjusted the schedule. His unit will be deploying again next year.

Quantum entanglement: When two particles interact, they become entangled. They could travel light-years apart, and the spin of each would remain correlated with that of the other.

I don't understand quantum entanglement, but I can't stop thinking about it—how an interaction leaves everything changed. How, when two things come together and then go apart, they are still connected. Know the spin of one, and predict the spin of the other. Change the spin of one, and you change the spin of the other.

Einstein called it *spooky action at a distance*.

. . .

The photograph is not my problem, the photographer said. *It's yours.*

. . .

I walked into the world of one picture: I met Howard and his family, listened to them, read their letters, stayed in their house, held the violin. The other picture walked into my world: Miles arrived in my classroom after serving at Abu Ghraib prison, talked to me about war, made a painting of a soldier I keep in my house.

When I teach about drones I ask my students, Now that images can be used to kill, what does that mean for image makers? I act as if drones ushered in a new way of seeing, but, in fact, drones didn't usher in anything new at all; they just expanded the work photography has been doing since its invention. Teaching viewers how to see or not see each other. Teaching viewers how to treat one another.

And my students ask: But what are we supposed to do?

I teach them about such terribleness. Everything troubling, everything tied to everything else, everyone complicit, enmeshed. I think of Howard in his prison cell. Maybe I'll just sit here, I think. Maybe I'll just sit here and not move. Maybe that will be better. Let my body go limp, the way protesters do when they're carried away by the police.

But Howard made a violin—and at the end of every semester, my students show up with new art in their hands. A metal sculpture of a drone. An image of a body made with a handheld scanner, enormous, distorted, as luminous as a Caravaggio painting. A letterpress book of a year's worth of drone alerts. A miniature diorama with mirrors that trick the eye—look at it from one angle, and see the man covered in the blanket on the box; look at it from another angle, and he's gone.

. . .

One of my teachers, the theologian Gordon Kaufman, often pointed to Genesis when we talked in his basement office at the divinity school, to the God who speaks words to bring the world into being, who uses clay and breath to make human beings. You see? he'd say. In this story God is a poet and a potter, and even though that doesn't tell us much about God, it tells us a lot about what the authors thought about artists: they knew artists' work was world making.

. . .

Behold, we are making a new thing.

. . .

Let there be light. Let there be no war. Let there be no battles on the whole globe. Let there be no planes in the sky raining down bullets. Let there be no trenches. Let there be no piles of dead bodies. Let there be no hollow-tipped bullets. Let there be no one in the desert in boxes kept at sixty-five degrees. Let there be no buttons to press. Let there be no buzzing. Let there be no shrapnel. Let there be no wet cloths over mouths. Let there be no wailing. Let there be no bones breaking. Let there be no hoods. Let there be no blindfolds. Let there be no hand-cuffs. Let there be no rope. Let there be no billy clubs. Let there be music. Let there be instruments waiting to be played. Let there be children. Let there be water. Let there be honey-bees. Let there be farmers in the fields. Let them all be left standing. Let the fields be fertile. Let the harvest be enough. Let the seeds be saved. Let there be cameras. Let there be photographs. Let there be people watching monitors looking for anyone in pain. Let there be songbirds. Let there be blue skies and no one to fear them. Let there be dreaming in the night. Let there be people sleeping on rooftops and under blankets and nothing to frighten them awake. Let there be feasting. Let there be singing. Let there be people rushing out of houses to dance together in the streets. Let there be pictures brought to lips and kissed. Let there be ghosts just behind. Let there be remorse. Let there be shame. Let there be truthtell-ing. Let there be accountability. Let there be repair. Let there be forgiveness. Let there be weapons laid down and never lifted. Let there be clean water to drink. Let there be cherry blossoms and mice smelling them and no shock. Let there be no one standing on boxes. Let there be no monkey on the plank. Let there be no island blown apart. Let there be no wak-ing in the dead of night to take down all the photographs. Let there be grief. Let there be grief for all bodies. Let them be

counted. Let there be names for every one. Let there be anti-
dotes. Let there be salves. Let there be poets. Let there be
painters. Let there be sculptors. Let there be woodworkers.
Let there be violin makers. Let there be enough money for
school. Let there be gardens. Let there be wilderness. Let there
be empty cells. Let the trauma in the cells be reversed. Let
laughter be what's passed down. Let there be language. Let
there be letters. Let there be words. Let there be stories. Let
there be memos that explain how to love. Let there be doubt.
Let there be people gathered. Let there be keening. Let there
be never again. Let there be rest. Let there be solace. Let there
be only birds' wings passing over the sun. Let there be breath.
Let there be lift. Let there be places to be alone. Let there be
hiding places. Let there be ancient trees. Let there be living
creatures of every kind. Let there be good. Let there be only
good. Let there be no reason to look away.

. . .

We sat in the Quaker meetinghouse, facing one another, win-
dows along two of the walls. One of Howard's sons-in-law ex-
plained how the service would work, how to leave space after
each person's offering. Think of the words like a pebble thrown
into a pond, he said. Leave enough time for the ripples to reach
the shore.

Toward the end of the gathering, one of Howard's oldest
friends stood.

He was always making music, Howard's friend said. He's
making music still. Can't you hear him?

ACKNOWLEDGMENTS

It took me ten years to write this book, and though I spent countless hours by myself at my desk, I did not write alone. Thank you, Hayley Barker, Faith Danforth, Carole DeSanti, Maylen Dominguez, Katie Ford, Gia Goodrich, Karen King, Elizabeth Malaska, Laura Moulton, Taura Null, Laurel Reed Pavic, ShuNahSii Rose, Natalie Serber, and Liz Sutherland. Thank you, Juliana Jones Munson. This book would not exist without you. Thank you, Amy Walsh, for supporting my art in every possible way. Thank you, Alice Dark, for always being willing to read drafts and for offering insightful ways to make the pages better. Thank you, Ruth Ozeki, for sharing your

agent and your wisdom with me, and for Hedgebrook. Thank you, Hedgebrook, for your radical hospitality. I finished a draft of *Draw Your Weapons* during my residency, and I learned I'd sold the book when I returned to take Carolyn Forché's master class. That place is magic. Thank you, Nancy Nordhoff, Vito Zingarelli, Amy Wheeler, Julie O'Brien, Harolynne Bobis, Rio Rayne, and Carolyn Forché for all you do to support women authoring change. Thank you, Tin House, Lance Cleland, and my workshop leaders, Nick Flynn and Maggie Nelson. Thank you, Steve Patterson and Willamette University, for inviting me to be the Teppola Chair and supporting me to take the master class at Hedgebrook. Thank you to all the students and colleagues I worked with at California State University Channel Islands, Pacific Northwest College of Art, and Willamette University, especially the artists, who showed me the world is made and can be remade. I hope you see your influence in these pages. Thank you, Emily Rapp, for reading a zillion drafts and for knowing the perfect editor for this project. You are one of the most generous people on the planet. Thank you to the best agent ever, Molly Friedrich. This book could not have happened without your fierce brilliance and advocacy. I am eternally grateful. Thank you, Alix Kaye and Clayton Wickham, for your careful reads, and thank you, Ellen Gomory, for all you do to help make books happen. Thank you to my exceptional editor, Andy Ward. Thank you for helping this book become itself and for your care, rigor, deep thinking, courage, and humor. You are extraordinary and so good at what you do. Let's hope language bombs can someday disarm actual bombs. Thank you to the incredible team at Random House, who made this book better and beautiful: Jessica Bonet, Evan Camfield, Benjamin Dreyer, Richard Elman, Susan Kamil, Rachel Kind, London King, Leigh Marchant, Oliver Munday,

Kaela Myers, Joe Perez, Tom Perry, and Bonnie Thompson. Working with you has been a pleasure and a gift. Thank you to my parents, Ann and Irwin Sentilles, who taught me to love words and the worlds they make. And thank you to my siblings, Emily, Irwin, and Della; my in-laws, Rebecca, Charley, Kristine, Dione, Barbara, and Jerry; and my nephews, Sam, Elwood, Mason, and Henry. Thank you to my grandparents, who were carrying wounds of war it took me too long to see. Thank you, Miles, for sharing your story with me and for troubling my pacifism so I could see being philosophically against war is not protest enough. Thank you, Kayleen Pritchard, for trusting me with your parents' story, for welcoming me into your home, and for being my Uni-Ma. Pixie dust. Thank you, Kathryn Willard, Karen Saxon, Paul Pritchard, Nolle Pritchard, and Jess Fox. Thank you, Howard and Ruane Scott. I hope this book is a testament to your commitment to making a more just and life-giving world for all beings, no matter the consequences that work carried for your own lives. Thank you for helping me remember it's possible to choose peace. I wrote these pages in your memory, and in memory of all the dead of our long wars. And, finally, thank you to my partner, Eric Toshalis, who makes everything possible, and who works, every day, to advocate for and be accountable to the marginalized and vulnerable. You inspire me to try to do the same.

NOTES

PREFACE

xii To see a photograph of suffering: Ariella Azoulay, *The Civil Contract of Photography* (New York: Zone, 2008), 113, 127.

xii *Let's face it:* Judith Butler, *Precarious Life: The Powers of Mourning and Violence* (New York: Verso, 2004), 23.

xii A professor at the art school: The artist is David Eckard, davideckard.com.

I. THE PHOTOGRAPH IN THE NEWSPAPER

3 It was Howard Scott's eighty-seventh birthday: Jack Thomas, "Howard Scott's Unfinished Sonata," *Boston Globe,* March 7, 2006, boston.com/ae /music/articles/2006/03/07/howard_scotts_unfinished_sonata.

5 The artist Ann Hamilton: I learned about Hamilton's mouth-held
pinhole camera on *Art 21*, pbs.org/art21/artists/ann-hamilton.

6 It is a mistake to associate: Roland Barthes, *Camera Lucida: Reflections on
Photography*, trans. Richard Howard (New York: Hill and Wang, 1981), 106.

8 Faces in photographs endure: Alex Danchev, *On Art and War and Terror*
(Edinburgh: Edinburgh University Press, 2009), 38.

9 The word *lost* comes from: Rebecca Solnit, *A Field Guide to Getting Lost*
(Edinburgh: New York: Canongate, 2006), 7.

2. ANOTHER PHOTOGRAPH IN THE NEWSPAPER

13 I saw a different photograph: The photo can be seen at newyorker.com
/magazine/2004/05/10/torture-at-abu-ghraib.

13 To look at a photograph: Roland Barthes, *Camera Lucida: Reflections on
Photography*, trans. Richard Howard (New York: Hill and Wang, 1981),
79, 84.

14 Let's start with a photograph: Virginia Woolf, *Three Guineas* (London:
Harcourt, Brace, 1938), 3–11. Susan Sontag writes about Woolf's
engagement with photographs at the beginning of *Regarding the Pain
of Others* (New York: Picador, 2003).

15 People in photographs watch you: Eduardo Galeano quoted by Alex
Danchev in a chapter titled "The Face, or, Senseless Kindness: War
Photography and the Ethics of Responsibility" in *On Art and War and
Terror* (Edinburgh: Edinburgh University Press, 2009), 38.

15 The first person to use: Nicholas Mirzoeff, *An Introduction to Visual Culture*
(London: Routledge, 1999), 77.

15 *Photography rendered slavery visible:* Mirzoeff, *Introduction to Visual
Culture*, 77.

15 Sabrina Harman: Joel Roberts, "She's No Stranger to Grisly Images,"
CBS News, May 10, 2004, cbsnews.com/news/shes-no-stranger-to-grisly-
images.

16 In 1850, the biologist Louis Agassiz: Robin Lenman, ed., *The Oxford
Companion to the Photograph* (Oxford: Oxford University Press, 2005), 650.

16 The abolitionist Frederick Douglass: Lenman, *Oxford Companion*, 650.

16 At Abu Ghraib, Sabrina Harman: Philip Gourevitch, "Exposure: The
Woman Behind the Camera at Abu Ghraib," *New Yorker*, March 24, 2008,
newyorker.com/magazine/2008/03/24/exposure-5.

17 More than one hundred years: Lenman, *Oxford Companion*, 650.

17 Despite the photographer's intentions: Mirzoeff, *Introduction to Visual
Culture*, 80.

17 Sabrina Harman had a pet: Gourevitch, "Exposure."

18 **At the root of all art:** André Bazin, "The Ontology of the Photographic Image," *Film Quarterly* 13, no. 4 (1960): 4–9.

18 **If you look up Agassiz:** britannica.com/EBchecked/topic/8791/Louis-Agassiz.

19 **The very first daguerreotype:** Ariella Azoulay, *The Civil Contract of Photography* (New York: Zone, 2008), 93–94.

19 **The artist Carrie Mae Weems:** I saw Weems's photographs at the Portland Art Museum in 2013. I learned more about her work in an audio interview for *MoMA 2000: Open Ends*, Museum of Modern Art and Acoustiguide, 2000, moma.org/explore/multimedia/audios/207/2012, and moma.org/learn/moma_learning/carrie-mae-weems-from-here-i-saw-what-happened-and-i-cried-1995.

20 *War tears, rends:* Susan Sontag, *Regarding the Pain of Others* (New York: Picador, 2003), 3–7.

3. DOORWAY TO THE DEEP

23 **Would you rather have a painting:** Susan Sontag, *On Photography* (New York: Farrar, Straus and Giroux, 1977), 154.

24 **In the water there is:** Nancy Rommelmann, "Book Review: *Deep* by James Nestor," *Wall Street Journal*, July 11, 2014, online.wsj.com/articles/book-review-deep-by-james-nestor-1405098623.

25 **Waterboarding began as a form:** William Schweiker, "Torture and Religious Practice," *Dialog: A Journal of Theology* 47, no. 3 (Fall 2008): 208–216.

26 *Swimming a witch:* mtholyoke.edu/courses/rschwart/hist257/saraclona/final/identification2.html and foxearth.org.uk/SwimmingOfWitches.html and shakespearesengland.co.uk/2009/11/26/swimming-a-witch.

26 **The memo Assistant Attorney General:** Jay S. Bybee, "Memorandum for John Rizzo, Acting General Counsel of the Central Intelligence Agency," August 1, 2002, pp. 3–4.

27 **When God saw the wickedness:** Genesis 5–8; adapted from Bruce M. Metzger and Roland E. Murphy, eds., *The New Oxford Annotated Bible: New Revised Standard Version* (New York: Oxford University Press, 1991).

27 **Weapon or tool? The difference depends:** Elaine Scarry, *The Body in Pain: The Making and Unmaking of the World* (New York: Oxford University Press, 1985), 174–75.

28 **Torture unmakes the world:** Scarry, *Body in Pain*, 41.

28 **In his sworn statement:** Mark Danner, *Torture and Truth: America, Abu Ghraib, and the War on Terror* (New York: New York Review Books, 2004), 227.

29 **At the National Rifle Association's:** Gabe LaMonica, "Palin:
'Waterboarding Is How We Baptize Terrorists,'" CNN, April 28, 2014,
politicalticker.blogs.cnn.com/2014/04/28/palin-waterboarding-is-how-
we-baptize-terrorists/.

29 *This crusade, this war on terrorism:* George W. Bush, September 16, 2001,
quoted by Jonathan Lyons, "Bush Enters Mideast's Rhetorical Minefield,"
Reuters, September 21, 2001.

29 **In 2005, the company Trijicon:** Joseph Rhee, Tahman Bradley, and
Brian Ross, "U.S. Military Weapons Inscribed with Secret 'Jesus'
Bible Codes," ABC News, January 18, 2010, abcnews.go.com/Blotter
/us-military-weapons-inscribed-secret-jesus-bible-codes/story?id=
9575794.

29 **In a letter she sent home:** JoAnn Wypijewski, "Judgment Days: Lessons
from the Abu Ghraib Courts-Martial," *Harper's,* February 2006, harpers
.org/archive/2006/02/judgment-days/.

30 **After forty days, Noah sent:** Genesis 5–8 (adapted from Metzger and
Murphy, eds., *New Oxford Annotated Bible*).

31 *Every living cell is essentially:* Hope Jahren, *Lab Girl* (New York: Knopf,
2016), 229.

32 **When Jesus stood in the river:** Matthew 3:13–17 (adapted).

33 **When torturers use domestic objects:** Scarry, *Body in Pain,* 41.

33 **The American lawyer Susan Burke:** Nick Flynn, *The Ticking Is the Bomb*
(New York: Norton, 2010), 91. The artist is Daniel Heyman.

34 **There were rumors:** Melody Hill and Steven B. Caudill, "Special
Interests and the Internment of Japanese Americans During World
War II," *Foundation for Economic Education,* July 1, 1995, fee.org/articles
/special-interests-and-the-internment-of-japanese-americans-during-
world-war-ii/.

4. Looking at the Same Picture

39 **Three thousand conscientious objectors:** Joseph Shapiro, "WWII
Pacifists Exposed Mental Ward Horrors," *All Things Considered,*
December 30, 2009, npr.org/templates/story/story.php?storyId=
122017757, and Steven J. Taylor, *Acts of Conscience: World War II, Mental
Institutions, and Religious Objectors* (Syracuse: Syracuse University Press,
2009).

39 **All photographs, Ulrich Baer wrote:** Ulrich Baer, *Spectral Evidence: The
Photography of Trauma* (Cambridge, Mass.: MIT Press, 2002), 76.

40 *Who can forget the three color:* Susan Sontag, *Regarding the Pain of Others*
(New York: Picador, 2003), 13–14.

41 **This is what happens when you:** John Berger, *About Looking* (New York: Pantheon, 1980), 42–44.

42 **Lucretius, an ancient Greek philosopher:** Oliver Wendell Holmes, "The Stereoscope and the Stereograph," in *Classic Essays on Photography*, ed. Alan Trachtenberg (New Haven: Leete's Island Books, 1980), 72, 74.

43 **To make the case:** Colin Powell, "Full Text of Colin Powell's Speech," *Guardian*, February 5, 2003, theguardian.com/world/2003/feb/05/iraq .usa; also abcnews.go.com/Archives/video/feb-2003-colin-powell-wmd-12802420 and youtube.com/watch?v=ErlDSJHRVMA.

44 **A digital image can easily contain:** Lev Manovich, "The Paradoxes of Digital Photography," in *Photography After Photography*, an exhibition catalog published in 1995, manovich.net/content/04-projects/004-paradoxes-of-digital-photography/02_article_1994.pdf.

44 **General Richard Myers and United States:** Steven Strasser, *The Abu Ghraib Investigations: The Official Reports of the Independent Panel and Pentagon on the Shocking Prisoner Abuse in Iraq* (New York: Public Affairs, 2004), 38.

44 **During a hearing:** Ed Henry, "GOP Senator Labels Abused Prisoners Terrorists," CNN, May 12, 2004, cnn.com/2004/ALLPOLITICS/05/11 /inhofe.abuse.

44 **He continued:** *I am also outraged:* Susan Sontag, "Regarding the Torture of Others," in Sontag, *At the Same Time: Essays & Speeches*, ed. Paolo Dilonardo and Anne Jump (New York: Farrar, Straus and Giroux, 2007), 141.

44 **In the fifteenth century:** Valentin Groebner, *Defaced: The Visual Culture of Violence in the Late Middle Ages* (New York: Zone, 2004), 95.

45 **When Roland Barthes looked:** Roland Barthes, *Camera Lucida: Reflections on Photography*, trans. Richard Howard (New York: Hill and Wang, 1981), 80–81.

45 **He was Thomas reaching out:** Barthes, *Camera Lucida*, 9.

45 **One day in 1861:** Therese Oncill, "Mr. Mumler's Ghosts: The Father of Spirit Photography," *mental_floss*, mentalfloss.com/article/53221/mr-mumler%E2%80%99s-ghosts-father-spirit-photography.

46 **Mumler showed the image:** Crita Cloutier, "Mumler's Ghosts," in *The Perfect Medium: Photography and the Occult*, ed. Clément Chéroux (New Haven: Yale University Press, 2005), 21.

46 **Mumler's wife, Hannah:** Ibid.

47 **No matter how careful:** Christopher Pinney and Nicolas Peterson, *Photography's Other Histories* (Durham, N.C.: Duke University Press, 2003), 6.

47 **French colonists arrived in Algeria:** Malek Alloula, *The Colonial Harem* (Minneapolis: University of Minnesota Press, 1986), 4.

48 **Luc Tuymans's *Our New Quarters*:** Madeleine Grynsztejn and Helen

Molesworth, eds., *Luc Tuymans* (San Francisco: San Francisco Museum of Modern Art and Distributed Art Publishers, 2010), 72.

48 **When reports about the death camps:** I found this information through the website for Yad Vashem, the World Holocaust Remembrance Center, yadvashem.org/yv/en/holocaust/about/03/terezin.asp.

49 **When the Red Cross left:** I found this information online through the *Holocaust Encyclopedia;* see the entry on Theresienstadt, ushmm.org/wlc/en/article.php?ModuleId=10005424.

49 *Gaskamer (Gas Chamber)* **is the first:** Grynsztejn and Molesworth, *Luc Tuymans,* 76. The editors are using a Tuymans quote from an essay titled "Disenchantment" (1991), translated by Shaun Whiteside and found in Ulrich Loock et al., *Luc Tuymans* (London: Phaidon, 2003).

49 **There were those who thought Mumler:** Oneill, "Mr. Mumler's Ghosts." Oneill is sourcing Henry Ridgely Evans's 1897 text *The Spirit World Unmasked: Illustrated Investigations into the Phenomena of Spiritualism and Theosophy.*

50 **The photographer William Guam:** Ibid.

50 **The founders of Spiritualism:** Nancy Rubin Stuart, "The Fox Sisters: Spiritualism's Unlikely Founders," *HistoryNet,* June 12, 2006, historynet.com/the-fox-sisters-spiritualisms-unlikely-founders.htm.

51 **When Colin Powell gave his speech:** David Cohen, "Hidden Treasures: What's So Controversial About Picasso's Guernica?," *Slate,* February 6, 2003, slate.com/articles/news_and_politics/the_gist/2003/02/hidden_treasures.html.

51 **On April 26, 1937:** "Guernica: Testimony of War," pbs.org/treasuresof theworld/a_nav/guernica_nav/main_guerfrm.html.

51 *Cries of children cries of women:* "A Journey Through the Exhibition," ngv.vic.gov.au/picasso/education/ed_JTE_ITG.html.

51 **In Spanish, the word for light bulb:** "Guernica: Testimony of War," pbs.org/treasuresoftheworld/guernica/glevel_1/2_process.html.

52 **The writer Mark Danner called:** Mark Danner, *Torture and Truth: America, Abu Ghraib, and the War on Terror* (New York: New York Review Books, 2004), 19.

52 **But the soldiers sometimes lit up:** Joseph Pugliese, "Abu Ghraib and Its Shadow Archives," *Law & Literature* 19, no. 2 (2007): 260.

5. MANZANAR

56 **For three thousand years, the Owens Valley:** Louis Sahagun, "The Owens Valley Paiute Massacre of 1863," *Los Angeles Times,* June 2, 2013, owensvalleyhistory.com/at_the_movies04/1863_paiute_massacre.pdf.

56 **The Paiutes wanted:** Alan Bacock, "A Paiute's Perspective," walking-water.org/water-stories/local-story/a-paiutes-perspective.

56 **By 1866, they were indispensable:** "Manzanar: Virtual Museum Exhibit," nps.gov/museum/exhibits/manz/print_version.html.

56 **In 1910, the town of Manzanar:** "Manzanar: Virtual Museum Exhibit," nps.gov/museum/exhibits/manz/print_version.html.

57 **If making one million innocent Japanese:** Henry McLemore, "This Is War! Stop Worrying About Hurting Jap Feelings," *Seattle Times,* January 30, 1942, densho.org/wp:content/uploads/2016/06/Documents_SPW.pdf.

59 **Though they are the oldest living:** "Bristlecone Pine," blueplanetbiomes .org/bristlecone_pine.htm.

63 **Plants that spread beyond the area:** David Allen Sibley, *The Sibley Guide to Trees* (New York: Knopf, 2009).

63 **The War Relocation Authority hired:** Linda Gordon and Gary Y. Okihiro, *Impounded: Dorothea Lange and the Censored Images of Japanese American Internment* (New York: Norton, 2006).

64 **Toyo Miyatake, a well-known photographer:** "Archie Miyatake: Father Avoids Photography Restriction in Camp," March 13, 2012, blog.densho .org/2012/03/archie-miyatake-father-avoids.html.

64 **Miyatake's son Archie was sixteen:** Pete Thomas, "At Manzanar, Fishing Was the Great Escape," *Los Angeles Times,* April 24, 2009, latimes.com /sports/la-sp-manzanar24-2009apr24-story.html.

64 **The United States spent $4 million:** "Chapter 16: The Manzanar War Relocation Site, November 21, 1945–Present," *Manzanar: Historic Resource Study Guide,* nps.gov/parkhistory/online_books/manz/hrs16b.htm.

65 **A building from Manzanar now houses:** Karen Piper, *Left in the Dust: How Race and Politics Created a Human and Environmental Tragedy in L.A.* (New York: St. Martin's, 2006).

6 *INTA MEANS YOU*

71 **In *Torture and Democracy,* Darius Rejali:** Darius M. Rejali, *Torture and Democracy* (Princeton: Princeton University Press, 2007), 4.

71 *Allegations of torture are simply less:* Ibid., 8.

71 **Stealth torturers use what's easy:** Ibid., 18.

71 **American slavers created ways to torture:** Ibid., 9.

72 *The Scourged Back* **is a photograph:** "The Whipping Scars on the Back of the Fugitive Slave Named Gordon," *US Slave,* October 13, 2011, usslave.blogspot.com/2011/10/whipping-scars-on-back-of-fugitive.html, and "Gordon (Slave)," *Wikipedia,* en.wikipedia.org/wiki/Gordon_ (slave).

73 **An eighteen-year ban on publishing photographs:** Elisabeth Bumiller, "U.S. Lifts Photo Ban on Military Coffins," *New York Times,* December 7, 2009, nytimes.com/2009/02/27/world/americas/27iht-photos.1.20479953 .html?_r=0.

73 **In *Soul Repair:*** Rita Nakashima Brock and Gabriella Lettini, *Soul Repair: Recovering from Moral Injury After War* (Boston: Beacon, 2012), 107.

74 **Pierre Bourdieu wrote that feelings:** Elizabeth Freeman, "Queer Belongings: Kinship Theory and Queer Theory," in *A Companion to Lesbian, Gay, Bisexual, Transgender, and Queer Studies,* ed. George E. Haggerty and Molly McGarry (Malden, Mass.: Blackwell, 2007), 309.

74 **I heard a story:** "Clever Bots," RadioLab, radiolab.org/story/137466-clever-bots. The computer scientist's name is Joseph Weizenbaum, and his program was called ELIZA.

75 **Some governments build elaborate torture chambers:** Rejali, *Torture and Democracy,* 18.

77 *Most civilian actions toward veterans:* Brock and Lettini, *Soul Repair,* 96.

78 **Fayum portraits—images created:** John Berger, *The Shape of a Pocket* (New York: Pantheon, 2001), 53–60.

79 **Consider this sentence, James Elkins suggested:** James Elkins, *The Object Stares Back: On the Nature of Seeing* (San Diego: Harcourt Brace, 1997), 18–19.

79 **The beholder looks at the object:** Ibid., 43.

80 **Or consider this sentence:** Ibid.

80 **In *The Body in Pain:*** Elaine Scarry, *The Body in Pain: The Making and Unmaking of the World* (New York: Oxford University Press, 1985), 58–59. Scarry meant something different by this quote than how I've used it in this passage: *Every weapon has two ends,* Elaine Scarry wrote, and the guard's attention had to stay exclusively on the *nonvulnerable end of the weapon,* the trigger end. The guard's attention could not slip down the body of the gun, could not follow the path of the bullet to the flesh of the prisoner, could not recognize *the internal experience of an exploding head and loss of life.* This is why concentration camp guards repeatedly said to prisoners, *I'd shoot you with this gun but you're not worth the three pfennig of the bullet,* Scarry wrote. Those words allowed the guard to worry about the lost money, to feel the weight on his shoulders of following orders, to lament having to watch. She wrote here about how Nazis trained soldiers to think of the impact on themselves—rather than the impact on their victims.

7. SOUVENIR

84 **The word *souvenir* comes from:** Harvey Young, "The Black Body as Souvenir in American Lynching," *Theatre Journal* 57, no. 4 (2005): 641–42.

85 **I read this in *Harper's*:** Scott Horton, "The Guantánamo Suicides," *Harper's,* March 2010, harpers.org/archive/2010/03/the-guantanamo-suicides.

88 **When White Americans lynched Black Americans:** Young, "Black Body as Souvenir," 639.

88 **The word *remains* is a noun:** Ibid., 655–57.

88 **In his book *The Cross and:*** James H. Cone, *The Cross and the Lynching Tree* (Maryknoll, N.Y.: Orbis, 2011), 30–31.

89 **There's a postcard of the lynching:** The postcard is kept at the Beinecke Rare Book and Manuscript Library at Yale University: brbl-dl.library.yale .edu/vufind/Record/3811230.

89 **Sometimes on their days off:** Dawn Bryan, "Abu Ghraib Whistleblower's Ordeal," *BBC News,* August 5, 2007, news.bbc.co.uk/2/hi/middle_east/6930197.stm, and Michele Norris, "Abu Ghraib Whistleblower Speaks Out," *All Things Considered,* August 15, 2006, npr.org/templates /story/story.php?storyId=5651609.

90 **In *On Longing*, Susan Stewart wrote:** Susan Stewart, *On Longing: Narratives of the Miniature, the Gigantic, the Souvenir, the Collection* (Durham, N.C.: Duke University Press, 1993), 136.

91 **Who doesn't know what it's like:** John Berger, *The Shape of a Pocket* (New York: Pantheon, 2001), 246.

92 **Joseph Darby—the soldier who:** Norris, "Abu Ghraib Whistleblower Speaks Out."

92 **One of the doctors at Auschwitz:** Madeleine Grynsztejn and Helen Molesworth, eds., *Luc Tuymans* (San Francisco: San Francisco Museum of Modern Art and Distributed Art Publishers, 2010), 89.

92 **Doctors working with amputees:** V. S. Ramachandran and Sandra Blakeslee, *Phantoms in the Brain: Probing the Mysteries of the Human Mind* (New York: Quill, 1999). The Oliver Sacks quote is from the book's forward.

93 **Aristotle referred to the camera obscura:** "History of Camera Obscura," camera-obscura.co.uk/camera_obscura/camera_history.asp.

93 **A man in Baghdad is asleep:** Nick Flynn, *The Ticking Is the Bomb* (New York: Norton, 2010), 141–42. Flynn did not note in which city this event occurred; when I asked him to clarify where it took place, he said he thought it was Baghdad, but he was not sure.

96 **I can't get one little boy out:** This passage is adapted from my book *Breaking Up with God: A Love Story* (San Francisco: HarperOne, 2011).

102 *You determine to go forward:* Steve Bentley, "A Short History of PTSD: From Thermopylae to Hue, Soldiers Have Always Had a Disturbing Reaction to War," January 1991, repr., March–April 2005, archive.vva.org /archive/TheVeteran/2005_03/feature_HistoryPTSD.htm.

103 The Greek historian Herodotus: Ibid. All quotes in this passage are from the same source.

104 During World War I, the soldiers': Ibid.

104 Many of the symptoms observed: "Conversion Disorder," Encyclopedia of Mental Disorders, minddisorders.com/Br-Del/Conversion-disorder .html.

104 In the 1880s at the Salpêtrière: Ulrich Baer, *Spectral Evidence: The Photography of Trauma* (Cambridge, Mass.: MIT Press, 2002), 25–60.

105 A forgetting pill: "If You Could Pop a Pill to Forget, Would You?," *Here & Now,* April 4, 2012, hereandnow.legacy.wbur.org/2012/04/04/forget-pill-wired, and Jonah Lehrer, "The Forgetting Pill Erases Painful Memories Forever," *Wired,* February 17, 2012, wired.com/2012/02/the-forgetting-pill/.

106 During the American Civil War: Bentley, "Short History of PTSD."

107 In World War II, the most: Ibid.

107 Charcot's patient Hortense: Baer, *Spectral Evidence,* 25–60.

108 Scientists train rats: Lehrer, "Forgetting Pill."

108 The artist Tejal Shah: I saw and read about the series of photographs on Shah's website: tejalshah.in/project/pentimento/hysteria-%E2%80%93-iconography-from-the-salpetrier-series.

108 It's a mental illness called: "Conversion Disorder," National Organization for Rare Disorders," rarediseases.org/rare-diseases /conversion-disorder.

109 Your legs may become paralyzed: Mayo Clinic Staff, "Conversion Disorder," mayoclinic.org/diseases-conditions/conversion-disorder /basics/definition/con-20029533.

109 A psychiatrist defines the symptoms: "Conversion Disorder," Encyclopedia of Mental Disorders, minddisorders.com/Br-Del /Conversion-disorder.html.

109 Being close to a blast: Robert F. Worth, "What If PTSD Is More Physical Than Psychological?," *New York Times,* June 10, 2016, nytimes .com/2016/06/12/magazine/what-if-ptsd-is-more-physical-than-psychological.html.

110 If you count all veterans: Alan Zarembo, "Detailed Study Confirms High Suicide Rate Among Recent Veterans," *Veterans Today,* January 16,

2015, veteranstoday.com/2015/01/16/detailed-study-confirms-high-suicide-rate-among-recent-veterans/.

110 **Moral injury:** Benjamin Sledge, "The Conversation About War and Our Veterans We Refuse to Have," May 27, 2016, medium.com/@benjaminsledge/the-conversation-about-war-and-our-veterans-we-refuse-to-have-a95c26972aee#.gxxxm6fei.

110 **Having killed or tortured:** Rita Nakashima Brock and Gabriella Lettini, *Soul Repair: Recovering from Moral Injury After War* (Boston: Beacon, 2012), xv.

111 **Reverend Herman Keizer, Jr.:** Brock and Lettini, *Soul Repair*, xi. The quote from Keizer is the epigraph to the introduction.

112 **An article about the forgetting pill:** Lehrer, "Forgetting Pill."

112 **In 2007, officials from the CIA admitted:** Mark Mazzetti, "C.I.A. Destroyed 2 Tapes Showing Interrogations," *New York Times,* December 7, 2007, nytimes.com/2007/12/07/washington/07intel.html?pagewanted=all.

112 **Two years later, they admitted:** Mark Mazzetti, "U.S. Says C.I.A. Destroyed 92 Tapes of Interrogations," *New York Times,* March 3, 2009, nytimes.com/2009/03/03/washington/03web-intel.html?_r=0.

112 **Rush Holt, a Democratic member:** Mazzetti, "C.I.A. Destroyed 2 Tapes."

113 **Every image of the past:** Walter Benjamin, "On the Concept of History," sfu.ca/~andrewf/CONCEPT2.html.

9. WRITTEN IN THE STARS

118 **Scientists exposed mice to the smell:** Richard Gray, "Phobias May Be Memories Passed Down in Genes from Ancestors," *Telegraph,* December 1, 2013, telegraph.co.uk/news/science/science-news/10486479/Phobias-may-be-memories-passed-down-in-genes-from-ancestors.html.

118 **The offspring of the shocked mice:** Ibid.

119 **Into fabric she's hand-dyed black:** The descriptions of her quilts are taken from Anna Von Mertens's website: annavonmertens.com/portfolio.php?genus=12&specimen=56.

120 **The brains of the mice scientists:** Gray, "Phobias May Be Memories."

120 **Before people donated their bodies:** I learned about anatomy theater from Chantal Forfota, who sent me a description of an opera by David Lang called *Anatomy Theater.*

122 *The most existential form of mapping:* Nick Stockton, "The Art of Sewing Science into Beautiful Quilts," *Wired,* September 10, 2014, wired.com/2014/09/needlepoint-science.

122 **During many of the title events:** Von Mertens, annavonmertens.com/portfolio.php?genus=12.

123 **Von Mertens's decision to make quilts:** Ibid.

123 **I found a website about the ship:** Joe E. Sherrill, "When Is a Rat Not a Rat," usslsm51.com/lsm51c.html.

127 **Darold A. Treffert, a psychiatrist:** Doreen Carvajal, "In Andalusia, on the Trail of Inherited Memories," *New York Times*, August 17, 2012, nytimes.com/2012/08/21/science/in-andalusia-searching-for-inherited-memories.html?pagewanted=2&_r=0.

128 **In a quilt titled** *Hiroshima:* Von Mertens, annavonmertens.com/portfolio .php?genus=12.

128 **This is the** *last operation:* I read the description of this operation on the website about my grandfather's ship: usslsm51.com.

131 **In her book** *Precarious Life:* Judith Butler, *Precarious Life: The Powers of Mourning and Violence* (New York: Verso, 2004), 22–28.

10. CALL OF DUTY

138 **Caddis flies—small winged insects:** Keith Arthur John Wise, "Caddisfly," *Encyclopedia Britannica*, britannica.com/EBchecked /topic/87882/caddisfly, and "Trichoptera," cals.ncsu.edu/course /ent425/library/compendium/trichoptera.html.

139 **After the bombing of Pearl Harbor:** "Hirabayashi, Gordon K.," *HistoryLink*, historylink.org/index.cfm?DisplayPage=output.cfm&file_ id=2070.

139 **The day after Japanese Americans:** "Gordon Hirabayashi," *Densho Encyclopedia*, encyclopedia.densho.org/Gordon_Hirabayashi, and "Hirabayashi, Gordon K.," *HistoryLink*.

139 **In the year 295, Maximilian:** Charles C. Moskos and John Whiteclay Chambers, *The New Conscientious Objection: From Sacred to Secular Resistance* (New York: Oxford University Press, 1993), 9.

139 **He was executed, beheaded by sword:** H. Brock, "Conscientious Objection in History," *War Resisters International*, November 17, 2015, wri-irg.org/cobook-online/co-in-history.

141 **When conscription was introduced in Egypt:** Ibid.

141 **After he was convicted of disobeying:** I learned about the prison camp and Hirabayashi from the following sources: "Catalina Federal Honor Camp," *Experience Arizona*, experience-az.com/About/arizona/places /catalinafederalhonorcamp.html; "Civil Disobedience! The Life and Legacy of Gordon K. Hirabayashi," *UW 360*, youtube.com/watch?v=qwBcj3DgtyE; and "Tucson (Detention Facility)," *Densho Encyclopedia*, encyclopedia .densho.org/Tucson_%28detention_facility%29/.

142 **During the Civil War:** Lillian Schlissel, *Conscience in America:*

A Documentary History of Conscientious Objection in America, 1757–1967 (New York: Dutton, 1968), 88.

142 **In the Confederacy:** Ibid.

143 **Quakers, Mennonites, Brethren, and Nazarenes:** "Brief History of Conscientious Objection," swarthmore.edu/library/peace /conscientiousobjection/co%20website/pages/HistoryNew.htm, and "Conscientious Objection," civilianpublicservice.org/storybegins /krehbiel/conscientious-objection.

143 **The artist Sabina Haque:** I read about *War Games* on her website: sabinahaque.com/nishana-war-games.html.

143 **Conscription in World War I:** Schlissel, *Conscience in America*, 129–31.

144 **In World War II, 72,354 men:** "Conscientious Objectors," *Wessels Living History Farm*, livinghistoryfarm.org/farmingin the40s/life_05.html.

144 **Roughly 20,000 conscientious objectors:** "Brief History of Conscientious Objection," swarthmore.edu/library/peace/conscientiousobjection /co%20website/pages/HistoryNew.htm.

146 **The French artist Hubert Duprat:** Christopher Jobson, "Artist Hubert Duprat Collaborates with Caddisfly Larvae as They Build Aquatic Cocoons from Gold and Pearls," *Colossal*, July 25, 2014, thisiscolossal .com/2014/07/hubert-duprat-caddisflies.

148 **On the Selective Service System's website:** "Conscientious Objection and Alternative Service," Selective Service System, sss.gov/consobj.

11. Smallest Possible Weapon

154 **At Baghdad International Airport, Miles:** I also wrote about this in *Breaking Up with God: A Love Story* (San Francisco: HarperOne, 2011).

156 *We are at war:* Barack Obama, "Remarks by the President at the Acceptance of the Nobel Peace Prize," December 10, 2009, whitehouse .gov/the-press-office/remarks-president-acceptance-nobel-peace-prize.

157 **Absolute pacifism: Some pacifists refuse:** Andrew Fiala, "Pacifism," *Stanford Encyclopedia of Philosophy*, August 14, 2014, plato.stanford.edu /entries/pacifism/.

159 *Perhaps the most profound issue surrounding:* Obama, "Remarks by the President."

159 **First a map with the names:** I don't know if I saw the same footage Kayleen saw, but this is what I watched: "Nuremberg, Day 8, Concentration Camp Film," youtube.com/watch?v=9NmaZlFlZGE.

161 **Pacifism is a *pathology of the privileged*:** Fiala, "Pacifism."

162 **He started with the face:** Judith Butler, *Precarious Life* (New York: Verso,

2004), 128–51. For the line that begins *the face as the extreme precariousness of the other,* Butler is quoting Levinas's essay "Peace and Proximity."

162 **Critics insist pacifism results from:** Fiala, "Pacifism."

164 **A skeptical version of pacifism:** Fiala, "Pacifism."

164 **Years ago, Amnon Weinstein:** "Restoring Hope by Repairing Violins of the Holocaust," *PBS NewsHour,* pbs.org/newshour/bb/restoring-hope-by-repairing-violins-of-the-holocaust.

165 **Transformational pacifism:** Fiala, "Pacifism."

166 *The religious discourse prior to all:* Emmanuel Levinas, *Of God Who Comes to Mind,* trans. Bettina Bergo (Palo Alto: Stanford University Press, 1998), 75.

166 **I watched a video of Hirabayashi:** "Densho Oral History: Gordon Hirabayashi," youtube.com/watch?v=8VNrUrEj7HU&NR=1&feature= endscreen, and "Receiving Encouragement from Mother: Gordon Hirabayashi," youtube.com/watch?v=KUjrsohc2w8.

168 **Kill or be killed:** Fiala, "Pacifism."

168 *Our weapon is the smallest possible:* I think Ruane is possibly quoting someone here (a letter? a book?), but in her own letter, she does not indicate what or who she is quoting, and I have not been able to locate the source.

12. Paint the Target

172 **Seymour Hersh recounted this story:** Seymour Hersh, "A Reporter's Report on Washington," Twenty-fifth Van der Leeuw Lecture, Groningen, October 26, 2007, sachhiem.net/SACHNGOAI/snS/SeymourHersh.php and vanderleeuwlezing.nl/sites/default/files/lezingHersh.pdf.

173 **There is a** *hierarchy of grief:* Judith Butler, *Precarious Life: The Powers of Mourning and Violence* (New York: Verso, 2004), 32–35.

173 **In 2010, during a live performance:** Laura Pellegrinelli, "Artist Tattoos Indelible Iraq Memorial into His Skin," *All Things Considered,* June 1, 2010, npr.org/templates/story/story.php?storyId=127348258.

174 **The critique of violence must begin:** Butler, *Precarious Life,* 51.

174 **Photographs are like tattoos:** Christopher Pinney and Nicolas Peterson, *Photography's Other Histories* (Durham, N.C.: Duke University Press, 2003), 5. In the introduction to the book, Pinney is quoting an essay by Hulleah J. Tsinhnahjinnie.

174 **Wafaa Bilal grew up in Iraq:** Wafaa Bilal, "Domestic Tension," wafaabilal .com/domestic-tension/.

175 **Naval warships were first painted gray:** Sam LaGrone, "Camouflaged Ships: An Illustrated History," *USNI News,* March 1, 2013, news.usni

.org/2013/03/01/camouflaged-ships-an-illustrated-history, and "Dazzle Camouflage," Fleet Library Special Collections, RISD, dazzle.risd.edu.

176 **In war, the goal of every:** Elaine Scarry, *The Body in Pain: The Making and Unmaking of the World* (New York: Oxford University Press, 1985), 133.

176 **There was no dazzle camouflage:** I read about this practical joke on the website about my grandfather's ship: usslsm51.com/for_sale.html.

177 **In his sworn statement detailing:** Mark Danner, *Torture and Truth: America, Abu Ghraib, and the War on Terror* (New York: New York Review Books, 2004), 245.

177 **Sometimes the soldiers wrote made-up names:** Philip Gourevitch, "Exposure: The Woman Behind the Camera at Abu Ghraib," *New Yorker* (March 24, 2008), 50, newyorker.com/magazine/2008/03/24/exposure-5.

178 **For Tsinhnahjinnie, the photograph is** *like:* Pinney and Peterson, *Photography's Other Histories*, 5.

178 **Before it was known for its:** "Editorial," *Nature,* June 2005, 537–38, nature.com/nature/journal/v435/n7042/full/435537b.html.

178 **In 2004, Paul Bremer, the top civil:** Mark Crispin Miller, "US Forced Iraqis to Buy Seeds from Monsanto—and Now We're ALL Under the Gun! (2)," *News from Underground,* January 24, 2005, markcrispinmiller.com/2013/03/us-forced-iraqis-to-buy-seeds-from-monsanto-and-now-were-all-under-the-gun-2, and "Iraq's New Patent Law: A Declaration of War Against Farmers," *Grain,* October 15, 2004, grain.org/article/entries/150-iraq-s-new-patent-law-a-declaration-of-war-against-farmers.

179 **Just before the camps were liberated:** Ulrich Baer, *Spectral Evidence: The Photography of Trauma* (Cambridge, Mass.: MIT Press, 2002), 77.

179 **In the film** *Soldiers of Conscience:* Rita Nakashima Brock and Gabriella Lettini, *Soul Repair: Recovering from Moral Injury After War* (Boston: Beacon, 2012). The epigraph for the book is a quote by Benderman from the film *Soldiers of Conscience,* pbs.org/pov/soldiersofconscience/.

180 **The science of camouflage:** Daniel Engber, "Lost in the Wilderness," *Slate,* July 5, 2012, slate.com/articles/health_and_science/science/2012/07/camouflage_problems_in_the_army_the_ucp_and_the_future_of_digital_camo_.html.

180 **As soon as people on the ground:** Paula Amad, "From God's-Eye to Camera-Eye: Aerial Photography's Post-Humanist and Neo-Humanist Visions of the World," *History of Photography* 36, no. 1 (2012): 83.

180 **On the seventh day:** "Was It a Baby Milk Factory?," *Fog of War: The 1991 Air Battle for Baghdad,* Washington Post Company, 1998, washingtonpost.com/wp-srv/inatl/longterm/fogofwar/vignettes/v4.htm.

181 **Again and again we mis-see:** Jakob von Uexküll, "A Stroll Through the Worlds of Animals and Men: A Picture Book of Invisible Worlds (1934),"

in *Instinctive Behavior: The Development of a Modern Concept,* ed. Claire H. Schiller (New York: International Universities Press, 1957).

181 **Some soldiers prosecuted for what happened:** Joanna Bourke, "Fallgirls: Gender and the Framing of Torture at Abu Ghraib," *Times Higher Education,* July 12, 2012, timeshighereducation.co.uk/420512.article.

181 **Sabrina Harman got her first tattoo:** Gourevitch, "Exposure."

182 **Harman later covered that tattoo:** Jonathannancy, "Gendering Abu Ghraib," *Sexism Class Violence,* March 5, 2015, sexismclassviolence.wordpress .com/2015/03/05/gendering-abu-ghraib/.

13. War Tourism

187 **In *The Civil Contract of Photography*:** Ariella Azoulay, *The Civil Contract of Photography* (New York: Zone, 2008).

188 **On a hilltop near the:** Debra Kamin, "The Rise of Dark Tourism," *Atlantic,* July 2014, theatlantic.com/international/archive/2014/07/the-rise-of-dark-tourism/374432.

188 **Humankind used to be *an object*:** Paula Amad, "From God's-Eye to Camera-Eye: Aerial Photography's Post-Humanist and Neo-Humanist Visions of the World," *History of Photography* 36, no. 1 (2012): 69. Amad is quoting Benjamin, "The Work of Art in the Age of Its Technological Reproducibility."

188 *And we: always and everywhere spectators:* Rainer Maria Rilke, "8th Duino Elegy," translated by Joanna Macy and Anita Barrows, joannamacy.net /poemsilove/rilke-favorites/193-8thduinoelegyrainermariarilke.html.

189 **Susan Sontag wrote, *To suffer is*:** Susan Sontag, *On Photography* (New York: Farrar, Straus and Giroux, 1977), 19–20.

189 **Azoulay argued that Sontag focused too:** Azoulay, *Civil Contract of Photography,* 18, 130.

189 **Kayleen read *A Principled Stand*:** Gordon Hirabayashi, *A Principled Stand: The Story of Hirabayashi v. United States* (Seattle: University of Washington Press, 2013).

190 **The internees transformed the landscape:** minidokapilgrimage.org /thepilgrimage.html.

190 **Photographs are *transit visas*:** Azoulay, *Civil Contract of Photography,* 113, 134.

191 **Adolf Eichmann sat in a bulletproof:** Hannah Arendt, "Eichmann in Jerusalem II," *New Yorker,* February 23, 1963, 88.

191 **Hannah Arendt wrote about Eichmann's trial:** Ibid., 84.

191 **Arendt wrote about the Nazis' attempts:** Elaine Scarry, *The Body in Pain: The Making and Unmaking of the World* (New York: Oxford University

Press, 1985), 58–59. Scarry wrote about Arendt's book *Eichmann in Jerusalem*.

191 **Viewers' revulsion at images of suffering:** Rebecca A. Adelman, *Beyond the Checkpoint: Visual Practices in America's Global War on Terror* (Amherst: University of Massachusetts Press, 2014), 52.

192 **For a class I taught called:** The student is Jill Falk.

192 **Sontag argued that photographs of people:** Susan Sontag, *Regarding the Pain of Others* (New York: Picador, 2003), 102–03.

192 **Explaining to Diane Sawyer on** *Good:* Information Clearing House, "ABC /Good Morning America, March 18, 2003," informationclearinghouse .info/article5041.htm.

193 **In the series** *House Beautiful:* "The Collection: Martha Rosler," MoMA, moma.org/collection/works/150127?locale=en.

194 **Fanny Howe:** *War can make people:* Fanny Howe, *The Wedding Dress: Meditations on Word and Life* (Berkeley: University of California Press, 2003), 126.

194 **Eichmann was taken on a tour:** Arendt, "Eichmann in Jerusalem II," 84–88.

195 **When Sontag saw two photographs:** Sontag, *On Photography*, 19–20.

196 **Photography was invented at the moment:** Azoulay, *Civil Contract of Photography*, 92–93, 123.

196 **Most prisoners at Abu Ghraib lived:** "Abu Ghurayb Prison," *Global Security*, globalsecurity.org/intell/world/iraq/abu-ghurayb-prison.htm, and "The Road to 'Camp Redemption,'" *Telegraph*, telegraph.co.uk/news /worldnews/middleeast/iraq/1462043/The-road-to-Camp-Redemption .html.

14. WATCHER OF HUMANITY

201 *It is a queer experience, lying:* Virginia Woolf, "Thoughts on Peace in an Air Raid," *New Republic*, October 20, 1940, newrepublic.com/article /113653/thoughts-peace-air-raid.

201 **She was listening:** "Doodlebugs and V2's," BBC, bbc.co.uk/history /ww2peopleswar/stories/43/a4476143.shtml.

202 **Doodlebugs made a droning sound:** "Doodlebug, V1, Buzz Bomb Attacks Against London and the Home Countries," *Live Leak*, liveleak .com/view?i=535_1253300423#lQXfXYvRyrIjvM70.99.

202 *It is a sound—far more:* Woolf, "Thoughts on Peace."

202 *Umwelt—German biologist Jakob von Uexküll's:* Giorgio Agamben, *The Open: Man and Animal*, trans. Kevin Artell (Palo Alto: Stanford University Press, 2003), 40–42. Agamben wrote about Jakob von

Uexküll's "A Stroll Through the Worlds of Animals and Men: A Picture Book of Invisible Worlds" (1934), which I read in *Instinctive Behavior: The Development of a Modern Concept*, ed. Claire H. Schiller (New York: International Universities Press, 1957).

202 **Children who live in North Waziristan:** Naureen Khan, "Drone Victims Give US Lawmakers Firsthand Account of Attack," Al Jazeera America, October 29, 2013, america.aljazeera.com/articles/2013/10/29/congressional briefingonpakistanidronevictimsdraws5lawmakers.html.

202 **Zubair and his sister Nabila:** Karen McVeigh, "Drone Strikes: Tears in Congress as Pakistani's Family Tells of Mother's Death," *Guardian*, October 29, 2013, theguardian.com/world/2013/oct/29/pakistan-family-drone-victim-testimony-congress, and Tomas van Houtryve, "Blue Sky Days: Photographs by Tomas van Houtryve," *Harper's*, April 2014, 37.

203 **The Predator drone appears faceless:** Robert Valdes, "How the Predator UAV Works," *How Stuff Works*, science.howstuffworks.com/predator1 .htm.

204 *Never before has an age been:* Paula Amad, "From God's-Eye to Camera-Eye: Aerial Photography's Post-Humanist and Neo-Humanist Visions of the World," *History of Photography* 36, no. 1 (2012): 69. Amad is quoting Siegfried Kracauer, "Photography," from his *The Mass Ornament: Weimar Essays* (1927), trans. and ed. Thomas Y. Levin (Cambridge, Mass.: Harvard University Press, 1995), 47–64.

204 **In *GQ* magazine, I read this:** Matthew Power, "Confessions of a Drone Warrior," *GQ*, October 22, 2013, gq.com/news-politics/big-issues/201311 /drone-uav-pilot-assassination.

205 *It is not with metal:* Quoted in Amad, "From God's-Eye to Camera-Eye," 63.

205 **The first aerial photographs were taken:** Amad, "From God's-Eye to Camera-Eye," 68.

205 **In the early 1900s, Julius Neubronner:** Lauren Davis, "Pigeon Photographers Took Aerial Pictures of Europe's Cities," January 8, 2012, io9.gizmodo.com/5874058/pigeon-photographers-took-aerial-pictures-of-europes-cities.

205 **One of his pigeons stayed away:** Alyssa Coppelm, "It's Not the Camera, It's the Pigeon," *Slate*, October 29, 2012, slate.com/blogs/behold/2012 /10/29/julius_neubronner_and_the_amazing_world_of_pigeon_ photography.html.

205 **Neubronner liked the pictures taken:** Silvia Mollicchi, "Julius Neubronner's Photographer Pigeons," *Full Stop*, March 26, 2015, full-stop.net/2015/03/26/blog/silvia-mollicchi/julius-neubronners-photographer-pigeons/.

206 **Neubronner would drive his birds:** "Now That's a Bird's Eye View: Amazing Aerial Photos from 1908 Taken by Fitting Mini Cameras to

Pigeons," January 15, 2013, dailymail.co.uk/sciencetech/article-2262708
/Dr-Julius-Neubronners-pigeon-camera—Amazing-aerial-photos-1908-
taken-fitting-mini-cameras-PIGEONS.html.

206 **If birds believed in God:** Ludwig Feuerbach, *The Essence of Christianity,*
trans. George Eliot (Amherst: Prometheus, 1989), 17.

206 **You have searched me out:** Psalm 139 (adapted).

207 **Neubronner brought his pigeons to photography:** Mollicchi, "Julius
Neubronner's Photographer Pigeons."

208 **Aerial vision is not human vision:** Quoted in Amad, "From God's-Eye
to Camera-Eye," 64, 67.

208 **Now planes controlled remotely are called:** Josh Begley, "Visual
Glossary," theintercept.com/drone-papers/a-visual-glossary/#credit.

208 **Aerial photography allowed people to see:** Amad, "From God's-Eye to
Camera-Eye," 69.

209 **In 1866, people in southern Ontario:** Sean Kane, "Here's How the
Passenger Pigeon Went from Billions to Extinct in Just 50 Years," *Business
Insider,* March 23, 2016, businessinsider.com/extinction-passenger-
pigeon-billions-hunting-2016-2/#the-passenger-pigeons-demise-is-a-dark-
example-of-humanitys-effect-on-the-environment-how-could-such-a-
numerous-species-be-wiped-out-of-existence-within-half-a-century-1.

210 *Does something mechanical like a camera:* Fanny Howe, *The Wedding Dress*
(Berkeley: University of California Press, 2003), 124.

210 **Project Pigeon: American behaviorist and Harvard:** Joseph Stromberg,
"B. F. Skinner's Pigeon-Guided Rocket," *Smithsonian,* August 18, 2011,
smithsonianmag.com/smithsonian-institution/bf-skinners-pigeon-
guided-rocket-53443995/?no-ist.

210 **Pigeons process visual information:** Staci Lehman, "WWII Files:
Pigeon-Guided Missiles and Bat Bombs," *Today I Found Out,* December 4,
2013, todayifoundout.com/index.php/2013/12/pigeon-guided-missiles-
bird-brained-ideas.

211 **Many birds of prey do not:** von Uexküll, "A Stroll Through the Worlds
of Animals and Men," 56.

211 **Hawk moths are known for hovering:** "Hawk Moth," *Encyclopedia
Britannica,* britannica.com/EBchecked/topic/257473/hawk-moth.

211 **Scientists attached reflective beads:** "Moth Drone Stays Rock Steady in
Gale-Force Winds," *New Scientist,* January 15, 2014, newscientist.com
/article/mg22129524.300-moth-drone-stays-rock-steady-in-galeforce-
winds.html#.U7A0qKiZ7FE.

212 **Have no fear:** Luke 12:2–7 (adapted).

212 **John Berger asked, *Has the camera:*** John Berger, *About Looking* (New
York: Pantheon, 1980), 57.

213 **In Islam, bodies are washed:** International Human Rights and Conflict

Resolution Clinic at Stanford Law School and Global Justice Clinic at NYU School of Law, *Living Under Drones: Death, Injury, and Trauma to Civilians from US Drone Practices in Pakistan,* footnotes 562–68, 551–57, chrgj.org/wp-content/uploads/2012/10/Living-Under-Drones.pdf.

213 *Unless we can think peace:* Woolf, "Thoughts on Peace in an Air Raid."

213 **The photographer Tomas van Houtryve:** van Houtryve, "Blue Sky Days: Photographs by Tomas van Houtryve."

214 **An experimental weapon designed:** Lehman, "WWII Files: Pigeon-Guided Missiles and Bat Bombs"; Alexis C. Madrigal, "Old, Weird Tech: The Bat Bombs of World War II," *Atlantic,* April 4, 2011, theatlantic.com /technology/archive/2011/04/old-weird-tech-the-bat-bombs-of-world-war-ii/237267; and Cara Giaimo, "The Almost Perfect World War II Plot to Bomb Japan with Bats," *Atlas Obscura,* August 5, 2015, atlasobscura.com /articles/the-almost-perfect-world-war-ii-plot-to-bomb-japan-with-bats.

215 **Double tap: the practice of hitting:** International Human Rights and Conflict Resolution Clinic at Stanford Law School and Global Justice Clinic at NYU School of Law, *Living Under Drones,* footnotes 522, 488–503.

215 **Do not think I have come:** Matthew 10:34–42 (adapted).

215 **Anticipatory traumatic stress disorder (ATSD):** I used the phrase "anticipatory traumatic stress disorder" as a variation on "post-traumatic stress disorder" because the authors of *Living Under Drones* write about the "anticipatory anxiety" that results from the constant worry and fear of never knowing when the next drone attack will come. International Human Rights and Conflict Resolution Clinic at Stanford Law School and Global Justice Clinic at NYU School of Law, *Living Under Drones,* footnotes 522, 488–503.

216 **Job talked to God:** Job 7:7–21 (adapted).

216 **The world is the world:** von Uexküll, "A Stroll Through the Worlds of Animals and Men."

217 **Think of it this way:** Agamben, *The Open,* 41.

217 **The day and hour no one:** Matthew 24:36–44 (adapted).

15. REENACTMENTS

222 **In *The Cruel Radiance,* Susie Linfield:** Susie Linfield, *The Cruel Radiance: Photography and Political Violence* (Chicago: University of Chicago Press, 2010), 40–41.

223 **The Box—a military training facility:** Dora Apel, *War Culture and the Contest of Images* (New Brunswick, N.J.: Rutgers University Press, 2012), 172.

223 **They perform the lives they left:** Christopher Sims, "Theater of War:

The Pretend Villages of Iraq and Afghanistan," chrissimsprojects.com /#/theater-of-war-the-pretend-villages-of-iraq-and-afghanistan.

223 **Other actors are residents:** Apel, *War Culture*, 172–73.

224 **At the end of "Looking at War":** Susan Sontag, "Looking at War," *New Yorker,* December 9, 2002, newyorker.com/magazine/2002/12/09 /looking-at-war.

225 **Frances Glessner Lee re-created:** Corinne May Botz, *The Nutshell Studies of Unexplained Death,* corinnebotz.com/about.

226 **Looking at a photograph of a veteran:** Sontag, "Looking at War."

226 **For a series titled** *Theater of War:* Sims, "Theater of War."

228 **Of Frances Glessner Lee's twenty completed:** Jimmy Stamp, "How a Chicago Heiress Trained Homicide Detectives with an Unusual Tool: Dollhouses," *Smithsonian,* March 6, 2014, smithsonianmag.com/arts-culture/murder-miniature-nutshell-studies-unexplained-death-180949943/.

229 **Outrage generated by documentary photographs:** Rebecca A. Adelman, *Beyond the Checkpoint: Visual Practices in America's Global War on Terror* (Amherst: University of Massachusetts Press, 2014), 27.

230 **Craft, care, visual power, framing:** Linfield, *Cruel Radiance,* 44–45.

231 **Photography makes violence visible, Linfield wrote:** Linfield, *Cruel Radiance,* 33.

231 **Sometimes to really see a photograph:** Roland Barthes, *Camera Lucida: Reflections on Photography,* trans. Richard Howard (New York: Hill and Wang, 1981), 53–55.

232 **Hysterics were not the only people:** James Elkins, *The Object Stares Back: On the Nature of Seeing* (San Diego: Harcourt Brace, 1997), 25–27.

233 **The student who used the Post-it:** The student is Qathi Hart.

233 **In** *Beyond the Checkpoint,* **Adelman:** Adelman, *Beyond the Checkpoint,* 52–53.

234 **Though I long for the perfect:** Linfield, *Cruel Radiance,* 60, 59.

234 **The Barbie Liberation Organization:** David Firestone, "While Barbie Talks Tough, G.I. Joe Goes Shopping," *New York Times,* December 31, 1993, nytimes.com/1993/12/31/us/while-barbie-talks-tough-g-i-joe-goes-shopping.html.

235 **I read this:** *In behavioral:* Bessel A. van der Kolk, "The Compulsion to Repeat the Trauma: Re-enactment, Revictimization, and Masochism," *Psychiatric Clinics of North America* 12, no. 2 (June 1989): 389–411, cirp.org /library/psych/vanderkolk.

236 **Sometimes when he visited the simulation:** Apel, *War Culture,* 173. Apel is quoting Christopher Sims.

236 **Torment—long a canonical subject:** Sontag, "Looking at War."

241 In the beginning God speaks: Genesis 1:1–31 (adapted).

241 *You have asked for this Office's:* Jay S. Bybee, "Memorandum for John Rizzo, Acting General Counsel of the Central Intelligence Agency," August 1, 2002, 1, 9–18.

242 *At what point . . . does the renaming:* Fanny Howe, *The Wedding Dress: Meditations on Word and Life* (Berkeley: University of California Press, 2003), 59.

242 For the artist Ann Hamilton's: Ann Hamilton, *tropos* (1993–94), annhamiltonstudio.com/projects/tropos.html.

243 In a 2002 memo, Bybee outlined: Bybee, "Memorandum for John Rizzo," 2–3.

244 The Greek word for this kind: Michael A. Sells, *Mystical Languages of Unsaying* (Chicago: University of Chicago Press, 1994), 2–3.

244 Fanny Howe put it another way: Howe, *The Wedding Dress,* 120.

245 One of my students went from: This student is Micah Weber.

246 In *Mystical Languages of Unsaying:* Sells, *Mystical Languages of Unsaying,* 9.

246 *Theology is a science without instruments:* Howe, *The Wedding Dress,* 67.

247 Bybee determined there was no intent: Bybee, "Memorandum for John Rizzo," 18.

247 The question to ask is what: Elisabeth Schüssler Fiorenza, *Rhetoric and Ethic: The Politics of Biblical Studies* (Minneapolis: Fortress, 1999).

247 For more than a decade: Jenny Holzer, *Dust Paintings,* cheimread.com /exhibitions/jenny-holzer-dust-paintings.

248 In the summer of 2004, Howard's: Jack Thomas, "Howard Scott's Unfinished Sonata," *Boston Globe,* March 7, 2006, boston.com/ae/music /articles/2006/03/07/howard_scotts_unfinished_sonata.

249 Let's say you miss your friend: Elaine Scarry, *The Body in Pain: The Making and Unmaking of the World* (New York: Oxford University Press, 1985), 161–71. Scarry wrote against Sartre's understanding of imagination in these passages.

250 In *Notes from No Man's Land:* Eula Biss, *Notes from No Man's Land: American Essays* (Minneapolis: Graywolf, 2009), 41.

250 In her diary, Virginia Woolf: Quoted in the introduction to Virginia Woolf, "Thoughts on Peace in an Air Raid," *New Republic,* October 20, 1940, newrepublic.com/article/113653/thoughts-peace-air-raid.

250 The artist Josh Azzarella doctored: Josh Azzarella, joshazzarella.com /stillworks200608/.

250 In "Potential History: Thinking Through Violence": Ariella Azoulay, "Potential History: Thinking Through Violence," *Critical Inquiry* 39, no. 3 (2013): 565.

252 Art—bringing a physical object into: Scarry, *Body in Pain*, 161–71.

253 *Our real lives hold within them:* Jeanette Winterson, *Art Objects: Essays on Ecstasy and Effrontery* (London: Jonathan Cape, 1995), 142.

254 *We understand from you that:* Steven G. Bradbury, "Memorandum for John A. Rizzo, Senior Deputy General Counsel, Central Intelligence Agency," May 10, 2005, 11.

255 Theology is, and always has been: Gordon D. Kaufman, *In the Beginning . . . Creativity* (Minneapolis: Fortress, 2004), 61.

255 The philosopher Richard Rorty: Richard Rorty, *Philosophy and Social Hope* (London: Penguin, 1999).

256 In the catalog essay for Jenny: Henri Cole, "Jenny Holzer: Dust Paintings," cheimread.com/exhibitions/jenny-holzer-dust-paintings.

256 *It is our understanding that:* Bybee, "Memorandum for John Rizzo," 17.

17. DRAW YOUR WEAPONS

263 Abraham lifts the knife and sees: I adapted this passage from Elaine Scarry, *The Body in Pain: The Making and Unmaking of the World* (New York: Oxford University Press, 1985), 174. Scarry imagines the block of wood replacing the ram. I borrowed that idea from her.

264 *The summer has ended and we:* Jeanette Winterson, *Why Be Happy When You Could Be Normal?* (New York: Grove, 2012).

265 One of my students tried: This student is Stephanie Fogel.

265 The artists Adam Broomberg and Oliver Chanarin: Jörg Colberg, "A Conversation with Adam Broomberg and Oliver Chanarin," *Conscientious Photo Magazine*, July 22, 2012, cphmag.com/convo-broomberg-chanarin.

265 The first day they were embedded: Adam Broomberg and Oliver Chanarin, "The Day Nobody Died," December 4, 2008, broombergchanarin.com /barbican-gallery-presentation. I read the parenthetical definition of fixer here: Ayub Nuri, "At War, at Home, at Risk," *New York Times*, July 29, 2007, nytimes.com/2007/07/29/magazine/29iraqi-t.html

266 In response to each event, at the: Broomberg and Chanarin, "The Day Nobody Died."

266 Those pieces of paper were there in: Colberg, "Conversation with Adam Broomberg and Oliver Chanarin."

266 *Bring your sorrow / for everyone:* Matthew Zapruder, *Come On All You Ghosts* (Port Townsend, Wash.: Copper Canyon, 2010), 41.

266 On the edge of the Predator: Robert Valdes, "How the Predator UAV Works," *How Stuff Works*, science.howstuffworks.com/predator1.htm.

267 *All seeing is heated,* James Elkins: James Elkins, *The Object Stares Back: On the Nature of Seeing* (San Diego: Harcourt Brace, 1997), 21, 18.

269 The student still trying to explain: "Quantum Theory Demonstrated: Observation Affects Reality," *Science Daily*, February 27, 1998, sciencedaily.com/releases/1998/02/980227055013.htm.

271 Quantum entanglement: when two particles interact: Natalie Wolchover, "New Quantum Theory Could Explain the Flow of Time," *Wired*, April 25, 2014, wired.com/2014/04/quantum-theory-flow-time.

271 *The photograph is not my problem:* Alex Danchev, *On Art and War and Terror* (Edinburgh: Edinburgh University Press, 2009), 52. Danchev quoted Garry Winogrand: "When the photographer Garry Winogrand was asked a stock question about photographs, 'What is this supposed to mean?,' he could give a standard answer. The answer was felt by some to be an evasion. On the contrary, it was a short lesson in the ethics of response, and responsibility. 'The photograph is not my problem,' he would say, 'it's yours.'"

ABOUT THE AUTHOR

SARAH SENTILLES is the author of four books. She earned a
bachelor's degree at Yale and master's and doctoral degrees
at Harvard. A writer, critical theorist, and scholar of religion,
she has taught at Pacific Northwest College of Art, Portland
State University, California State University Channel Islands,
and Willamette University. She has been awarded residencies
at Hedgebrook and Yaddo. She grew up in Texas and now
lives in Idaho's Wood River Valley.

sarahsentilles.com